The Vitality of Hong Kong

江 啟 明 香 港 大 自 然 組 畫
A Collection of "Hong Kong's nature" by **Kong Kai Ming**

中 華 書 局

作者簡介

———

江啟明，1932 年出生於香港，是本地極少數的第一代土生土長自學畫家及藝術教育家。江氏自幼喜愛藝術，完成初中課程後，便開始為家庭生活奔波，他同時抽空自學、苦練繪畫技巧，研究藝術理論；尤其擅長人物及風景寫生，並精通鋼筆及鉛筆速寫、水彩、油彩、版畫等多個媒介。江氏 20 歲起便從事美術教育工作，直至 1993 年宣佈退出教育工作，60 多年一直醉心於藝術繪畫創作和美術教育傳承，曾任教九龍塘學校、香港美術專科學校、嶺南藝專、大一藝術設計學校、香港中文大學專業進修學院、香港浸會大學持續教育學院、香港理工大學、香港大專美術聯會、香港警察書畫學會及香港懲教署等，可謂桃李滿門。除畫作及教授外，還先後出版了 60 多本美術教育書籍，對香港藝壇貢獻良多。江氏為擴闊及深化自己的藝術思維，從不間斷地挑戰自己，經常到世界各地旅行及寫生，作品曾於美國、日本、馬來西亞、中國大陸和台灣展出。參加及受邀之聯展共數十次。《香港史畫》及《香港今昔》畫集更獲前港督麥理浩爵士、前港督衛奕信爵士、前英國首相戴卓爾夫人曾經收藏於香港督憲府和英國首相府圖書館。

近年獲頒之主要獎項和榮譽：
· 1996 年獲香港浸會大學林思齊東西學術交流研究所授予「榮譽院士」
· 2006 年獲香港特別行政區頒授銅紫荊星章
· 2008 年獲香港藝術發展局頒發「香港藝術發展獎 2007」之「藝術成就獎」
· 2016 年獲康樂及文化事務署定位為「香港文學作家」

「江啟明在藝術上的追求是『藝術屬靈』，他要求自己不單把外物的形色世界繪入作品，還要在作品裏引進靈性的認知，讓藝術的精神回歸到自然中，用真正的自性去體驗靈性的無限。……讓思維馳騁穿梭在無滯無礙的空間，一份安寧的平常心油然而生。」

前廣東美術館館長：林抗生　王璜生

—— 節錄自《江啟明‧錦繡中華系列》，
廣東美術館畫展《現當代藝術家叢書》（2000），前言

「他不單是一位藝術家，一位無私傳授技藝、分享藝術熱誠、啟迪學生心靈的老師，……對世界藝壇來說，更是不可或缺的重要組成部分。」

龐馬

前美國水彩畫協會會員（終生會員及前會長）
—— 節錄自《水游自在：江啟明水彩畫選輯》
（香港：經濟日報出版社，2014）序言

About the Author

Born in 1932, Mr Kai Ming Kong is one of the very few first-generation self-taught painter born and raised in Hong Kong. Kong has had a passion for art since childhood, but soon after completing junior secondary school, he has become a breadwinner of his family. He taught himself painting techniques and art history in his own time. Kong is especially good at drawing people and scenery. He is also skilled at using fountain pens, pencil sketching, painting with watercolours and oil pastel, and printmaking. Kong has been engaged in art education since the age of 20, until retiring from teaching in 1993. Dedicated to art creation and art education for over 60 years, he has taught at institutions including Kowloon Tong School, the Hong Kong Academy of Fine Arts, Hong Kong Ling-hai Art Institute, First Institute of Art and Design, School of Continuing and Professional Studies at the Chinese University of Hong Kong, School of Continuing Education at the Hong Kong Baptist University, Hong Kong Polytechnic University, Hong Kong Tertiary Society of Art, Hong Kong Police Painting and Calligraphy Club, and Hong Kong Correctional Services, nurturing numerous talents in arts. Apart from painting and teaching, Kong has published more than 60 volumes of art education-related books, contributing to the local arts industry. In order to expand and further his artistic horizon, Kong keeps challenging himself by travelling to and drawing worldwide. His works were exhibited in the United States, Japan, Malaysia, Mainland China and Taiwan. He has been invited and has participated in 10 joint exhibitions. His albums *Paintings of Hong Kong Historic Landmarks* and *Landmarks of Hong Kong* are among the collections of former Governor Sir Murray MacLehose, former Governor Lord David Wilson, former British Prime Minister Baroness Margaret Thatcher, and the Government House and the Library of 10 Downing Street.

Recent accomplishments:

- Honorary Fellow of David C. Lam Institute for East-West Studies awarded by the Hong Kong Baptist University in 1996
- Bronze Bauhinia awarded by the HKSAR government in 2006
- 2007 Arts Development Awards (Visual Arts) accorded by the Hong Kong Arts Development Council in 2008
- The title "Hong Kong Literary Author" given by the Leisure and Cultural Services Department in 2016

"Kai Ming Kong is pursuing artistic spirituality. He not only paints the outer world, but also includes spiritual awareness in his works. He brings the spirit of art back to nature and let one's true self to experience the spiritual infinity.

··· Let the mind wander freely, and inner peace will come."

Kang Sheng Lin, Huang Sheng Huang
Former Directors of Guangdong Museum of Art
—— Excerpt from Foreword, *Kai Ming Kong: Splendid China Series,* Modern and Contemporary Artists Series from the Guangdong Museum of Art exhibition, September 2000

"I salute him and his marvelous career – not only as an artist, but also as an inspiring teacher who has shared his unlimited skill and sincere love of art – and of Hong Kong – with countless students and aspiring artist – and with the world of Asian Art. Kong is a one-of-a-kind teacher, artist and friend – a marvelous addition to the world of art."

G.F. Brommer,
Former Member of National Watercolor Society (Life Member and Former President)
—— Excerpt from Foreword, *Reaching the Highest Level through Watercolor: A collection of watercolor paintings by Kong Kai Ming*, published by *Hong Kong Economic Times* in March 2014

序一

江啟明老師是我們香港土生土長的美術大師。他的素描工夫極其扎實。他的具象寫實水彩畫,更令人嘆為觀止。他畫的自然景物,極為細緻傳神,包括每一塊石的節理或裂紋。一些從事地質勘探工作達數十年的學者(例如香港大學地球科學系的陳龍生教授等)亦讚嘆不已,於是把江老師的畫作放在校內展覽,成為學生學習和參考的教材。我完全同意陳教授的觀點和用意。

江老師的畫儘管極具體寫實,但同時亦充分表達了前輩藝術家對自然、對景物的感受和感悟。他認為一個真正的藝術家,不單用肉眼去繪出景物的表象,還需要靠心眼及靈性深入絕對靈空裏。所以我們在觀看一幅真正的藝術作品時,需要用心靈去感受肉眼以外靈的電波所給予的靈性上的慰藉。中華書局(香港)有限公司為江老師出版的這組「香港元氣」系列水彩畫作,正代表了江老師的這個藝術取向。

眾所周知,江老師對香港懷有極深厚的感情,過去數十年來,他透過畫筆,把香港的歷史變遷、山川風物和日常生活都忠實地紀錄下來,幾乎把香港的每一個角落都畫遍了。正如饒宗頤教授所言,香港是片福地。讓我們好好地傳承孕育這片福地的元氣。但願港人好好珍惜,一同感恩!

李焯芬
香港珠海學院校監

2016 年 4 月

Foreword1
The Vitality of Hong Kong

Mr Kai Ming Kong is a master of fine arts born and raised in Hong Kong. His foundation in sketching is solid. He impresses the audience with watercolour paintings rich in figurative realism. His paintings of the nature are detailed and vivid, never missing a joint or a crack of a piece of stone. Academics who have engaged in geological exploration for decades (e.g. Prof Lung Sang Chan from the Department of Earth Sciences, University of Hong Kong) are awed and display Mr Kong's works in school as study and reference materials for students. I fully agree with Prof Chan's viewpoints and intentions.

Mr Kong's paintings, although belonging to the school of realism, fully express the sentiments of previous artists towards the nature and the scenery. To Kong, a true artist not only presents what he or she sees with naked eyes, but also includes understanding obtained through spiritual mind in depth. Therefore, we should appreciate a piece of art with our hearts, in order to find the spiritual consolation that cannot be understood simply with naked eyes. The Vitality of Hong Kong, a collection of Kong's watercolour paintings published by Chung Hwa Book Co. (H.K.)Ltd., reflects such artistic orientation of Mr Kong.

As we all know, Mr Kong loves the city. In the previous decades, with his paint brush, he has faithfully recorded the historical changes, mountains and scenery, and daily life of Hong Kong. His paintings cover almost every corner of this city. Prof Jao once said that Hong Kong is a blessed piece of land. Let us all cherish and pass on the vitality of the blessed land with gratitude.

Prof. Chack Fan Lee, GBS, SBS, JP
Vice-Chairman, Board of Governors
Chu Hai College of Higher Education, Hong Kong

April 2016

序二

———

啟明是我 60 多年前培正中學的同班同學。我們曾共一張書枱相鄰為伴。我最怕美術課，外出寫生或靜物寫生，我都無從下筆，這時他就來幫我以至代我完成畫作。他的數學稍差，我給點幫助以作回報，因此我們建立了難忘的友誼，多年來仍然牢記這段「互助合作」的往事。那時他的繪畫才能已顯露，畫的聖誕卡在校內展覽，簡直比市面賣的還好。因此我認定將來他會是個大畫家。

歷盡滄桑，去年在老同學吳漢榆的安排下，我們再次見面。兩個老頭子一見如故，毫無生疏之感。他慣性地發表了一番藝術偉論，臨走時贈送兩本畫冊。回家後我仔細觀賞，確實心靈有所震憾。深切感受到作者對自然界的熱烈嚮往，對祖國和香港本土的濃厚感情，特別是從中可看到香港市鎮的變遷，以及作者對此的獨特詮釋。

我得承認個人缺乏藝術鑑賞力。曾去過巴黎的羅浮宮、美國及意大利不少著名的美術博物館，我能看出一些畫作的獨特性，並引起心靈的震動。但藝術水平誰高誰低，真是說不清。把啟明的作品和這些名作放在一起，我覺得也只是尺寸小一點，油彩與水彩的差別。各有各的欣賞者。

我知道啟明在香港獲得一些獎勵和榮譽，國際上有一定的知名度，但與我中學時的期望有點落差。最近我才知道，他中學畢業後，原有機會出外深造，但因須侍奉雙親而放棄。否則會出現一個與張大千、齊白石齊名的大師。在香港這樣一個美術荒蕪之地，啟明單打獨鬥，達到今日之成就，已屬難能可貴。

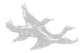

最後我想對啟明的「大自然萬物都是由數字組成」偉論作點評論和發揮。對從事數學研究的我來說，自然界是由各種基本粒子和能量組成，它的運動發展可由一系列數學方程式描述（還在不斷探索中）。人類由於有各個感覺器官而感知宇宙萬物的存在，其中視覺是最基本的。然而對畫家而言，他們主要感受到的就是色彩的世界，而色彩就是由不同頻率（或波長）的光組成。這是電腦把畫作（及照片）數碼化（數字化）的物理基礎。故由畫家說出「大自然萬物由數字組成」在一定意義上不僅沒錯，而且是從感性進到理性。一幅畫可由電腦通過數碼化表現出來，那麼電腦能否作畫？這問題就自然地提出來。眾所周知，現代的科學研究，工程設計，高精尖的工業產品，都離不開電腦。前些年，發現電腦可做幾何證明這樣高難度的思考，最近又出現了戰勝一流圍棋大師的轟動新聞，使人覺得電腦似乎無所不能。其實，無論電腦計算速度多快，也只能完成具有所謂「可計算性」的複雜難題。對於人類的精神現象，「靈性」、藝術創作，以及其評價標準，都無法從科學或邏輯上加以說明。所以正如啟明所言，畫作是靈性的產物，不具備「可計算性」。由電腦去產生的色彩（或音符）組合，極其量只能達到「工匠」的水平。可以斷言，藝術創作是不能用電腦代替的。

黃鴻慈

前 中國科學院計算數學研究所研究員

國際信息處理聯合會數值軟件工作組（代號 WG2.5）成員

香港浸會大學數學系教授

Foreword2

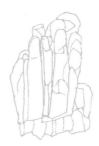

Kai Ming was my classmate in Pui Ching Middle School 60 years ago. We shared the same desk in classroom. My biggest fear was arts class. Be it sketching outdoors or still life, I would not know how to start. Kai Ming would help me finish the paintings. As he was weaker in mathematics, I would help him back. Thus we have built up a strong friendship over the years. We would still remember about this "mutual cooperation" for a long time. At that time, his artistic talent was already apparent. The Christmas cards drawn by him, which were displayed in school, were better than those sold at shops. Therefore, I was certain that he would be a successful artist.

Having experienced vicissitudes of life, under the arrangement of an old schoolmate Hon Yu Wu, we were reunited last year. We, the two old men, were like any other old friend, without any sense of unfamiliarity. As usual, he expressed his insights on arts. He also gave me two of his albums before he left. Having looked at the paintings carefully, my soul was deeply touched. I could feel the painter's yearning for the nature, his strong ties with the motherland and Hong Kong. The audience could especially see the urban changes of Hong Kong and the painter's unique interpretation.

I have to admit that my artistic appreciation skills are lacking. I have been to The Louvre in Paris, and a number of famous art museums in the United States and Italy. While I can observe unique details of certain paintings and have my soul be touched, I cannot differentiate between the artistic levels among painters. When Kai Ming's works are placed alongside the masterpieces, to me the differences would be the sizes, or whether the medium is oil pastel or watercolour. They each have their own admirers.

I know that Kai Ming has received a number of prizes and honours in Hong Kong, and is of respectable reputation in the international arena. However, this is not what I would have expected in secondary school. I have only recently learned that after graduation, he gave up the opportunity to study abroad in order to take care of his parents. Otherwise, we would have another great painter comparable to Daqian Zhang and Baishi Qi. In Hong Kong, an artistic desert, it is already commendable for Kai Ming to achieve this level of success by his own efforts.

Lastly, I would like to make a point on Kai Ming's comment that "everything in nature is composed of numbers". To me, someone who conducts mathematical research, nature is made of elementary particles and energy. Its kinetic development can be described by a series of mathematical formulae (which are still under research). With our senses, we can feel the presence of the universe. While vision is the most basic sense, to artists, what they mainly perceive is the world of colours, and colours are made up of light with varying frequency (or wavelength). This is the basis in physics of digitalising paintings (and photos) on computers. Therefore, it is not only correct for a painter to say that "everything in nature is composed of numbers", but is also a progress from emotions to rationality. As a painting can be digitalised, the question of whether computer can paint ensues. As we all know, modern scientific research, engineering design and high-end industrial products are inseparable from computers. A few years ago, computers could do complicated geometric proof; recently, there was a sensational victory of computers beating a first-class Go master. All this makes people think that computers are invincible. In fact, no matter how fast can a computer calculate, it can only solve "calculable" complex problems. Regarding spirituality, artistic creation and evaluation criteria, they cannot be explained scientifically or logically. Therefore, as what Kai Ming said, paintings are products of spirituality and are not "calculable". Colours (or musical notes) created by computers can only reach the standard of "craftsmen". I can say with certainty that artistic creation cannot be replaced by computers.

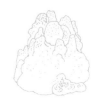

Prof. Hong Ci Huang

Former Researcher at the Institute of Computational Mathematics and Scientific /
Engineering Computing
Member of Working Group 2.5 on Numerical Software, International Federation for Information
Processing Professor, Department of Mathematics,
Hong Kong Baptist University

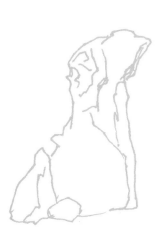

前言

——

「香港元氣」是一個大標題，它蘊含着整個香港地域的源起、地質、土壤、地貌、年齡、氣候、風水、歷史、人文、生物、色素等等的客觀面貌，是一個整體的結構。「妄想」要由一支畫筆去表達出來，真有點「妙想天開」，這是一個富挑戰性的「任務」和「使命」。因表現出來一定要透過具象手法，這是實實在在的工作，不能用「假設」、「寓意」或「幻想」等不切實際的個人主觀手法去描繪，要忠於現實，深入現實，甚至解剖現實。

我這一輯「香港元氣」，本於 2011 年就已開始繪畫，打算以二百幅為上限，怎知愈畫愈多，愈要求完整，每地域盡可能除全景外，還有中景，甚至深入到近景的特寫部分。已過五年了，還是停不下，變成一個「大工程」來處理，內容包括「海、陸、空」。我身為本港第一代土生土長而自學的畫家，對本土凝聚了一份分不開的深厚情懷，且我年青時到處翻山涉水去寫生，無論是自然景色或風土人情都可以說是瞭如指掌，且我自小對地理、地質及人文歷史都很有興趣，一生除繪畫外更寫下本土掌故，出版有《香江史趣》、《香港舊事重提》及《談古論今話香江》（獲 2015 年度金閱獎最佳書籍），也寫下不少世界和國內的遊記。

我教導學生，一開始就強調藝術最高境界是「屬靈」的，能進入靈的層面才是真正的藝術家，即已超越專業的界限及物質世界，靈的層面是與宇宙共為一體，屬靈的藝術家理應把名利拋開，進入「無極」、「無限」、「無為」、「無常」、「無求」的大我、大千世界。繪畫只是人類肉眼看到的媒介物，真正的視覺藝術是在有限的空間進入無限的空間，把有限的人生融入宇宙永恆的太虛裏。亦即是說，肉眼看見的並不是恆久不變的。故一個真正的藝術家，他不單用肉眼繪出景物的表象，還需要靠心眼及靈性深入絕對的靈空裏。所以我們觀看一幅真正的藝術作品，你要用心靈去感受肉眼以外靈的電波給予你靈性上的慰藉。我晚年更感應到宇宙間，存在不少肉眼看不見的波幅在有序地運行着，且超越現有人類認知的空間，它們對人類及物質世界起着什麼作用就不得而知。有些是人類早已知悉的，如人體內的氣血運行、命運帶給我們的起伏、衛星及星體的運行軌道等。故我近年的作品，多少有着這種我還弄不清的電波存在，我稱之為「靈性粒子」，可能與霍金的「上帝粒子」同屬，願科學家們將來能夠有所發現和引證。

以獅子山組畫，
作為揭開本畫集之序幕⋯⋯

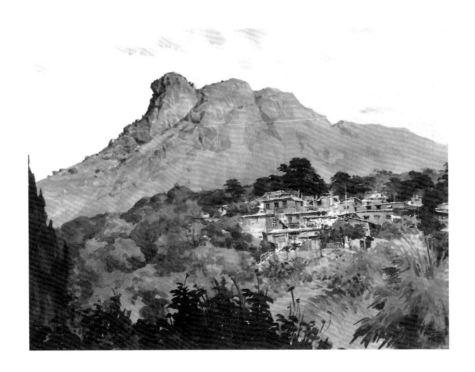

1987

獅子山（495 米） Lion Rock(495m)

57 x 76cm

昔日的獅子山下
Below the Lion Rock in the old days

我這輯作品（只選出部分），亦代表我晚年的藝術思維取向。物質世界本是數字的交叉重疊組合，我也曾說，物質世界是色彩世界，色彩就是一組數字，早由科學家及醫學界認可及運用重組，造福及有益於人類。而運用到藝術理論上，也許我是第一人。我這組「香港元氣」系列水彩畫，就是採用數字去重新演繹出來的，但與科學及醫學不同，他們一定要十分準確，一加一等於二，而運用到藝術上就不可能，因太準確就不如採用攝影及電腦繪畫，電腦是公式的、絕對的，但死板的，故藝術除了專業的技能外，是較靈活的，灌以靈性的，有生命的。

最近有人請我畫「獅子山」，山下要有木屋群，我反對，原因已成香港「人」的歷史，過去了。那年代是香港人艱苦的歲月，現在山下已是高樓大廈。要表現「獅子山精神」，那種包含着刻苦、勤奮、犧牲（容量）及包容（器量）的拼搏精神，是港人主觀地把獅子山的實體昇華為一種人為的精神力量，以鼓勵年青一輩傳承下去，可惜傳至今時今日的年青一代，很多都只作為一種政治口號，完全失去本來的意義！我反對畫木屋區，原因是它與獅子山本身無關，因此我把山下改為象徵香港的紫荊花、杜鵑花、木棉樹及松柏等植物，得以保留大自然的元氣。

我這一系列「香港大自然的組畫」希望能給予你們第一眼看到的、感受到的，並不是繪畫者的專業技巧，而是上天賦予港人的一首交響詩，那天籟之音與靈氣的波動是洗滌你心靈的甘露。我只是一位使者，盡一點綿力，但願港人好好珍惜！一同感恩，謳歌讚美！

在此謹以萬分誠意，感謝李焯芬教授、黃鴻慈教授為此書賜序，以及金嘉倫先生為書名添賜墨寶！

江啟明

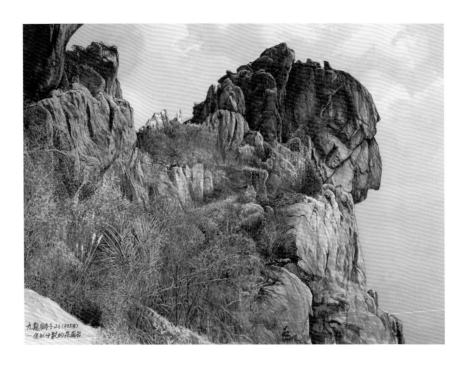

2011

獅子山側面 Side of Lion Rock

57 x 76cm

獅子山的另一面
The other side of Lion Rock

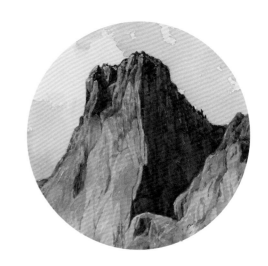

Introduction

"Vitality of Hong Kong" is an overall topic. It encompasses objective aspects including the origin, geology, soil, landscape, age, climate, feng shui, history, humanities, biology, and colours of the entire Hong Kong. It is an overall structure. It could be "wishful thinking" and a challenging "task" and "mission" to represent the above using a paint brush. Since expression needs to be representational, this is a concrete task. Unrealistic subjective approaches like "assumptions", "allegories" or "fantasies" cannot be used in description. One needs to be true to the reality, be committed to the reality, or even dissect the reality.

I started painting for this album of "Vitality of Hong Kong" in 2011. The initial upper limit was 200 paintings, but I turned out to draw more and more, and imposed on myself stricter requirements on completeness. For each region, apart from panorama, I would try to include also the medium shot, or even zoom in for a close up. It has been five years and I still cannot put a stop to this project that has turned "big", with paintings covering "the sea, the land, and the air". As a first-generation self-taught painter born and raised in Hong Kong, I have deep feelings inseparable from the city. As I would wander around the countryside to draw when I was young, I am highly familiar with natural scenery or local customs. Since I have always been much interested in geography, geology and humanities, apart from painting, I have also published about this city. Works include Anecdotes of Hong Kong, Revisiting Historical Accounts of Hong Kong, The Past and Present of Hong Kong (Best Book Award of Hong Kong Golden Book Awards 2015). I have also published stories on travelling within the country and abroad.

When I teach, I emphasise at the outset that the highest level of arts is "spirituality". Only by entering the realm of spirituality can one be a true artist. It means surpassing the professional boundaries and the materialistic world, the spiritual realm and the universe combining into one. A spiritual artist should put fame aside and pursue the "infinite", "unlimited", "inactive", "uncertain" and "contented" boundless universe. Paintings are only media that can be seen by human eyes. The true visual arts mean entering boundless space from limited space, and putting limited life into the eternal void of the universe. It also means that what the eyes can see is not constant or eternal. Therefore, a true artist not only needs to depict an object's appearance with his eyes, but also requires his heart and spirituality in order to understand the spiritual void. When we appreciate a real piece of art, we need to feel with our heart beyond the naked eyes, in order to find the spiritual solace. During my later years, I can feel the invisible wavelengths running in an orderly manner in the universe. They even go beyond our existing spatial knowledge, although it is unclear the roles they play towards the mankind and material world. Some are already known to mankind, such as the circulation of qi and blood in our body, the ups and downs in fate, and the orbits of satellites and stars. My works in recent years thus still contain this unknown electric wave, which I name as "the spiritual particle". This may be similar to Hawking's "the God particle". I hope that scientists could find relevant proofs in the future.

This album of works (the selected pieces) also represents my take on arts in later years. The material world is the overlap of numbers. I have also said that the material world is the world of colours, which is indeed a series of numbers. This has been recognised and reorganised for use by scientists and the medical industry, benefitting mankind. I may be the first to apply this to artistic theories. This collection of watercolour paintings titled "Vitality of Hong Kong" is an interpretation through numbers. Different from science and medicine, which must be accurate, any application on arts cannot be too precise. Otherwise, photography or computer arts would suffice. Arts done by computers are formulaic and absolute, but rigid. Therefore, arts do not only demonstrate professional skills, but are also flexible, spiritual, and vigorous.

Recently I was asked to draw Lion Rock with squatters, but I refuse to do so because squatters have become part of the city's history. That was a difficult period of Hong Kong people, and now the city is filled with skyscrapers. The Lion Rock Spirit represents a tough, hardworking, sacrificial (enduring) and tolerant can-do spirit. Hong Kong people had subjectively transformed Lion Rock into a man-made spiritual power for the younger generation to pass on. However, the younger generation of today simply considers it a political slogan, causing the Lion Rock Spirit to lose its significance. I refuse to draw squatters as they are not related to Lion Rock itself. Instead, I include plants that symbolise Hong Kong, such as bauhinia, azaleas, kapok trees and conifers, preserving the vitality of nature.

I hope that as you browse through this painting collection of "Hong Kong's nature", the first thing you can observe or feel is not the professional skill of the painter, but a symphonic poem gifted to Hong Kong people by God. The music from heaven and the undulations of spirituality are nectar to cleanse your soul. I am just a messenger playing my role. I hope all the Hong Kong would cherish, be grateful, and praise for the blessings!

I would like to express my heartfelt gratitude to Prof Chack Fan Lee and Prof Hong Ci Huang for writing the foreword, and Mr Chia Lun King for inscribing the book title.

Kai Ming Kong

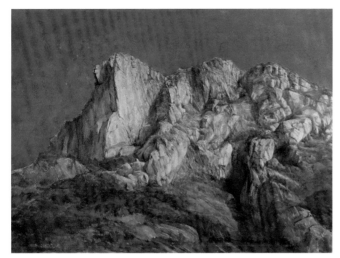

睡（瑞）獅 Sleeping (Auspicious) Lion

57 x 76cm

日月星辰，運轉乾坤，生生不息。
The heaven and the fortune revolve endlessly

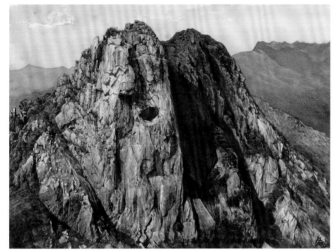

解剖獅子山
Dissecting Lion Rock

57 x 76cm

一塊狀似分裂的花崗岩
A piece of granite that seems to split

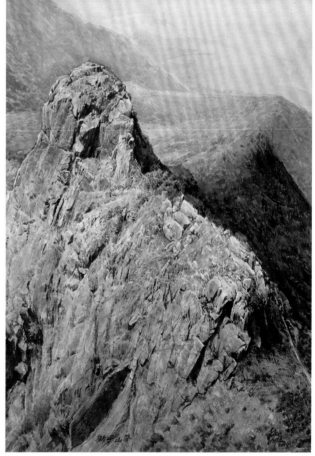

獅子山山脊 Ridge of Lion Rock

76 x 57cm

險峻難行，但可高瞻遠矚。
Steep and difficult, but far-sighted.

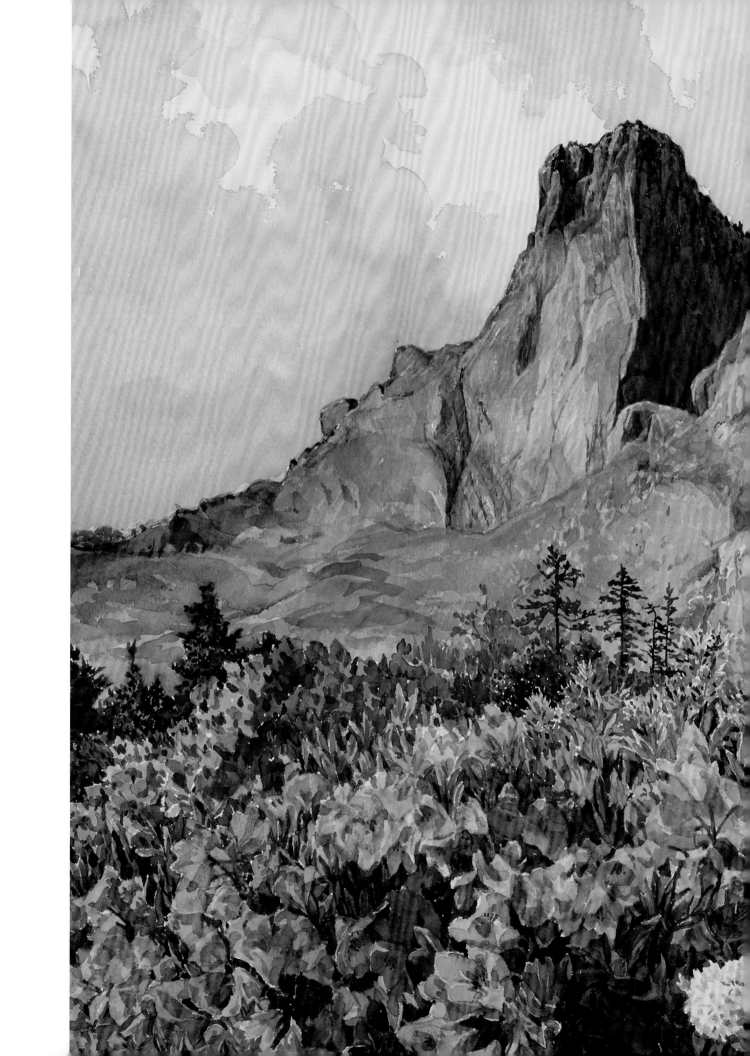

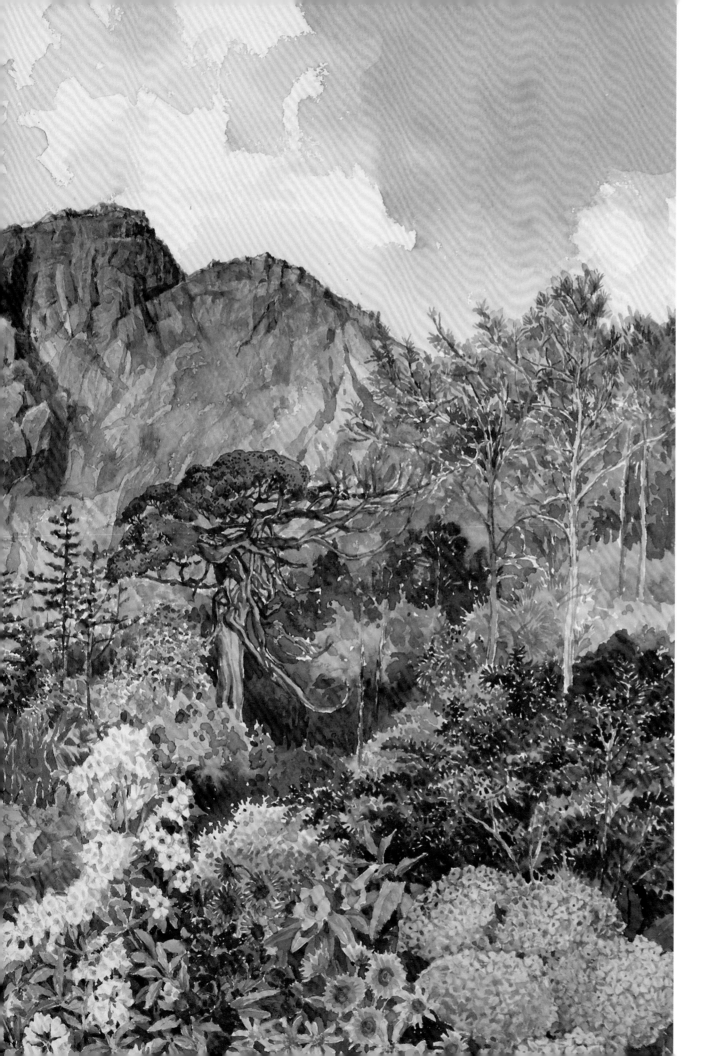

2016

獅子山元氣
Vitality of Lion Rock

57 x 76cm

元氣就是生命。
Vitality and vigour

目錄 Contents

目錄 Contents

大自然是一個龐大的生命體，

包含着永恆的靈性，有益於人類，

願君好好地珍惜和運用！

Nature is a vast body of life.

It encompasses eternality and benefits to humans.

May you cherish and make good use of the nature.

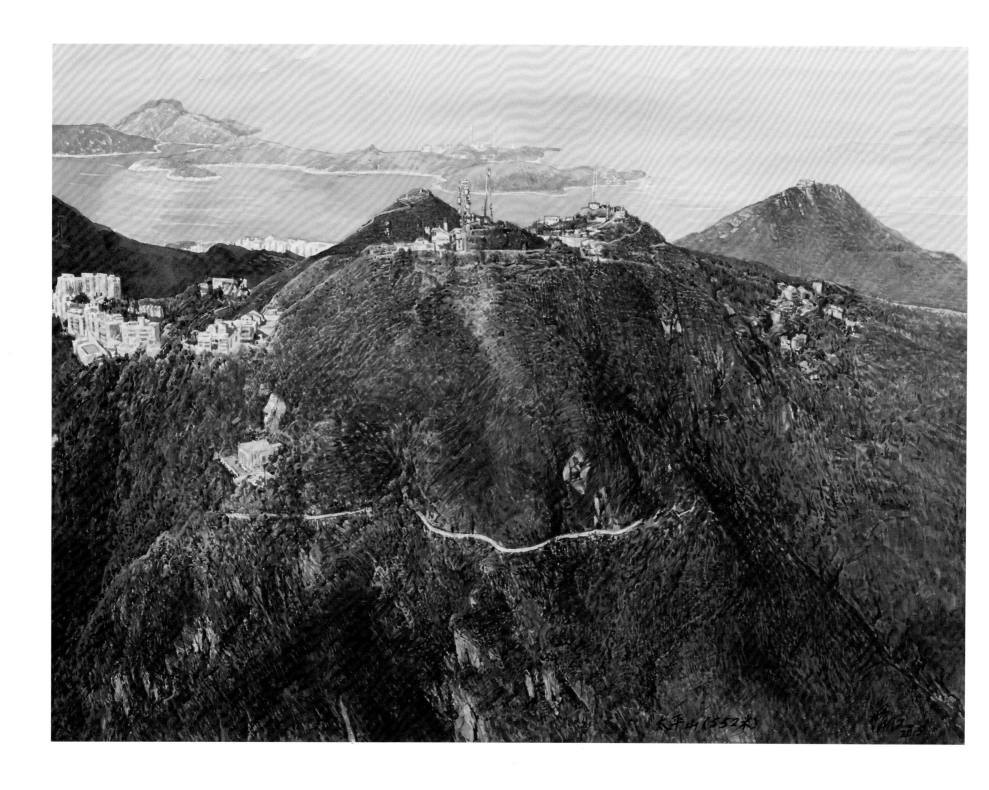

2015

1. 太平山（552 米）Victoria Peak (552m)

57 x 76cm

2. 西高山 High West

57 x 76cm

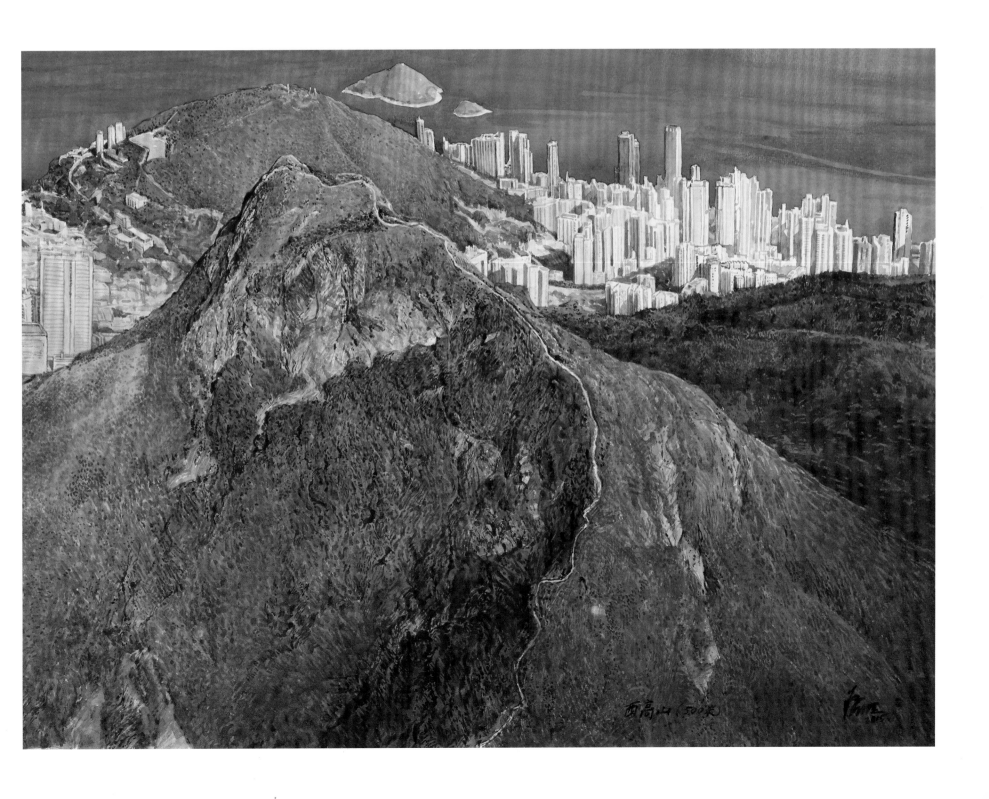

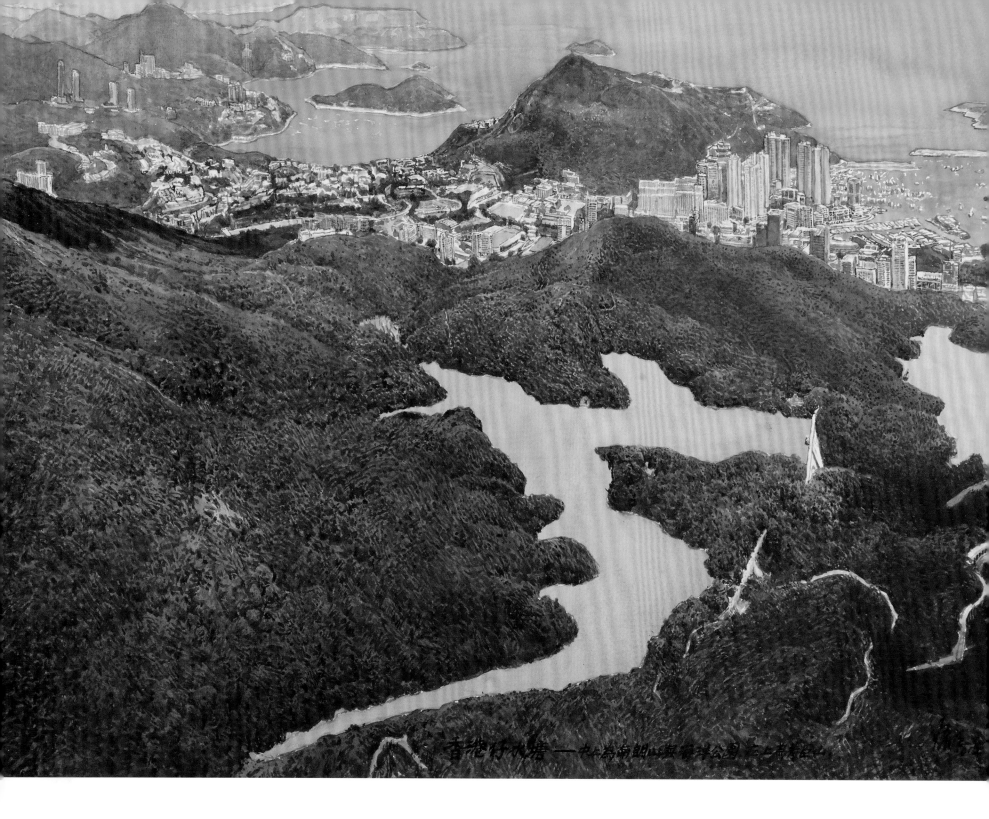

香港仔水塘 —— 中上為南朗山及海洋公園 右上為班納山

2015

3. 香港仔水塘 Aberdeen Reservoir

57 x 76cm

4. 大潭灣與水塘 Tai Tam Bay and Tai Tam Reservoir

57 x 76cm

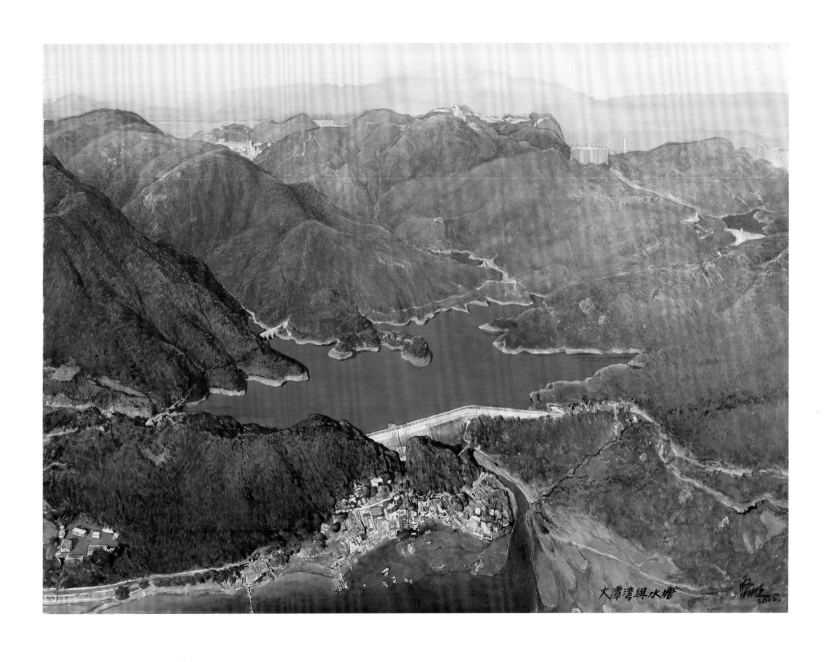

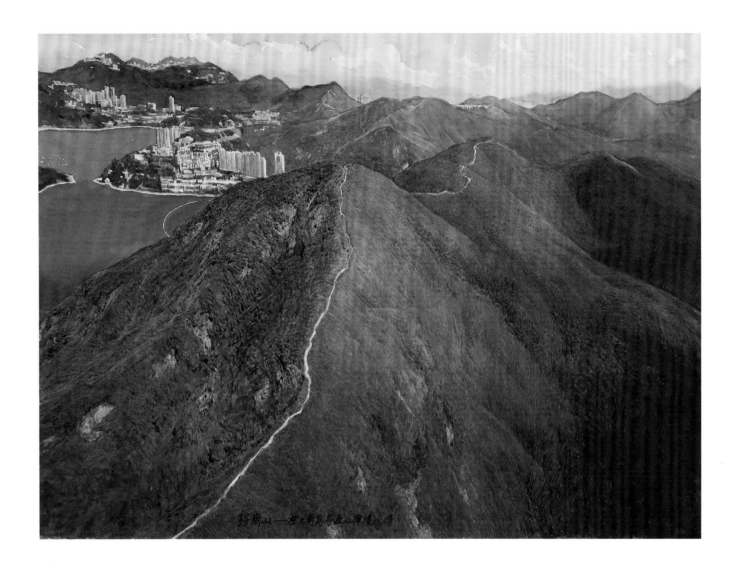

5. 孖崗山 The Twins

57 x 76cm

6. 石澳龍脊 Dragon's Back, Shek O
57 x 76cm

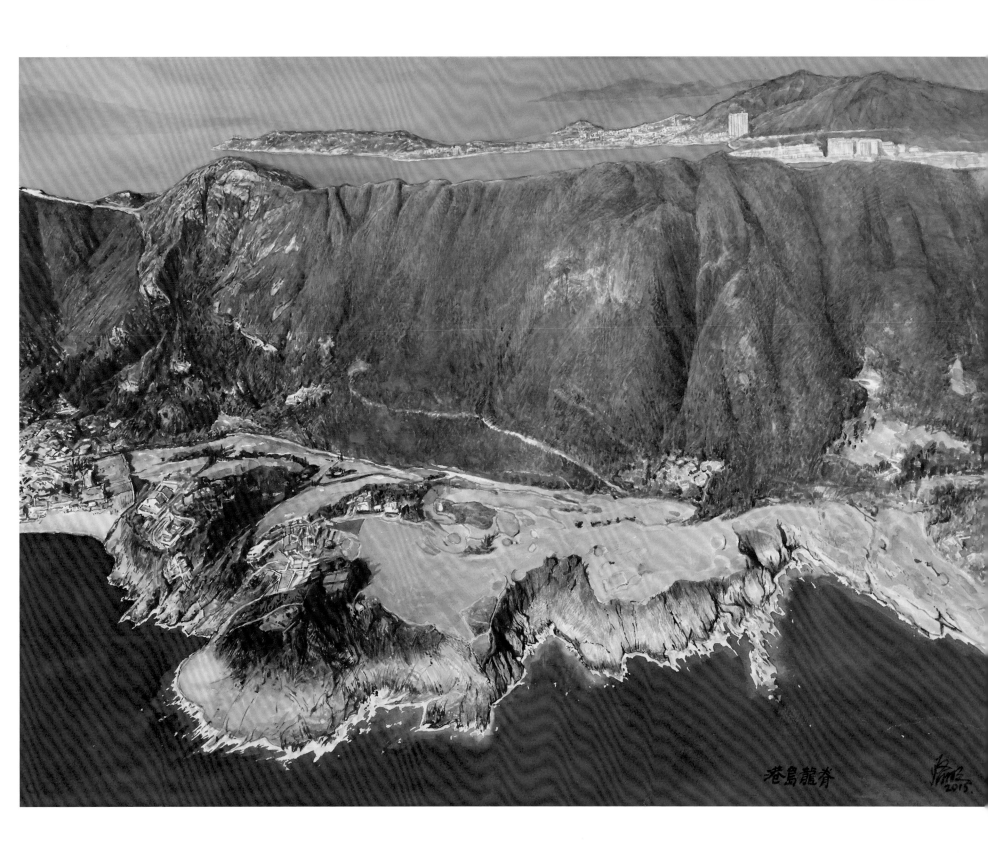

港島龍脊

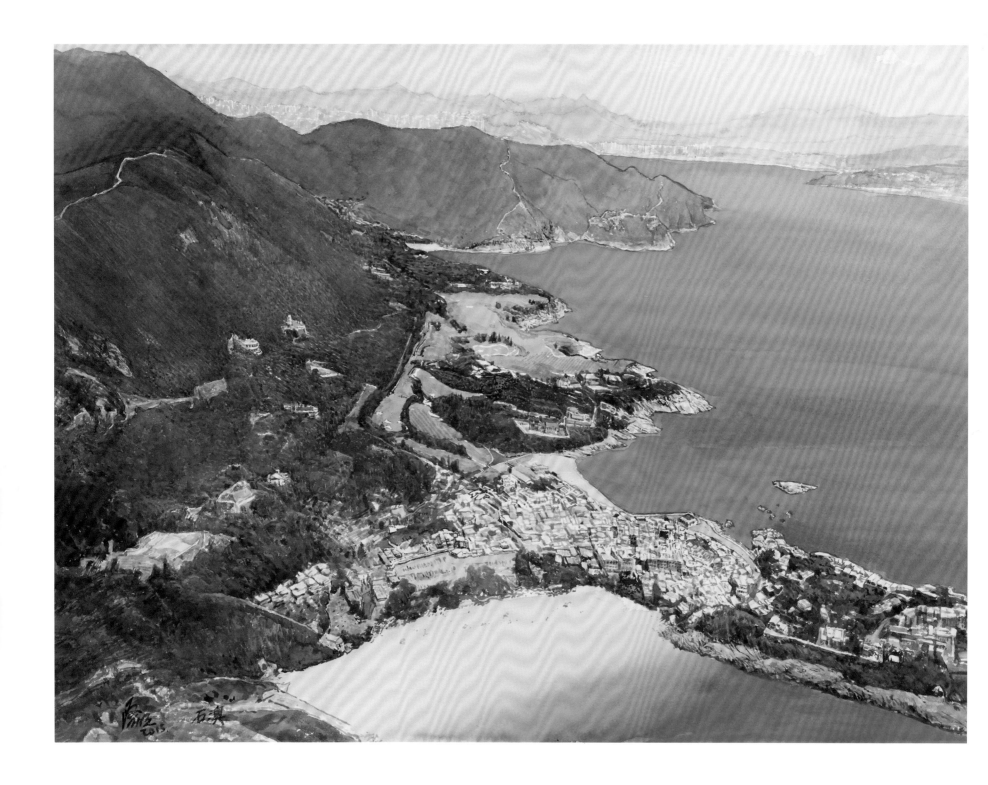

2015

7. 石澳 Shek O

57 x 76cm

8. 鶴咀之狗髀洲 Kau Pei Chau, Cape D'Aguilar

57 x 76cm

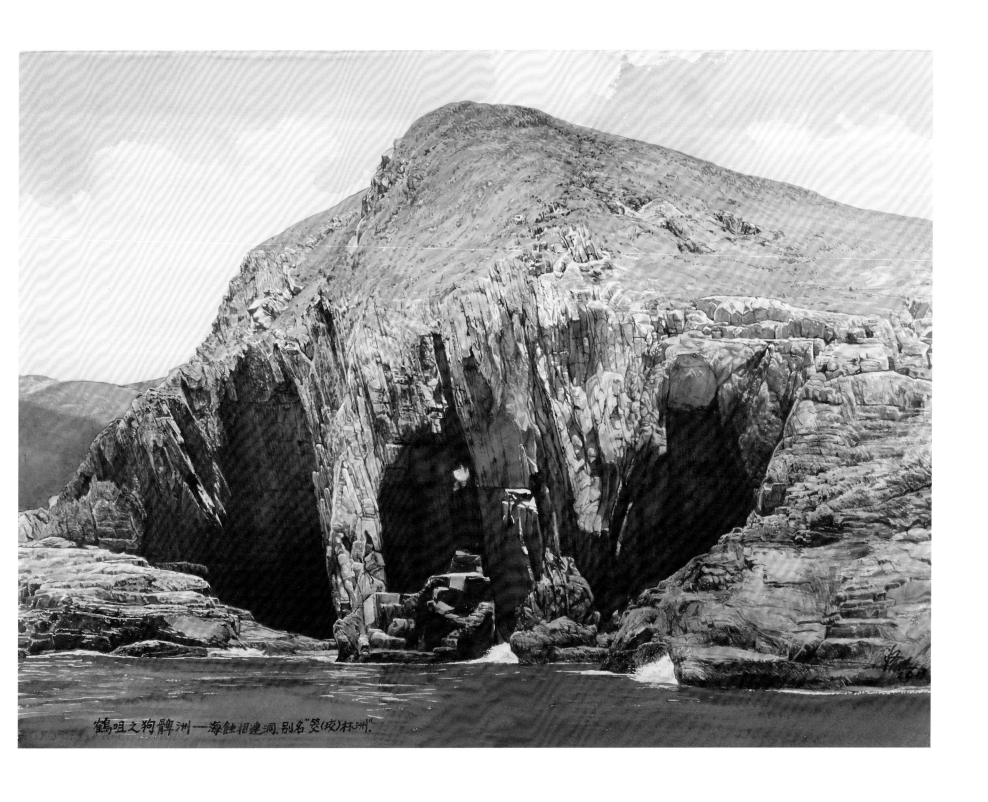

鶴咀之狗髀洲—海蝕相連洞, 別名"焋(坈)杯洲".

2014

9. 南丫島 Lamma Island

57 x 76cm

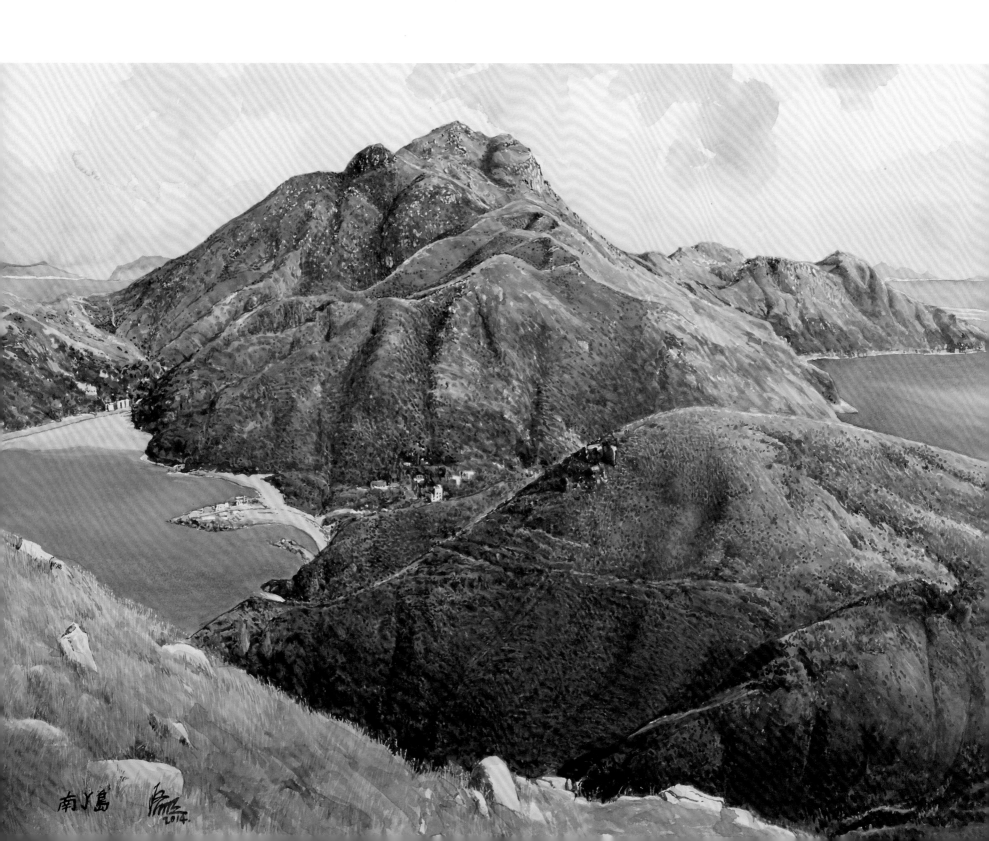

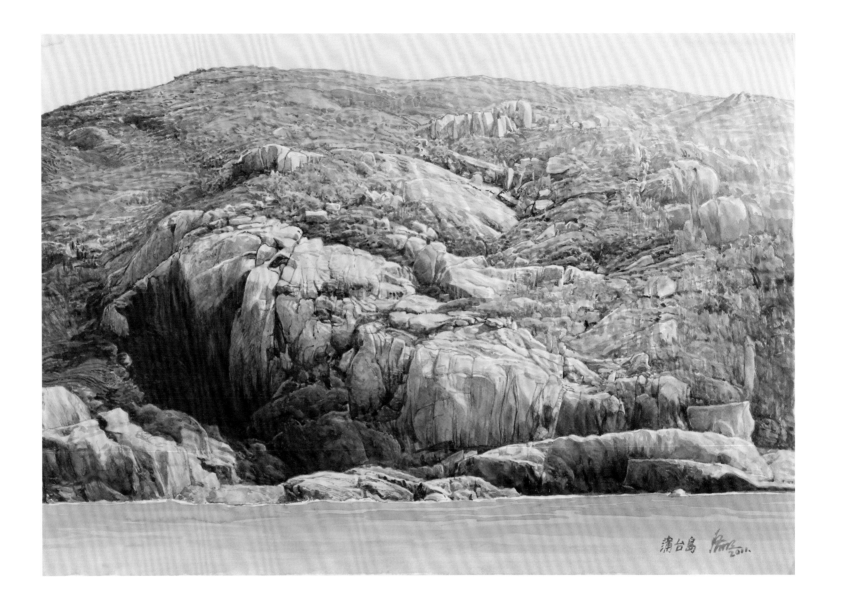

10. **蒲台島 Po Toi Island**

57 x 76cm

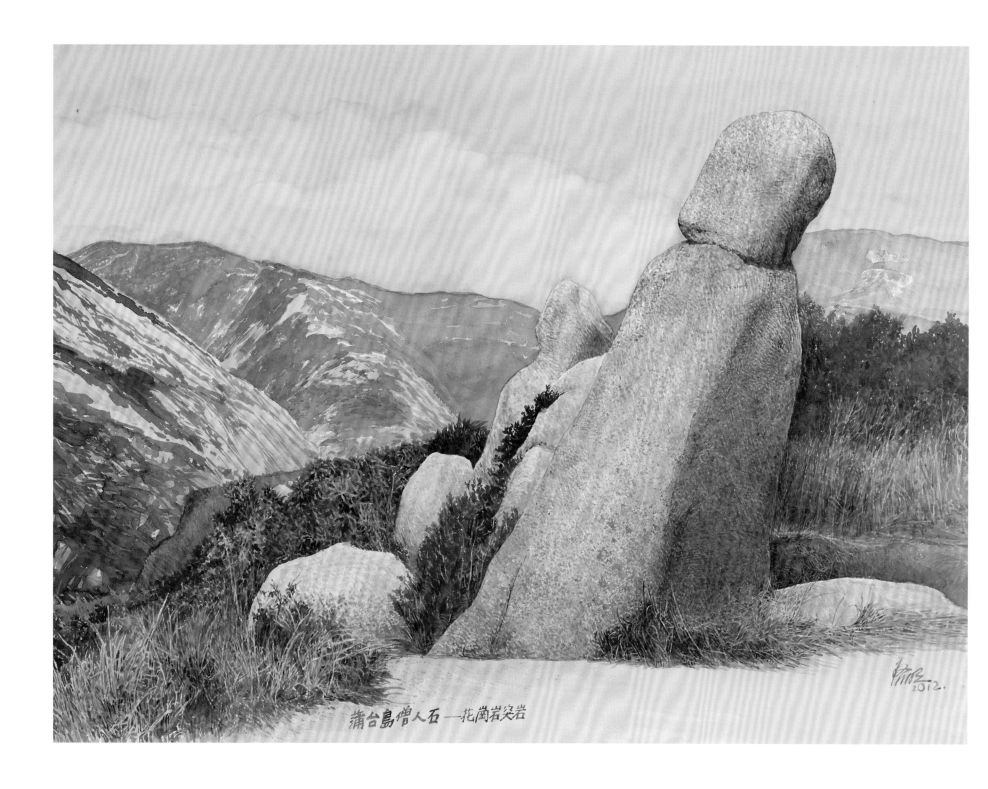

蒲台島僧人石—花崗岩突岩

2012

11. 蒲台島僧人石 Monk Rock, Po Toi Island

57 x 76cm

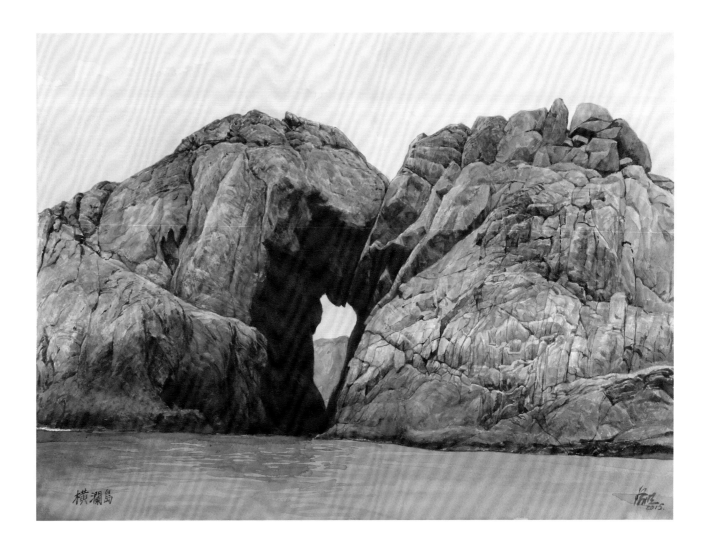

橫瀾島

2015

12. 橫瀾島 Waglan Island

57 x 76cm

2011

13. 中華白海豚 Chinese White Dolphin

57 x 76cm

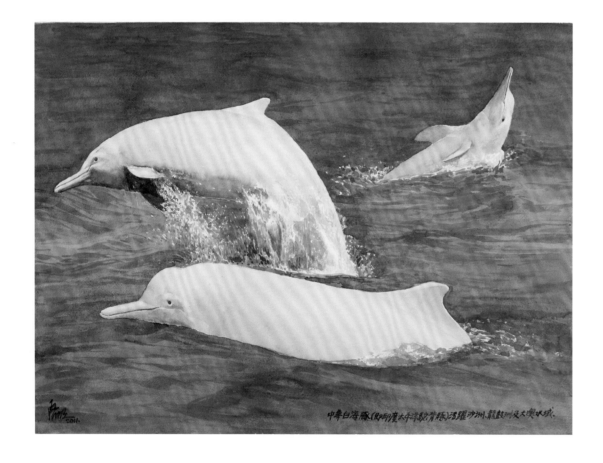

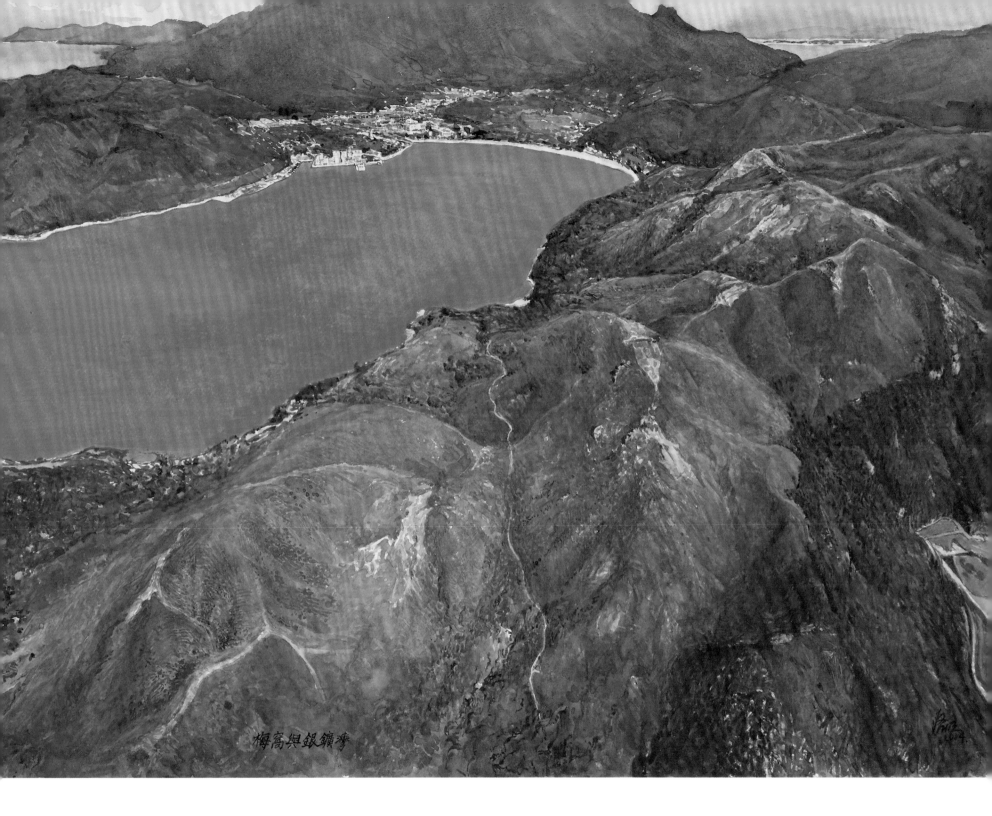

14. **梅窩與銀礦灣** Mui Wo and Silvermine Bay Beach

57 x 76cm

2014

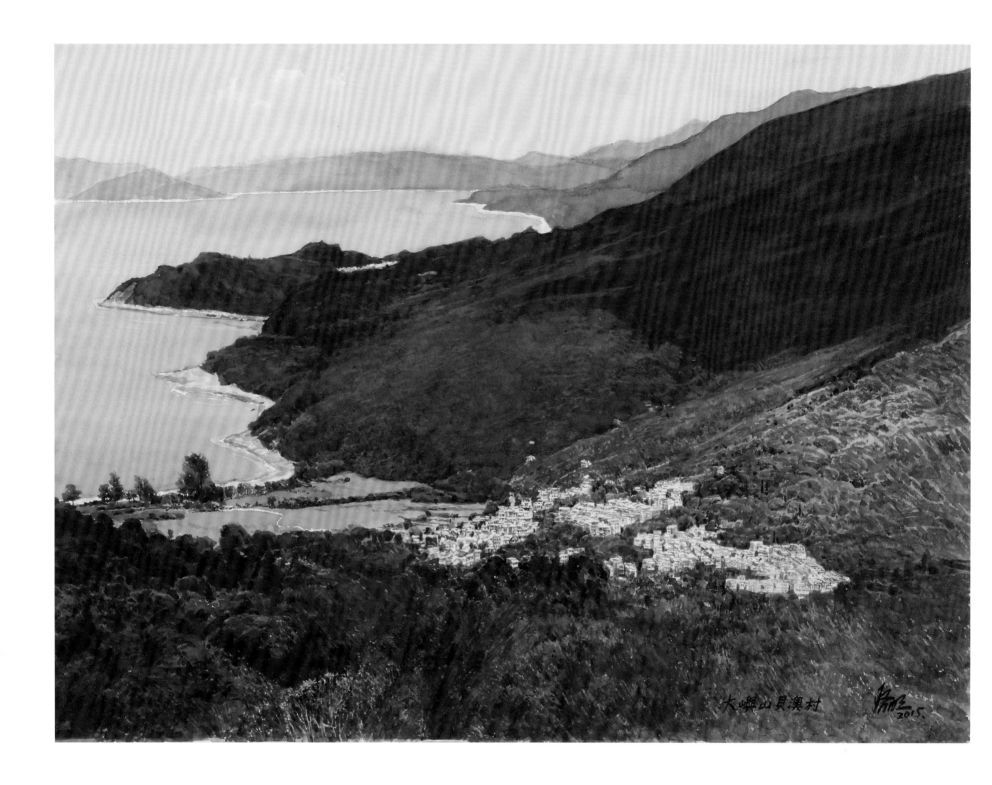

15. 大嶼山貝澳村 Pui O Tsuen, Lantau Island

57 x 76cm

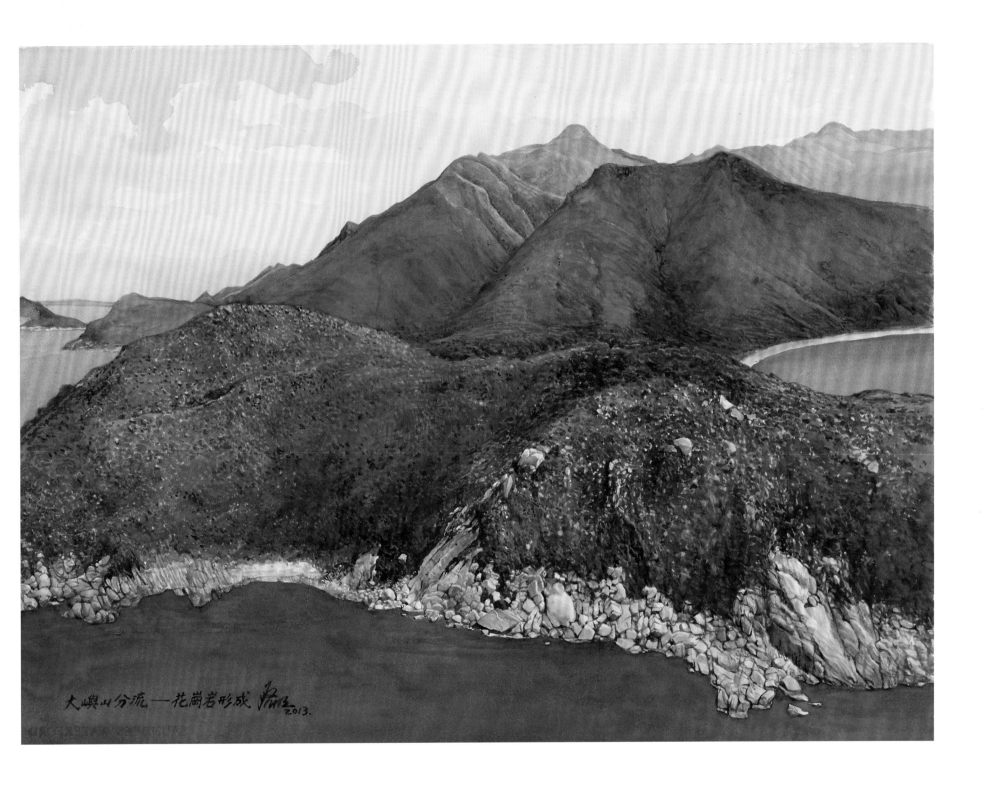

大嶼山分流——花崗岩形成 2013.

2013

16. **大嶼山分流 Fan Lau, Lantau Island**

57 x 76cm

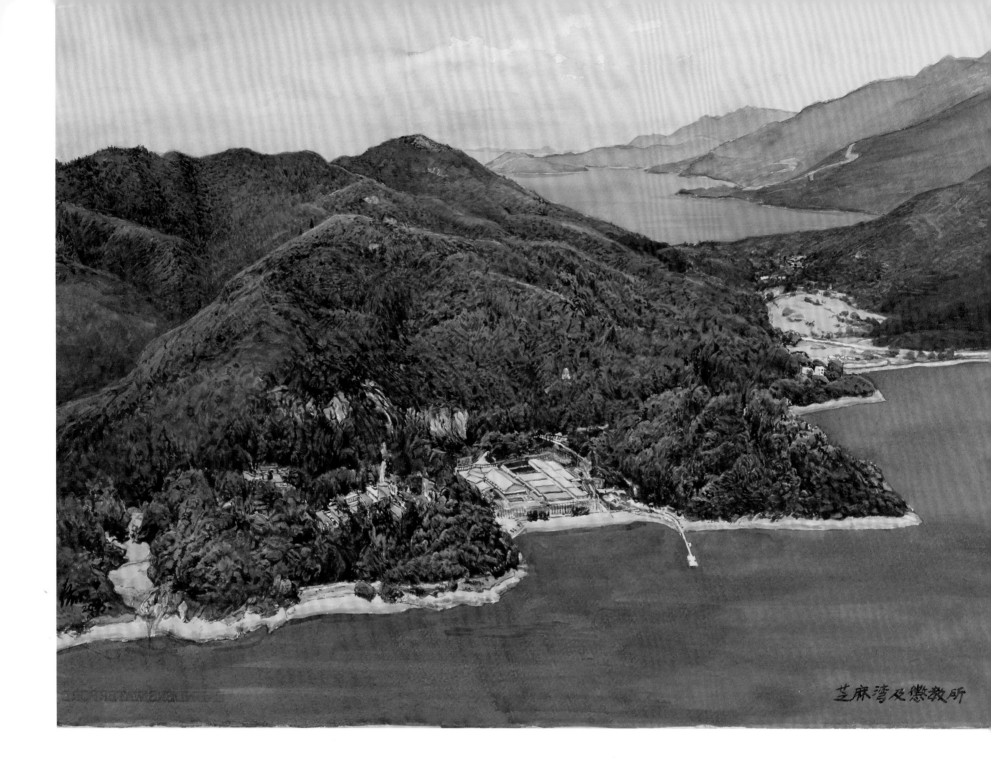

芝麻灣及懲教所

2015

17. 芝麻灣及芝麻灣懲教所 Chi Ma Wan and Chi Ma Wan Correctional Institution

57 x 76cm

18. 大嶼山狗牙嶺 Kau Nga Ling, Lantau Island
57 x 76cm

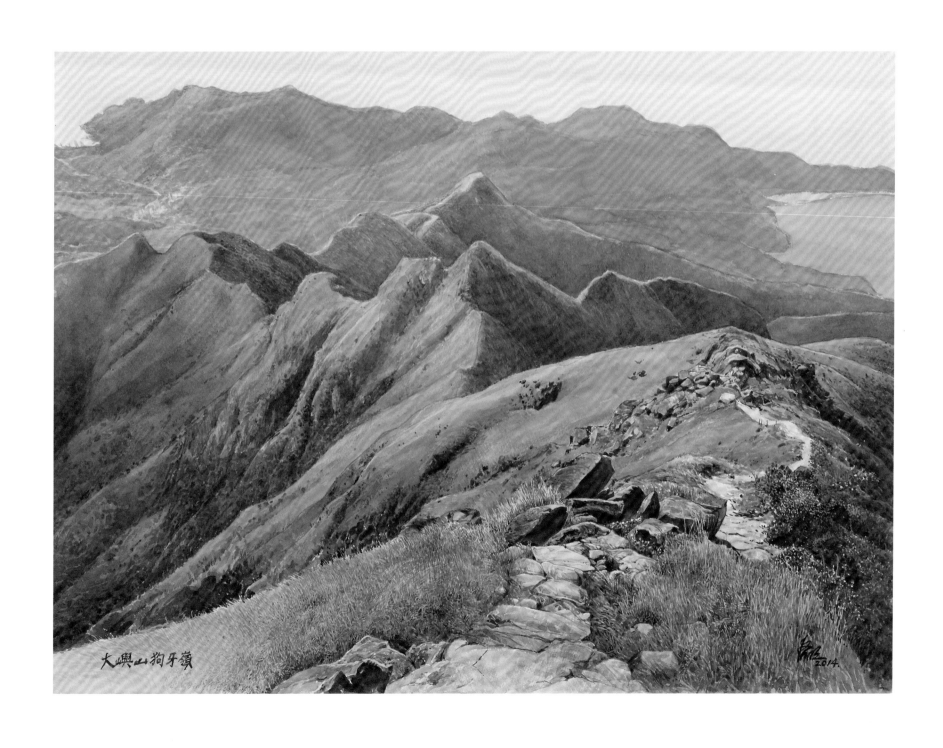

大嶼山狗牙嶺

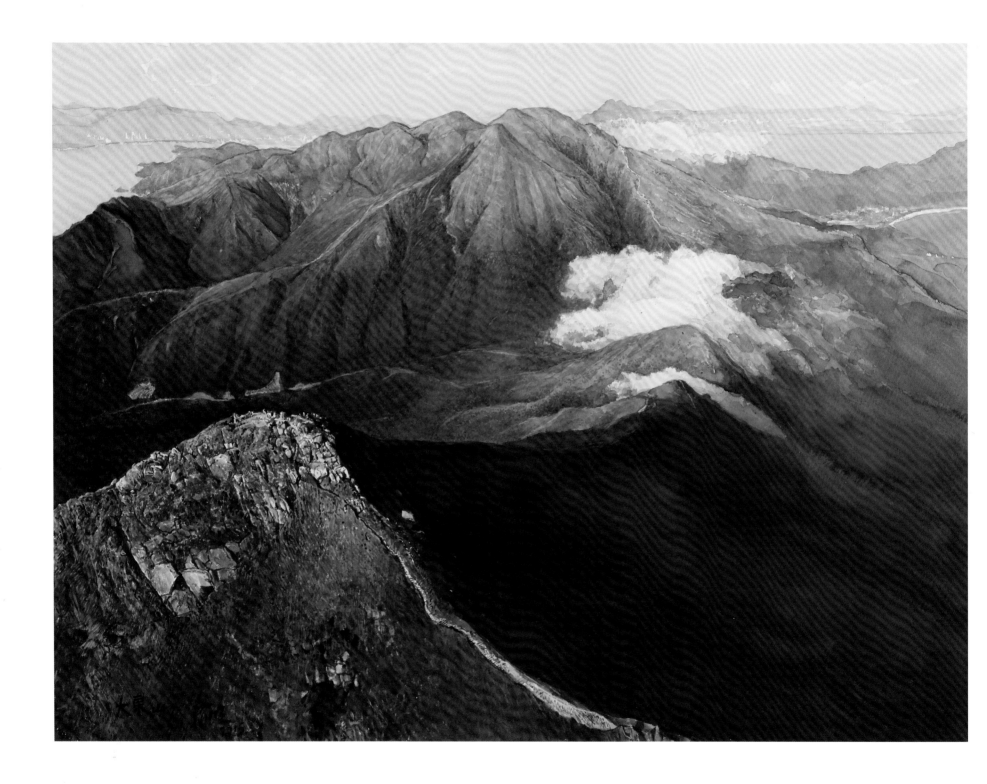

2015

19. 大嶼山之大東山 Sunset Peak, Lantau Island

57 x 76cm

20. 鳳凰山（934 米） Lantau Peak (934m)

57 x 76cm

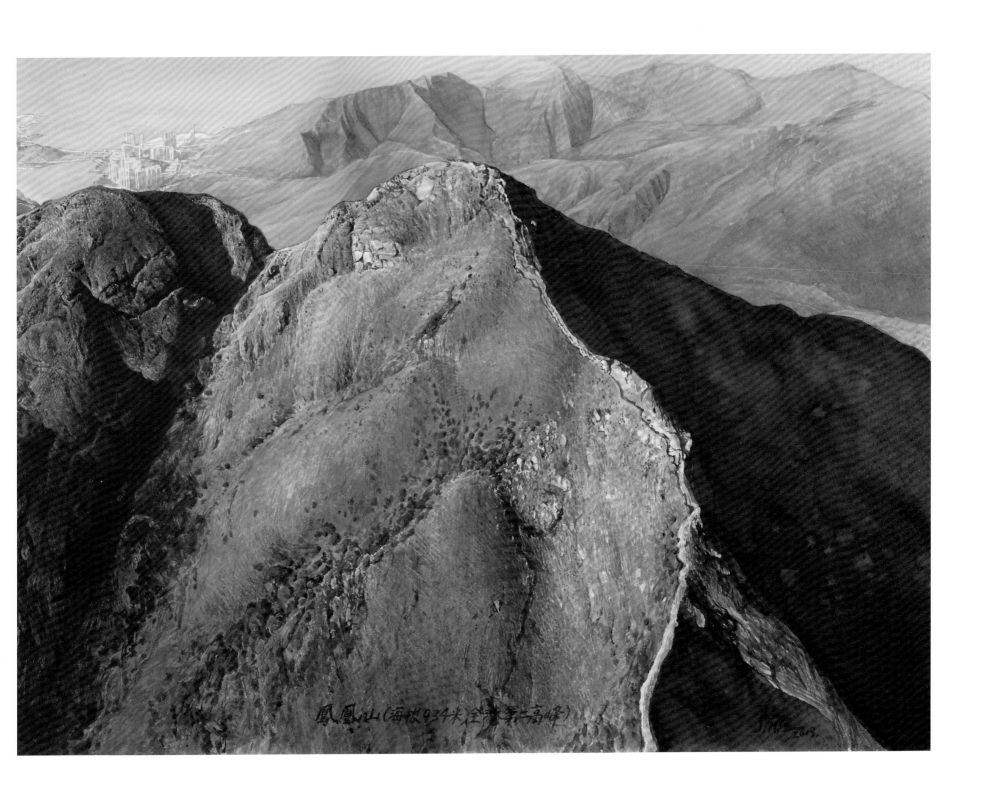

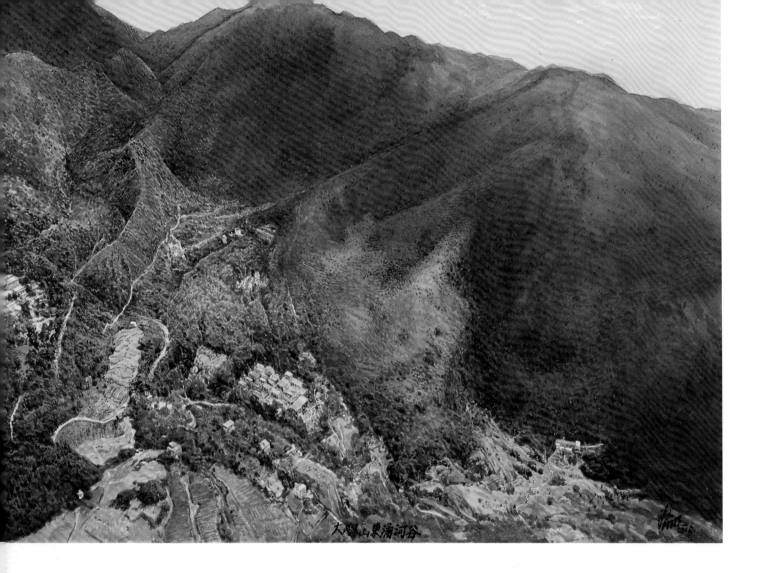

2016

21. 大嶼山之東涌河谷 Tung Chung Valley, Lantau Island

57 x 76cm

22. 大嶼山昂坪心經簡林 Wisdom Path, Lantau Island

57 x 76cm

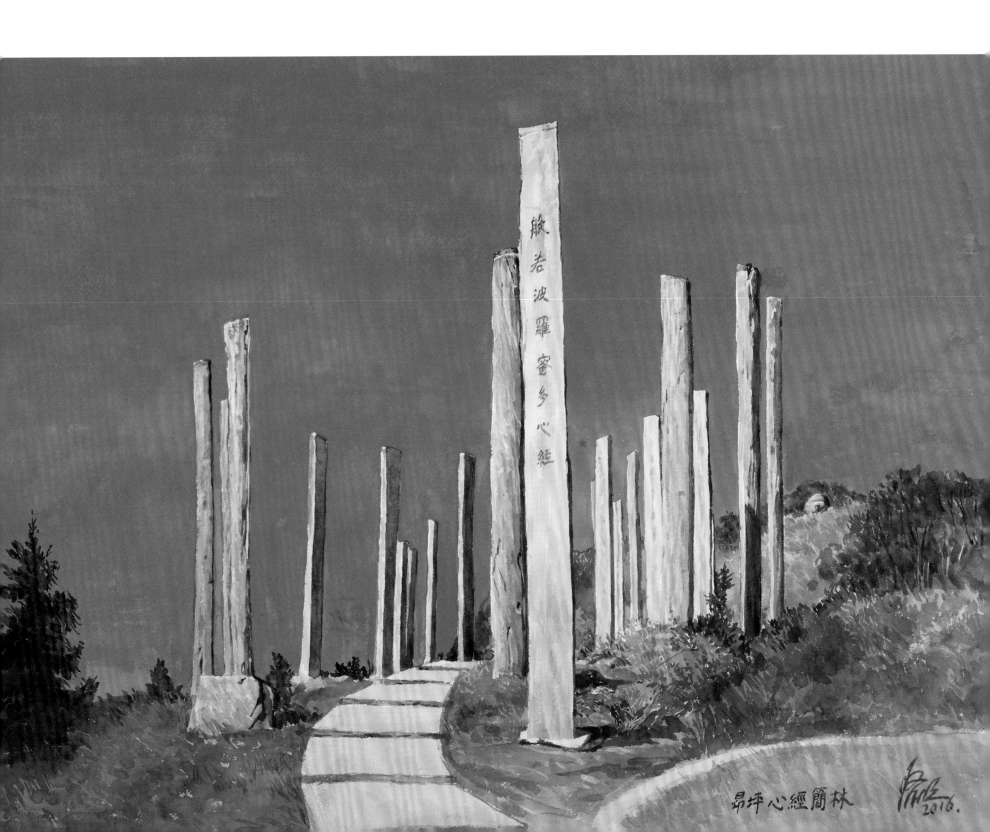

昂坪心經簡林

2011

23. 長洲人頭石 Human Head Rock, Cheung Chau

57 x 76cm

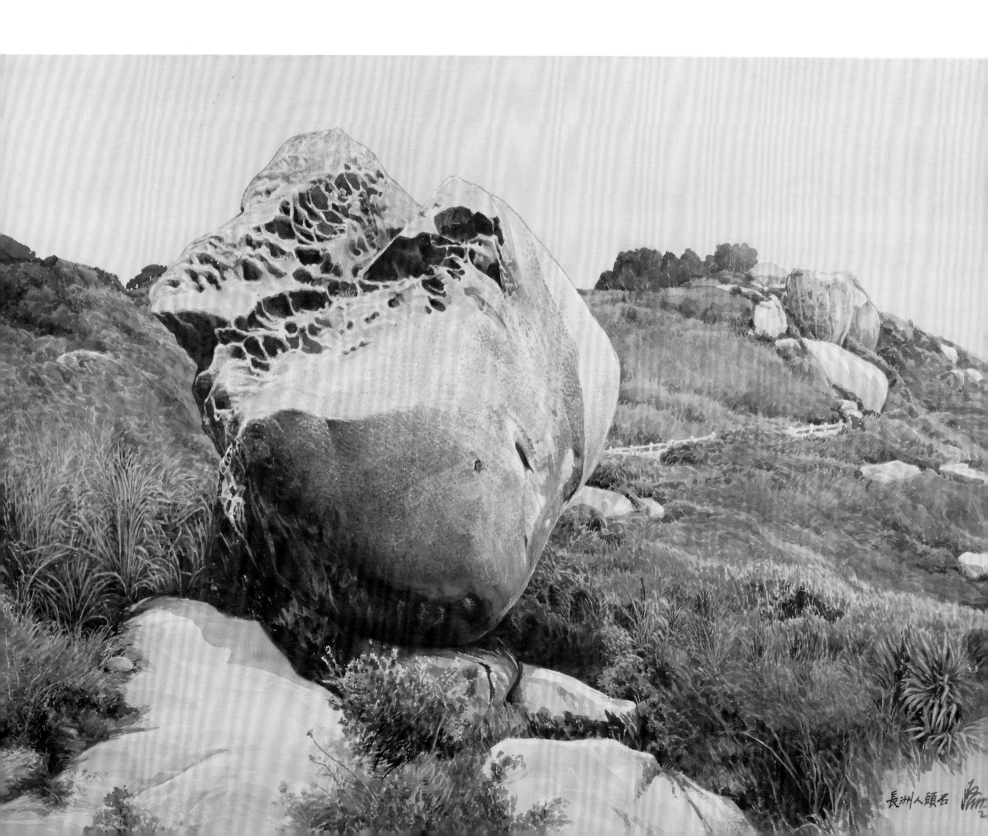

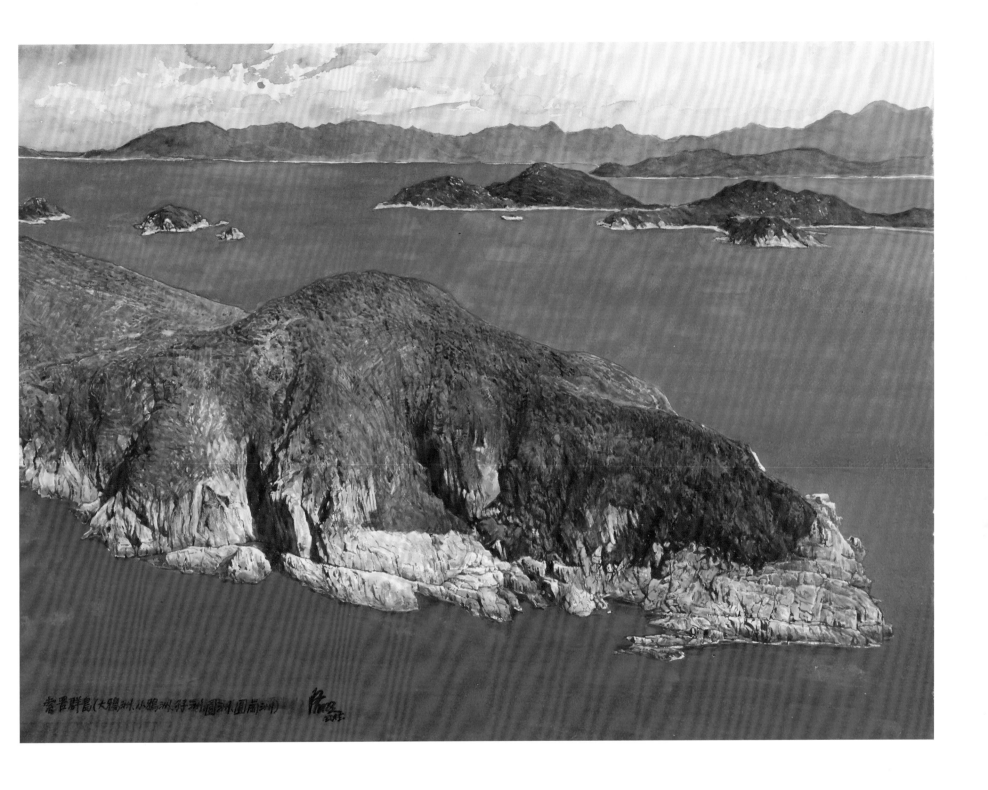

索罟群島 (大鴉洲、小鴉洲、孖洲、圓洲、小圓崗洲)

2015

24. **索罟群島 Soko Islands**

57 x 76cm

2011

25. 吉澳黃泥洲之「靈龜守洞」
Apparition of Turtle the Custodian, Wong Nai Chau, Kat O (Crooked Island)

57 x 76cm

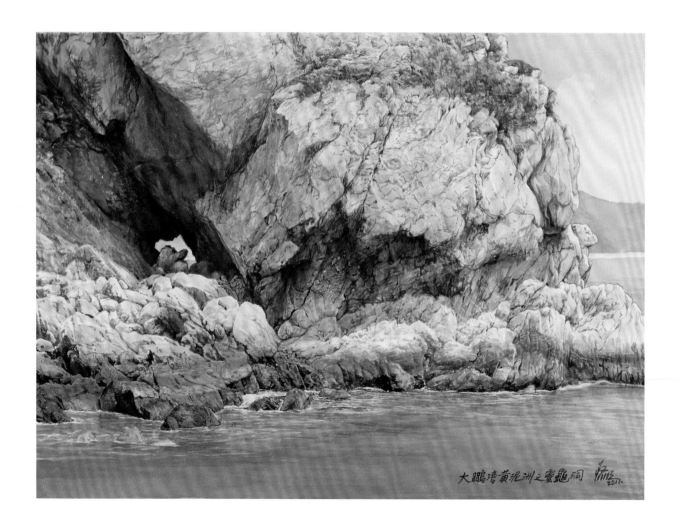

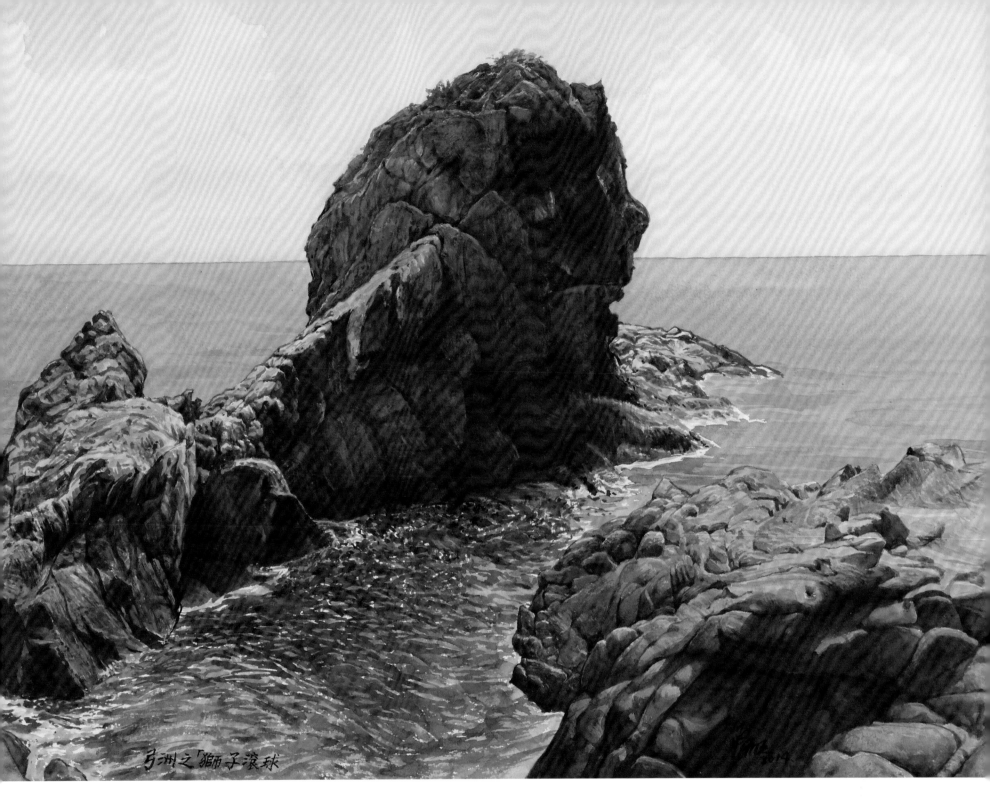

弓洲之「獅子滾球」

26. **弓洲之「獅子滾球」 Lion Rolling Balls, Kung Chau Island**

57 x 76cm

2012

27. 塔門呂字叠石 Layered Rocks, Grass Island

57 x 76cm

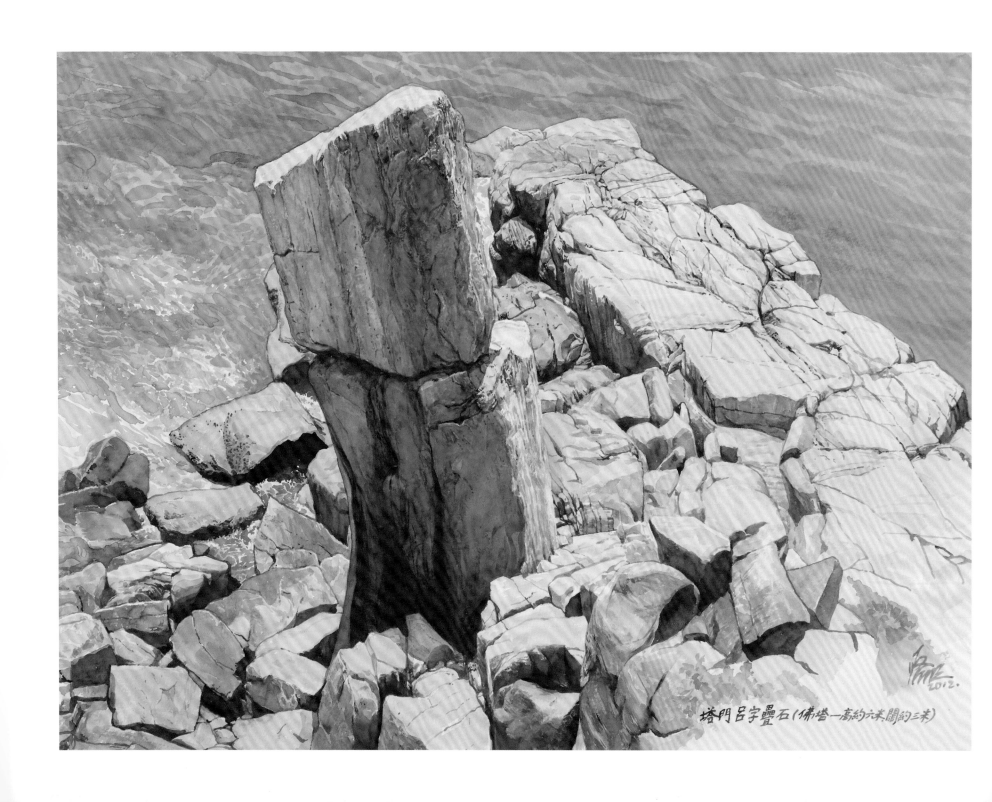

塔門呂字疊石 (佛塔一高約六米閣約三米)

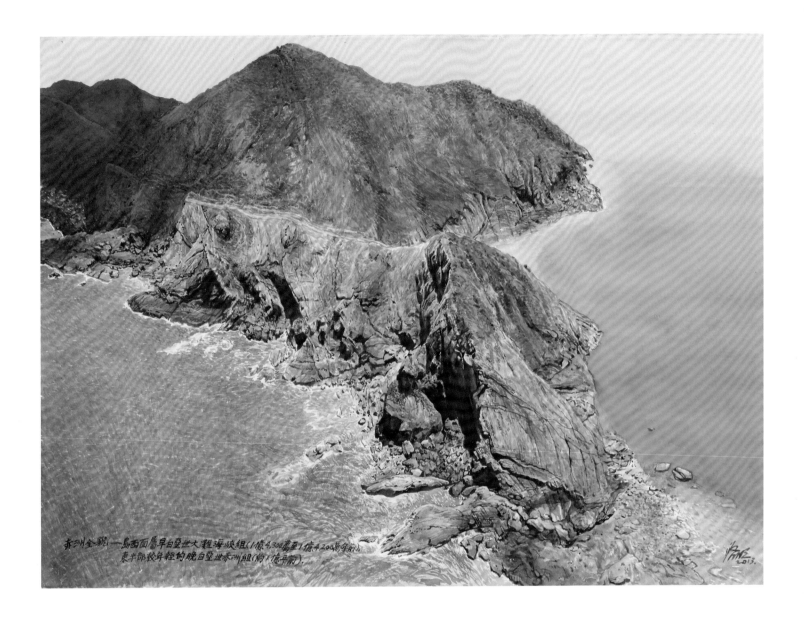

赤洲全貌；一島面面皆早白堊世大灘海峽組(1億4,300萬至1億4,200萬年前)，
更卡部較年輕的晚白堊世赤洲組(約1億年前)。

2013

28. 赤洲全貌 Port Island (Chek Chau)

57 x 76cm

2013

29. 赤洲小島之「群鼠出洞」　Escape of Mice, Port Island (Chek Chau)
57 x 76cm

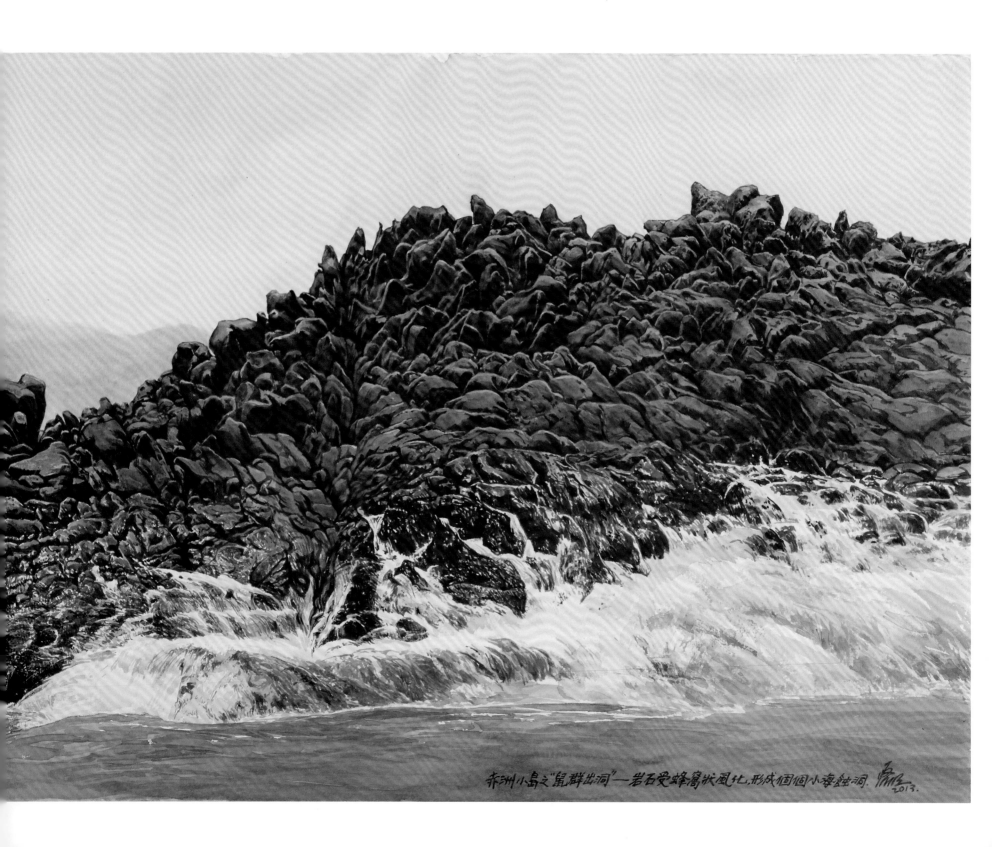

赤洲小島之"鼠群出洞"──岩石受蜂窩狀風北,形成個個小夢鈍洞. 鼎臨
2013.

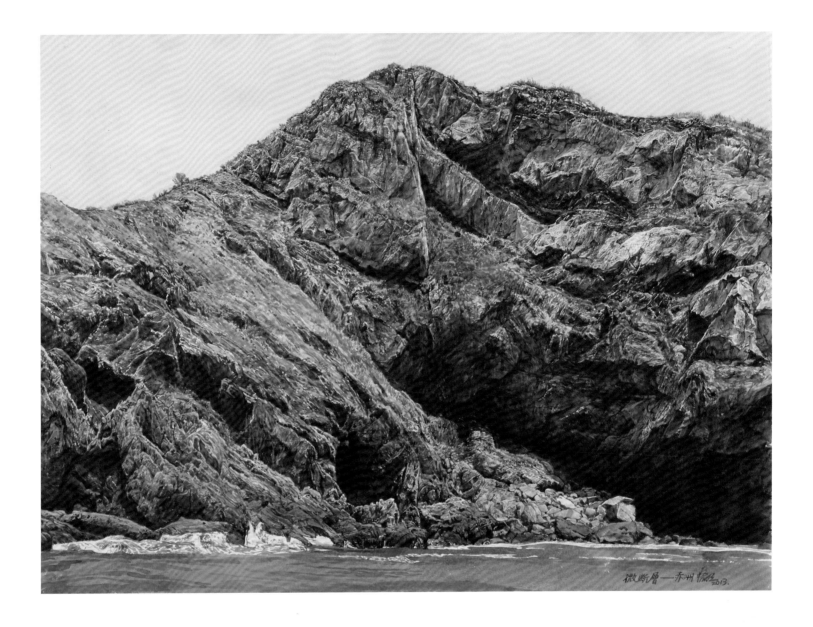

30. 赤洲微斷層 Faults at Port Island (Chek Chau)

57 x 76cm

31. 赤洲人工巢箱 Nest Box at Port Island (Chek Chau)

57 x 76cm

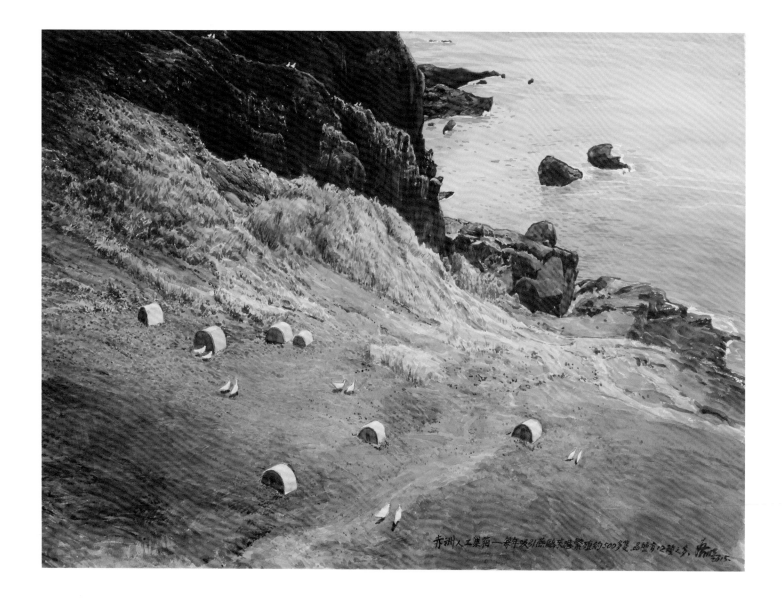

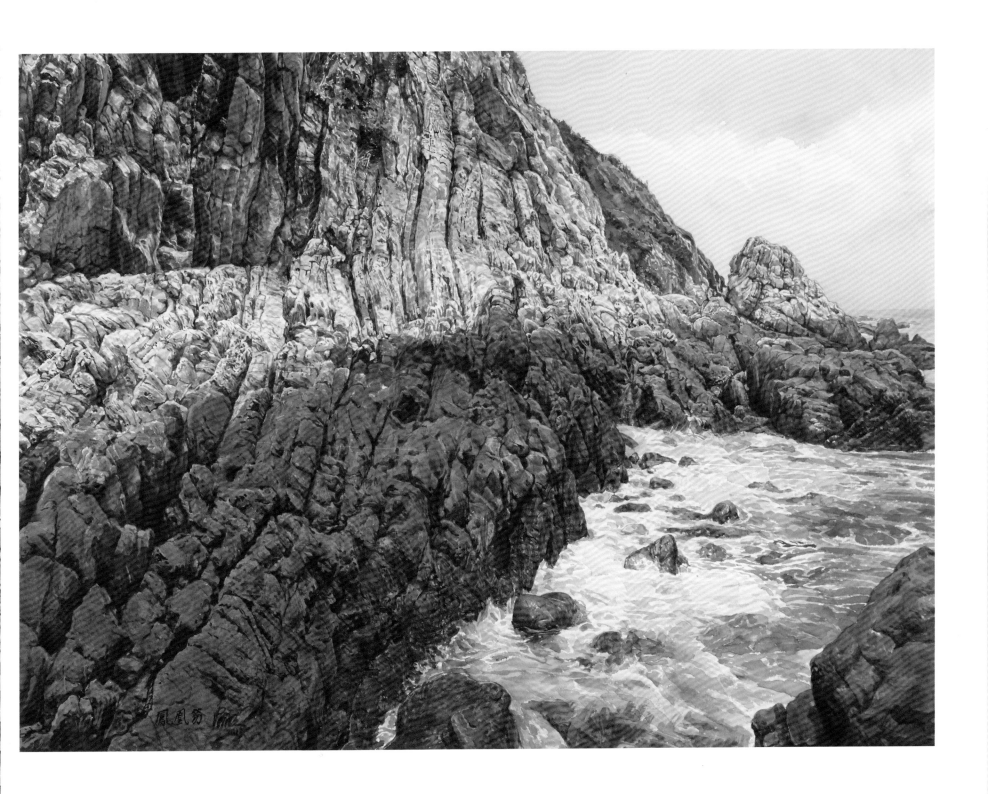

32. 鳳凰笏 Fung Wong Wat

57 x 76cm

2013

33. 東平洲 Tung Ping Chau

57 x 76cm

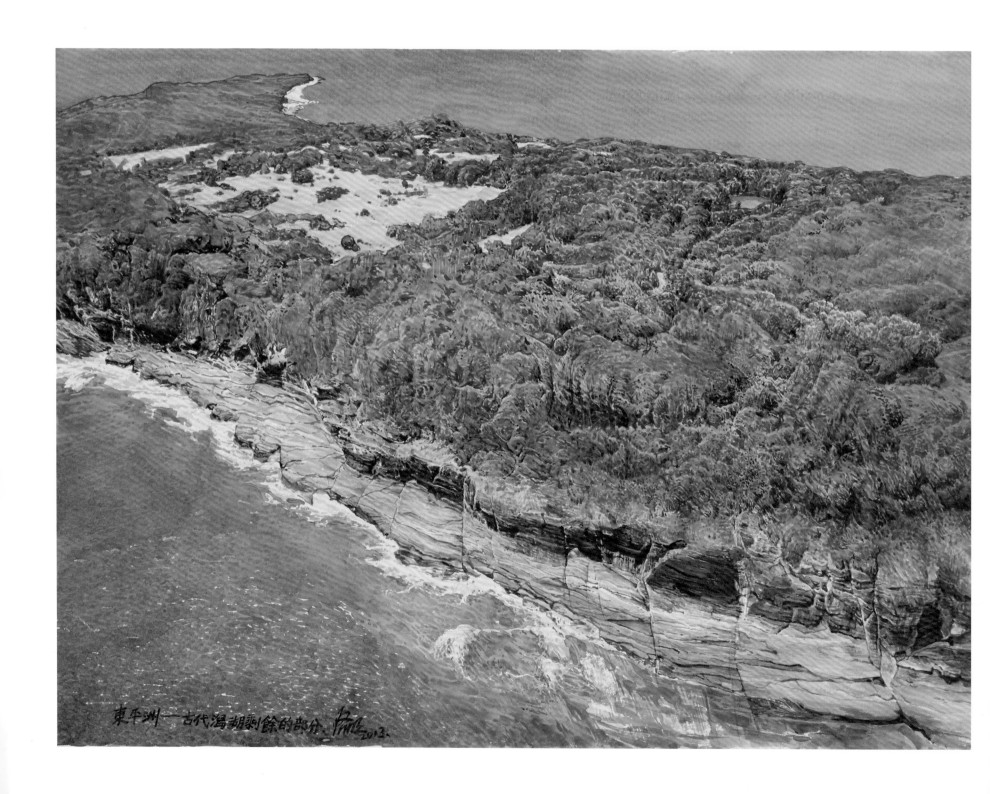

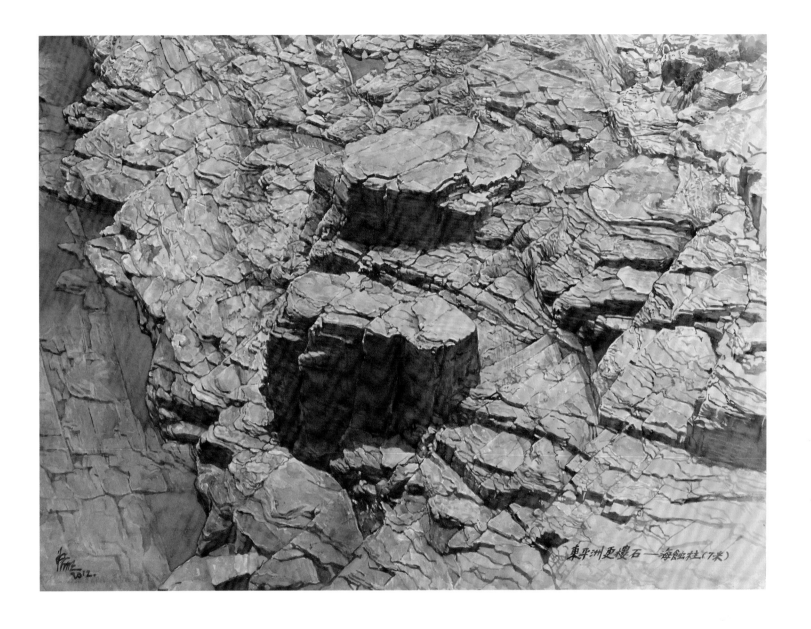

東平洲更樓石——海蝕柱(7米)

2012

34. **東平洲更樓石 Watch Tower Rock, Tung Ping Chau**

57 x 76cm

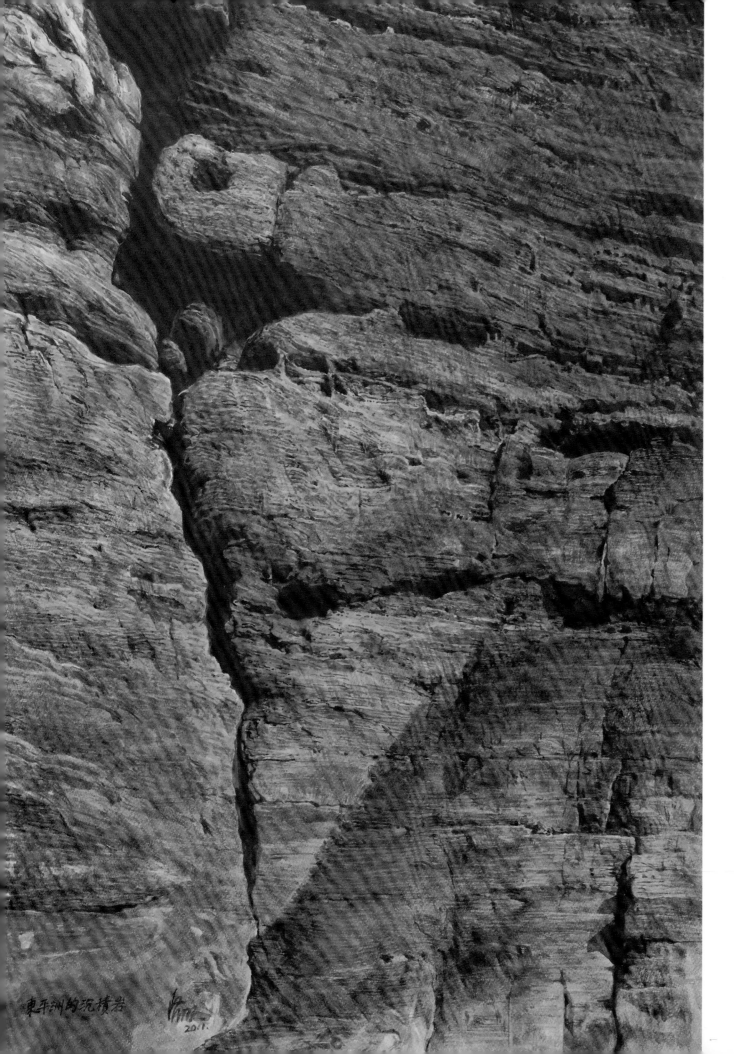

東平洲的沉積岩

2011

35. 東平洲的沉積岩
Sedimentary Rock of Tung Ping Chau

79 x 54cm

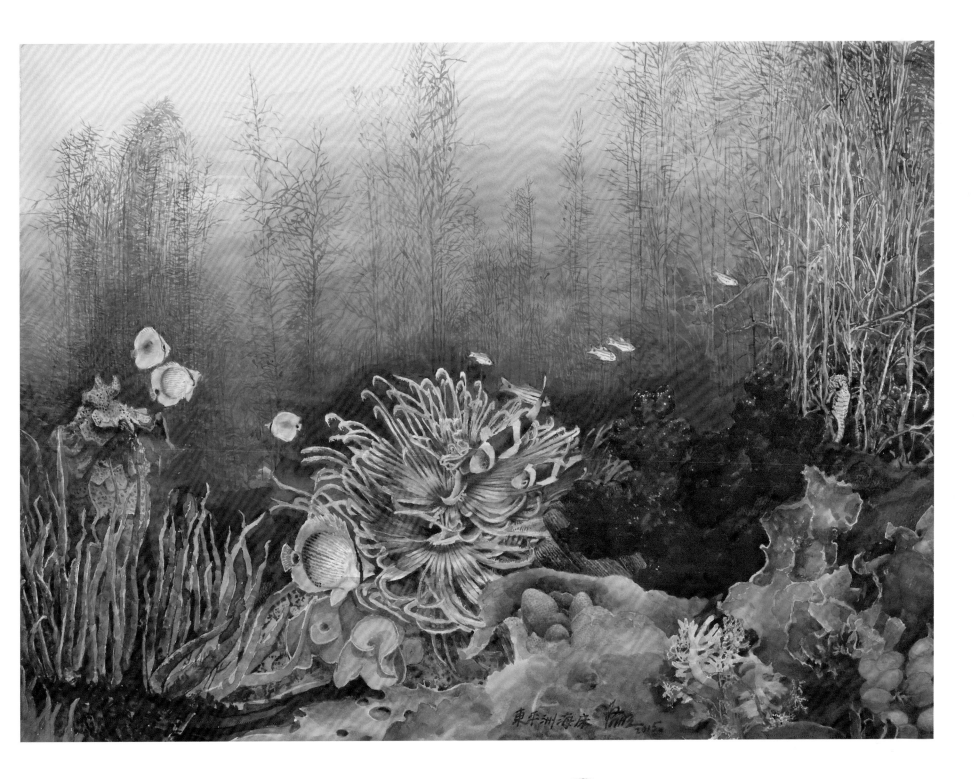

2015

36. 東平洲海床 The seabed of Tung Ping Chau

57 x 76cm

2014

37. 吊鐘洲之「金魚擺尾」 Goldfish Wagging Tail, Tiu Chung Chau

57 x 76cm

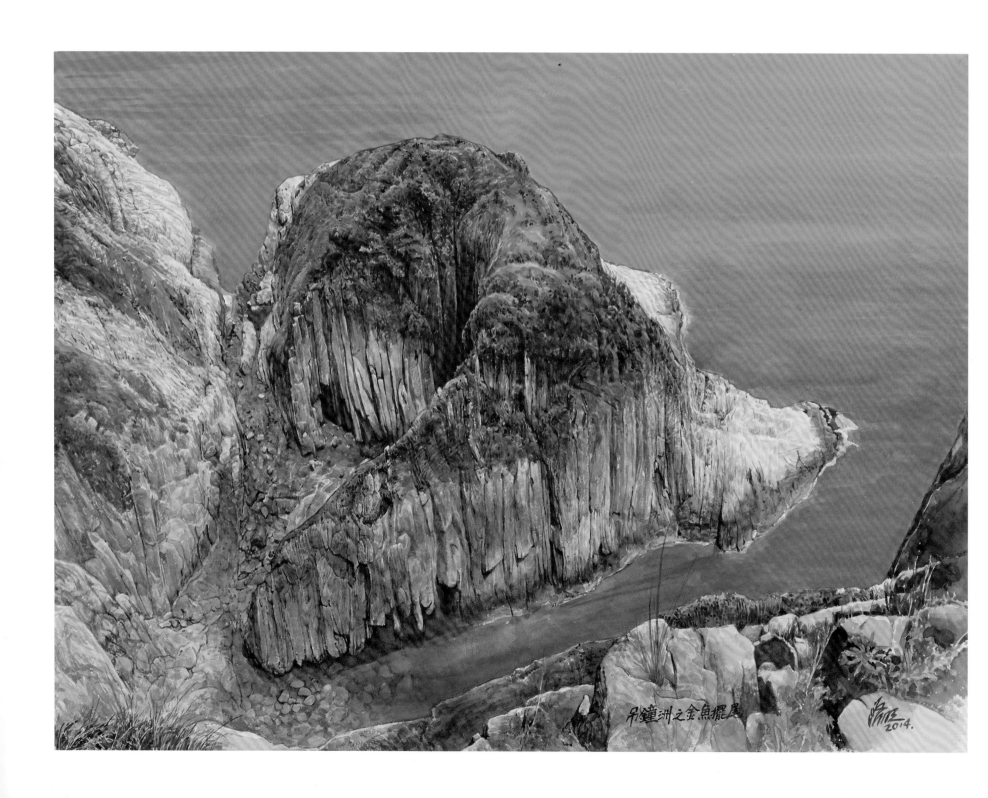

吊鐘洲之金魚擺尾
2014.

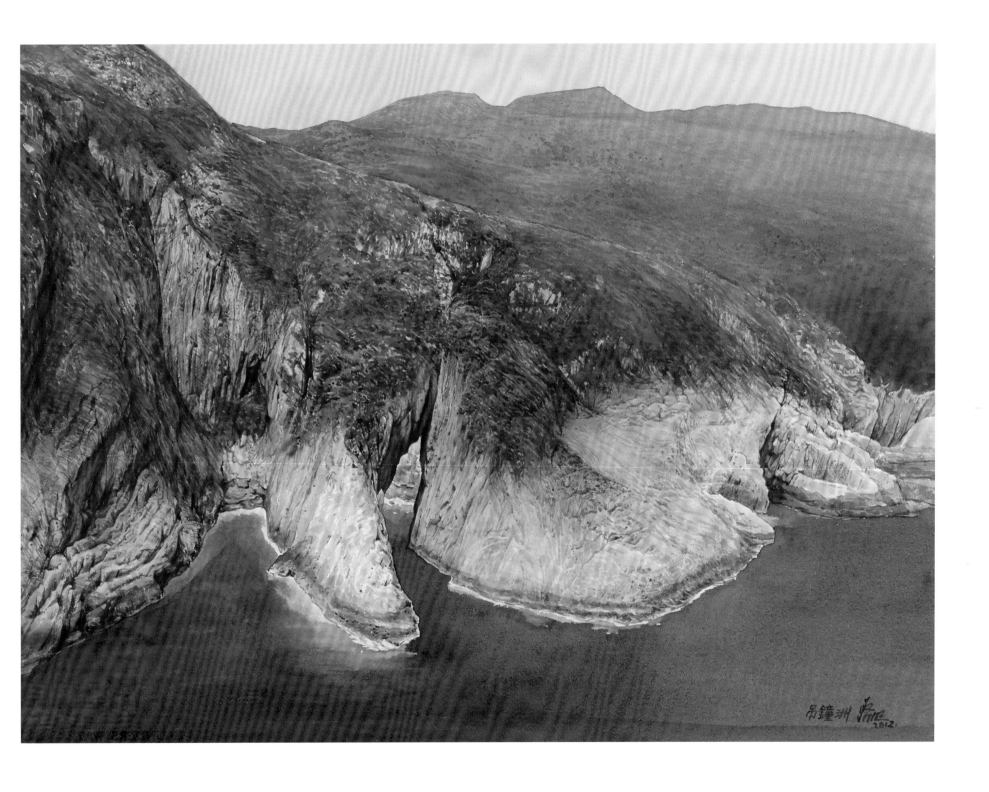

38. 吊鐘洲 Tiu Chung Chau

57 x 76cm

2012

39. 橋咀洲 Sharp Island (Kiu Tsui Chau)

57 x 76cm

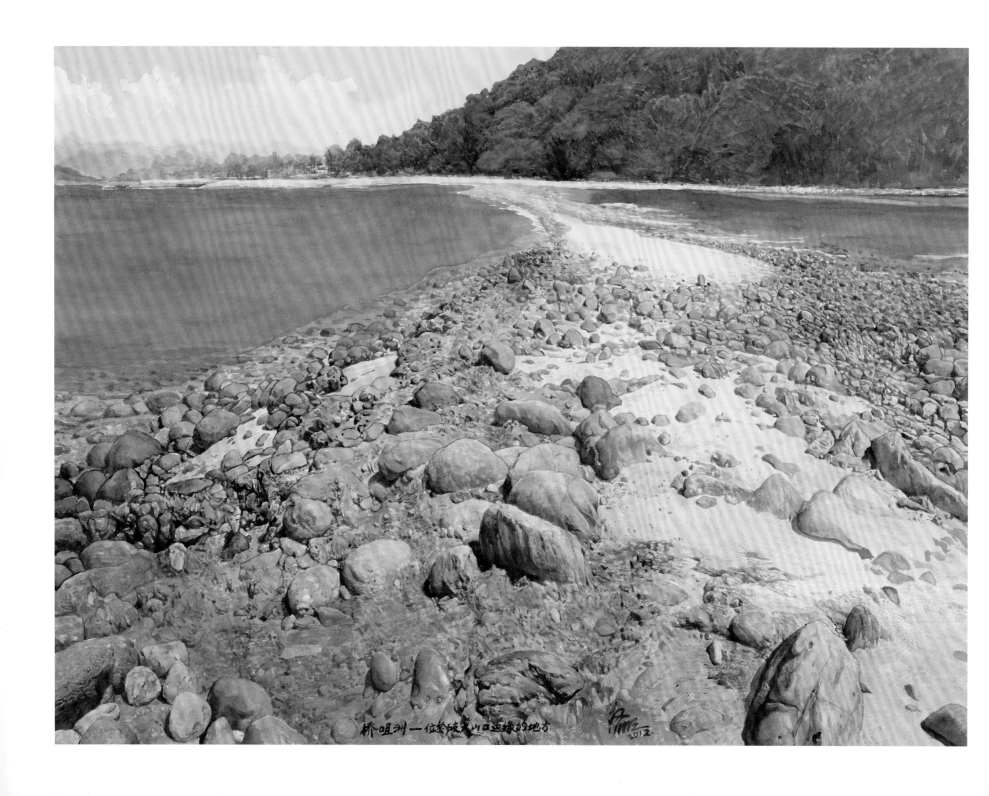

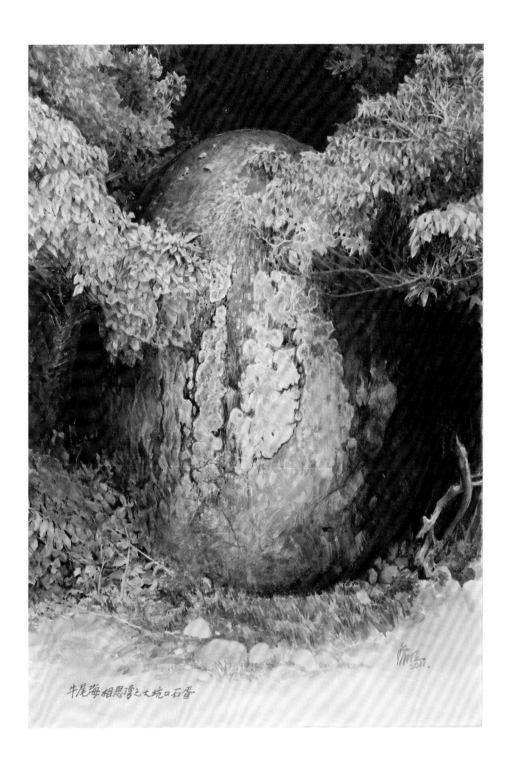

牛尾海相思灣之大坑口石蛋

40. **牛尾海相思灣之大坑口石蛋**
Rocky Egg at Tai Hang Hau, Sheung Sze Wan, Port Shelter

79 x 55cm

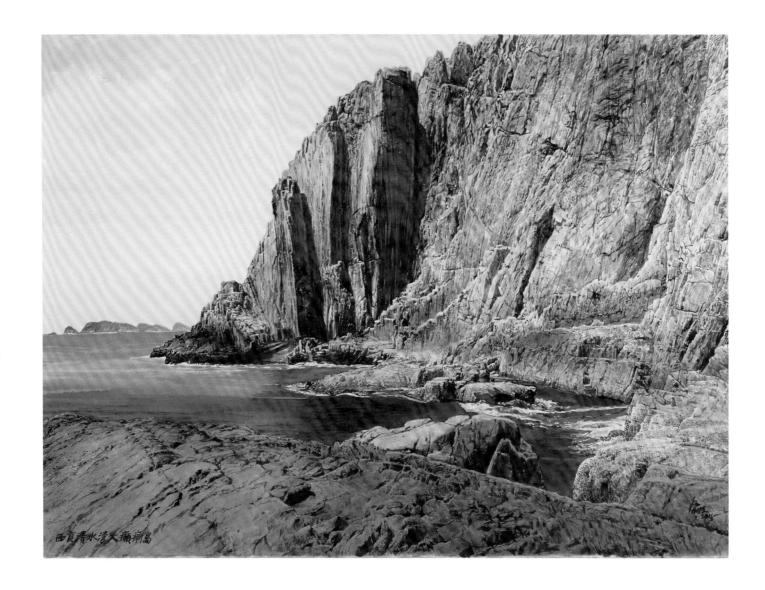

2011

41. 清水灣大癩痢 Trio Island, Clear Water Bay

57 x 76cm

42. 清水灣檳榔灣水紋岩岸
Wave Rock, Pan Long Wan, Clear Water Bay

57 x 76cm

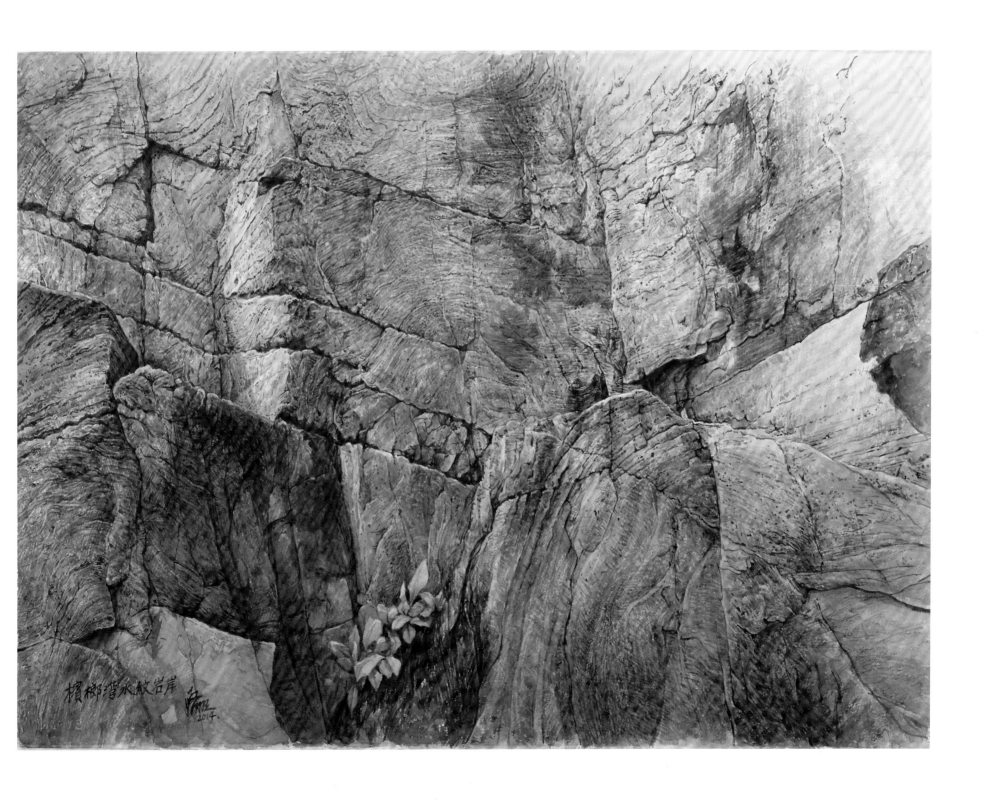

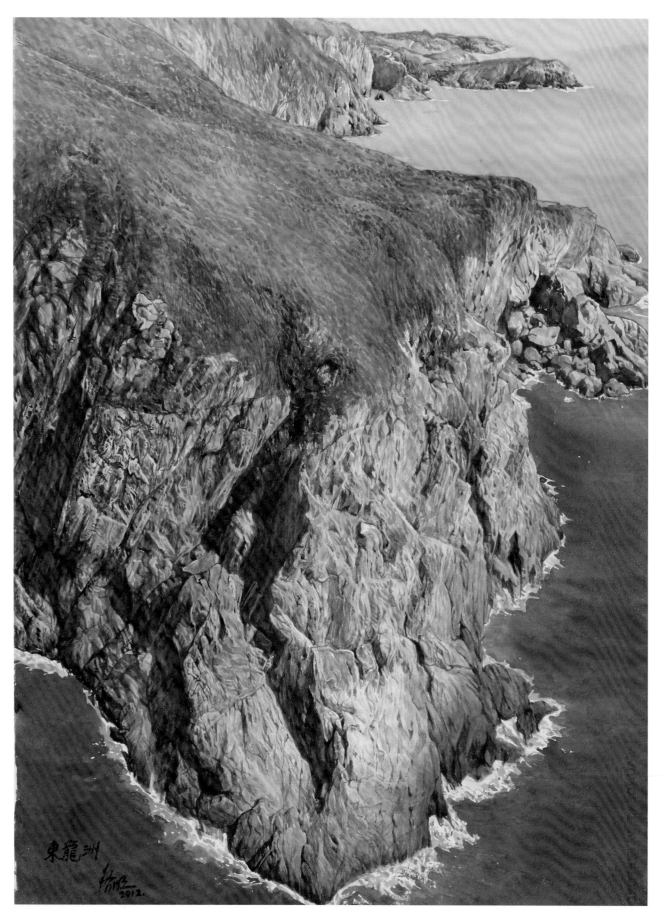

43. 東龍洲 Tung Lung Chau

76 x 57cm

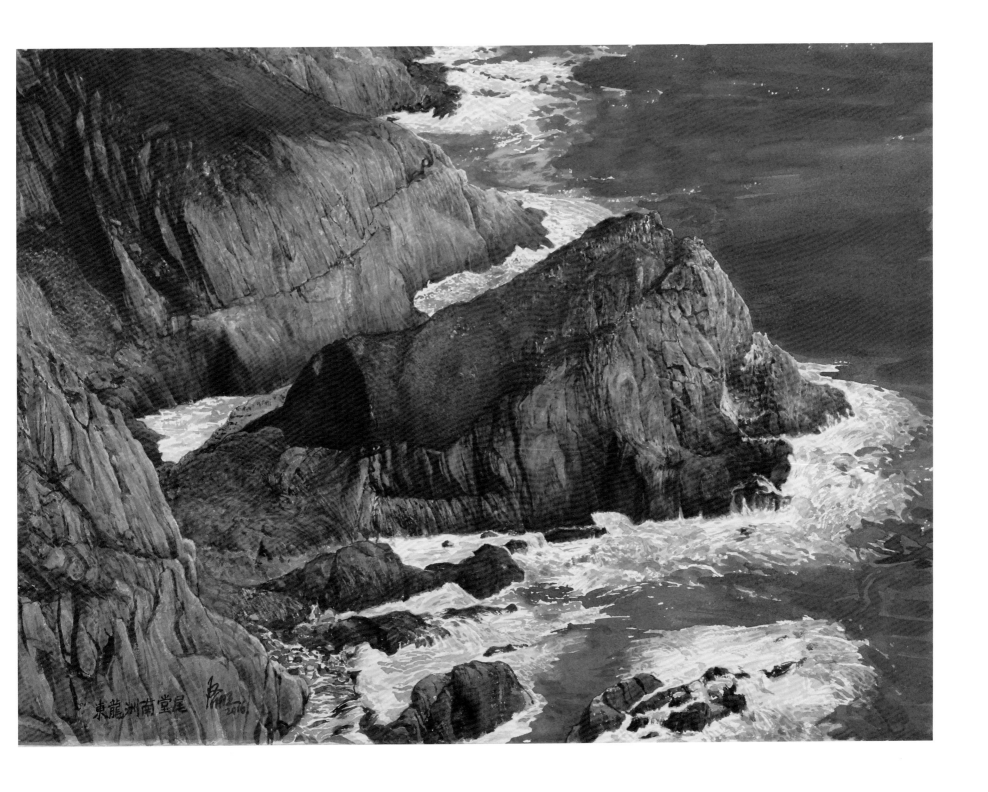

44. **東龍洲南堂尾 Tathong Point, Tung Lung Chau**

57 x 76cm

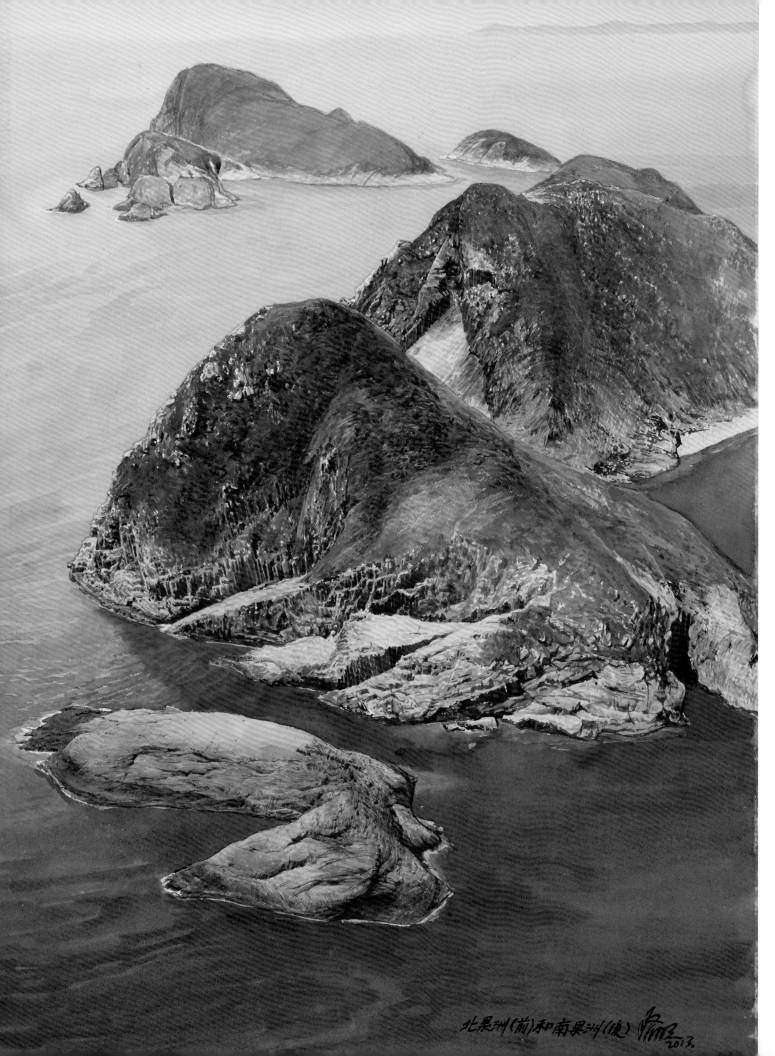

北果洲（前）和南果洲（後） 2013.

2013

45. 北果洲和南果洲
North Ninepin Island and South Ninepin Island

76 x 57cm

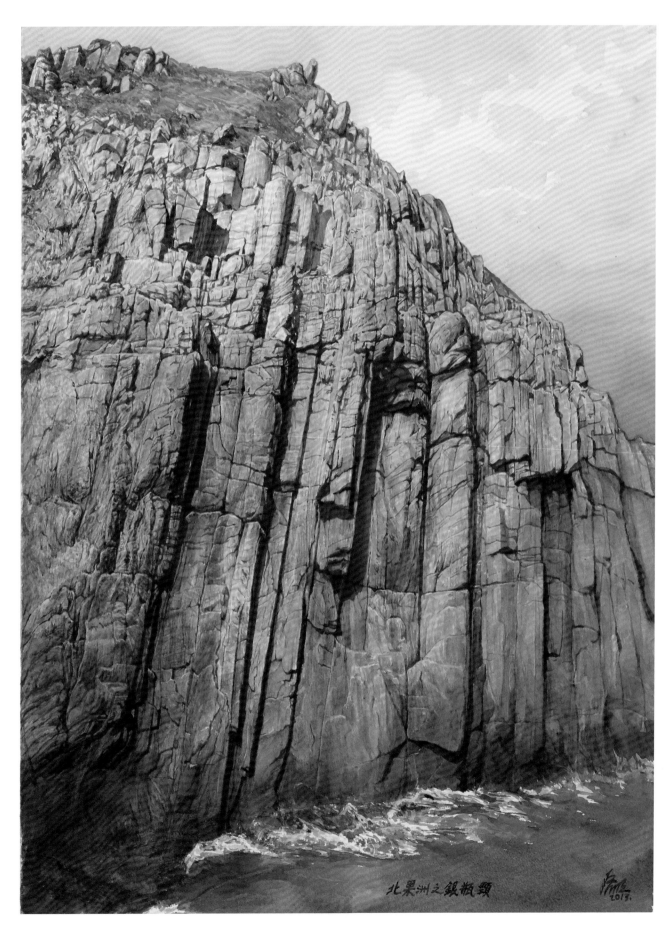

2013

46. 北果洲之銀瓶頸
"Silver Bottleneck",
North Ninepin Island

76 x 57cm

北果洲之銀瓶頸

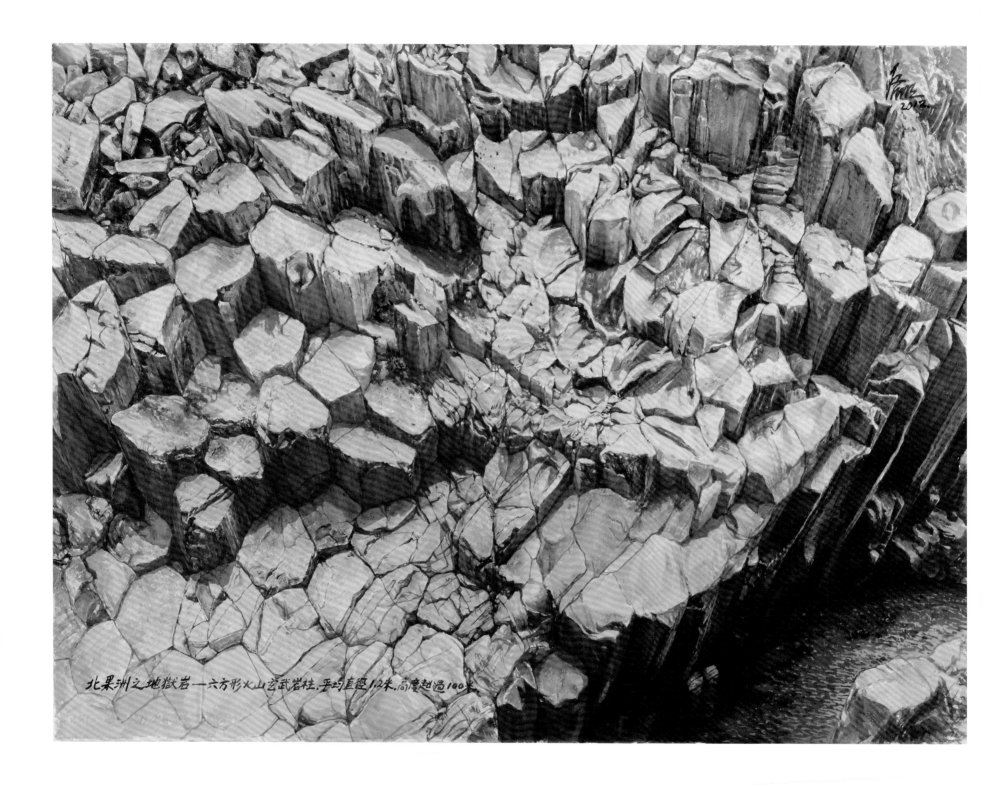

北果洲之地獄岩—六方形火山玄武岩柱,平均直徑1.2米,高度超過100米

2012

47. 北果洲之地獄岩 "Hell Rock", North Ninepin Island

57 x 76cm

2011

48. 南果洲 South Ninepin Island

57 x 76cm

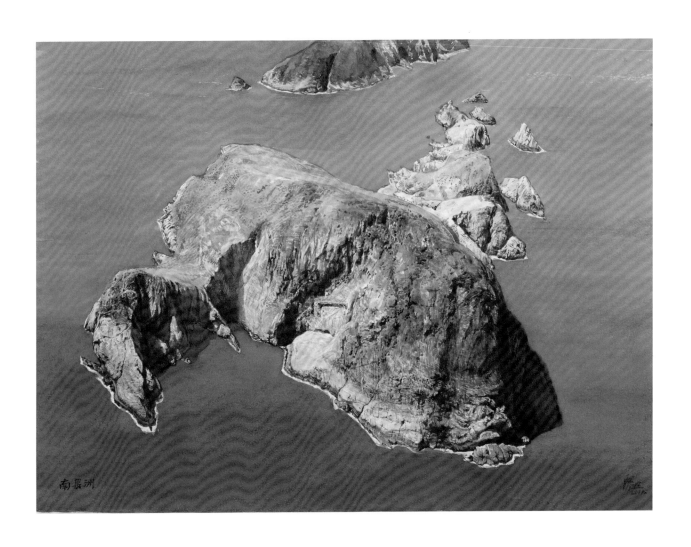

2011

49. 南果洲之穿窿門 Sea Arch of South Ninepin Island

57 x 76cm

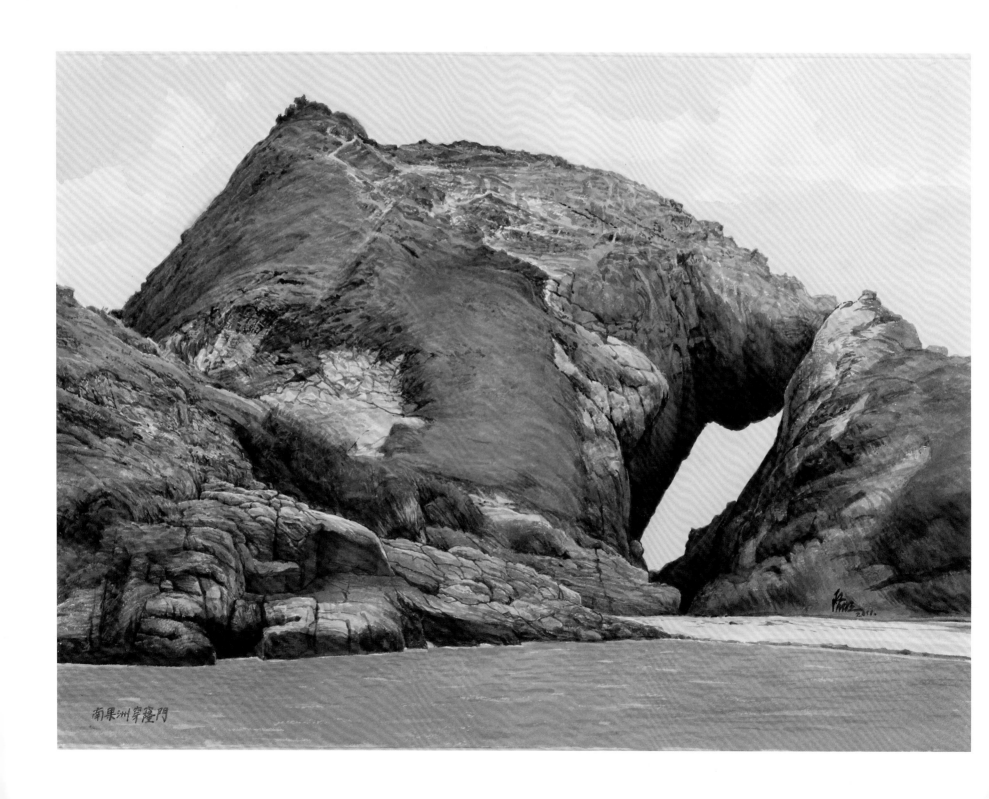

南果洲穿窿門

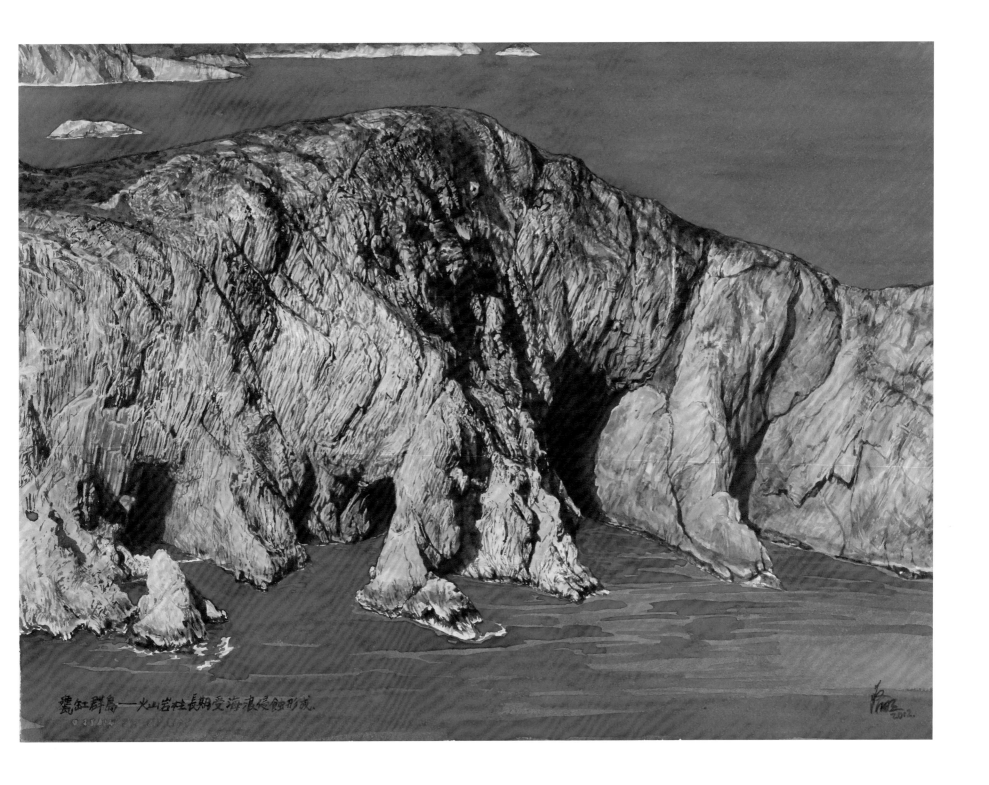

甕缸群島──火山岩柱長期受海浪侵蝕形成.

2012

50. **甕缸群島** Ung Kong Islands

57 x 76cm

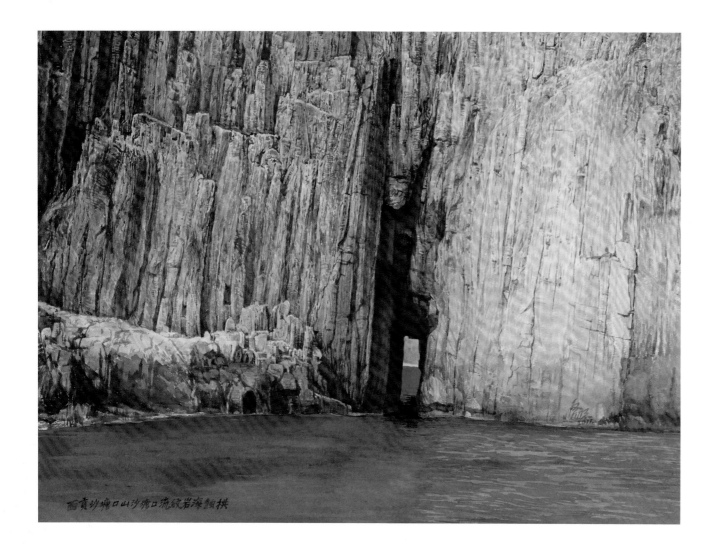

2011

51. 西貢沙塘口山海蝕拱 Sea Arches of Bluff Island (Sha Tong Hau Shan)

57 x 76cm

52. 沙塘口山 Bluff Island (Sha Tong Hau Shan)

57 x 76cm

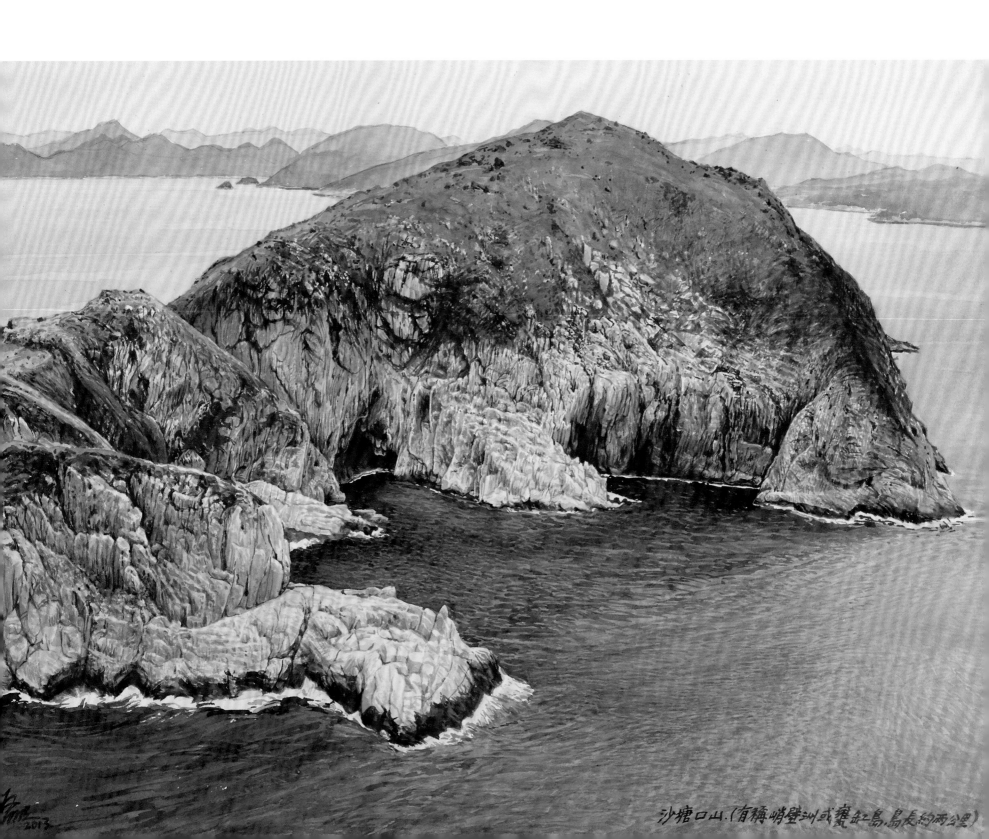

沙塘口山．(有稱峭壁洲或賽缸島,島長約兩公里)

2014

53. 扁洲、圓崗洲及棟心洲（三洲）
Pin Chau, Yuen Kong Chau and Tung Sam Chau (Ung Kong Islands)
57 x 76cm

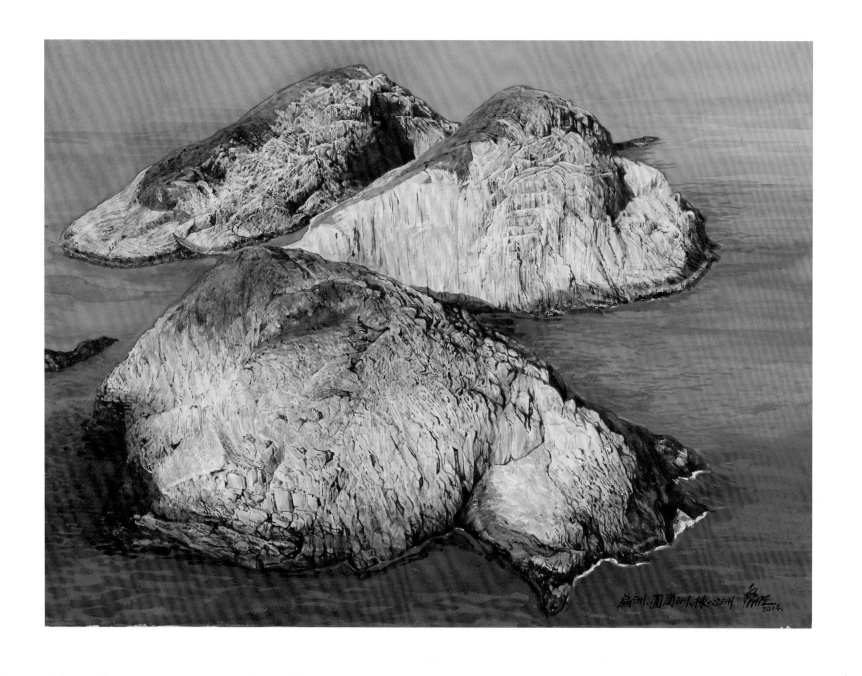

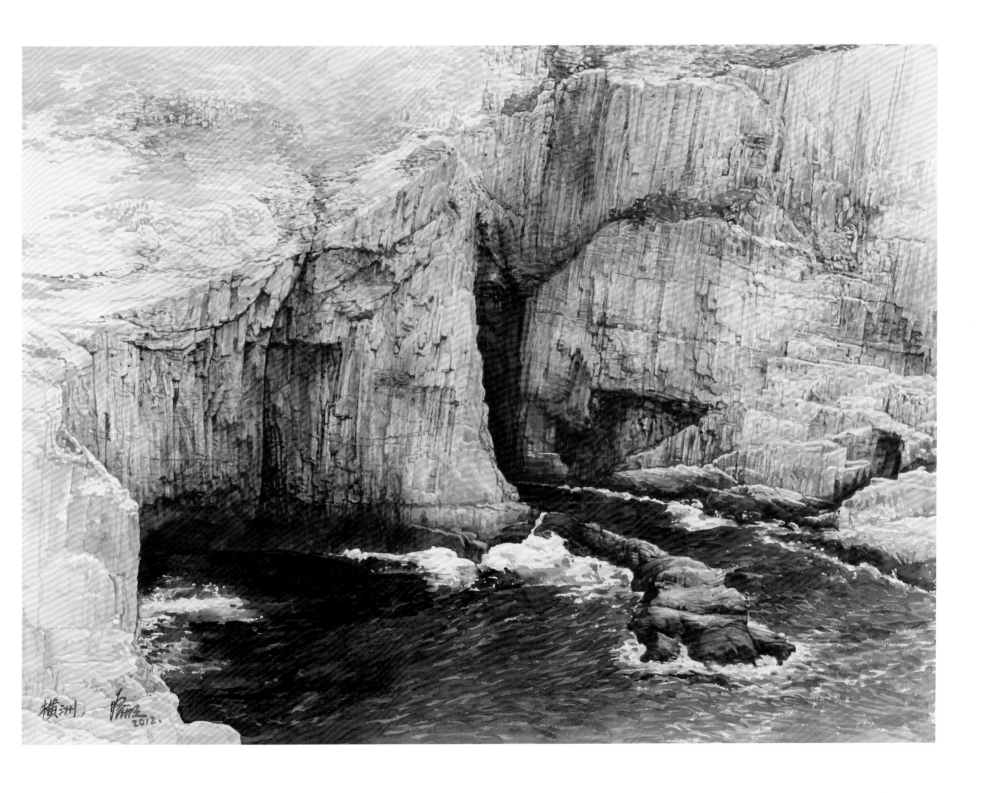

2012

54. 橫洲 Wang Chau

57 x 76cm

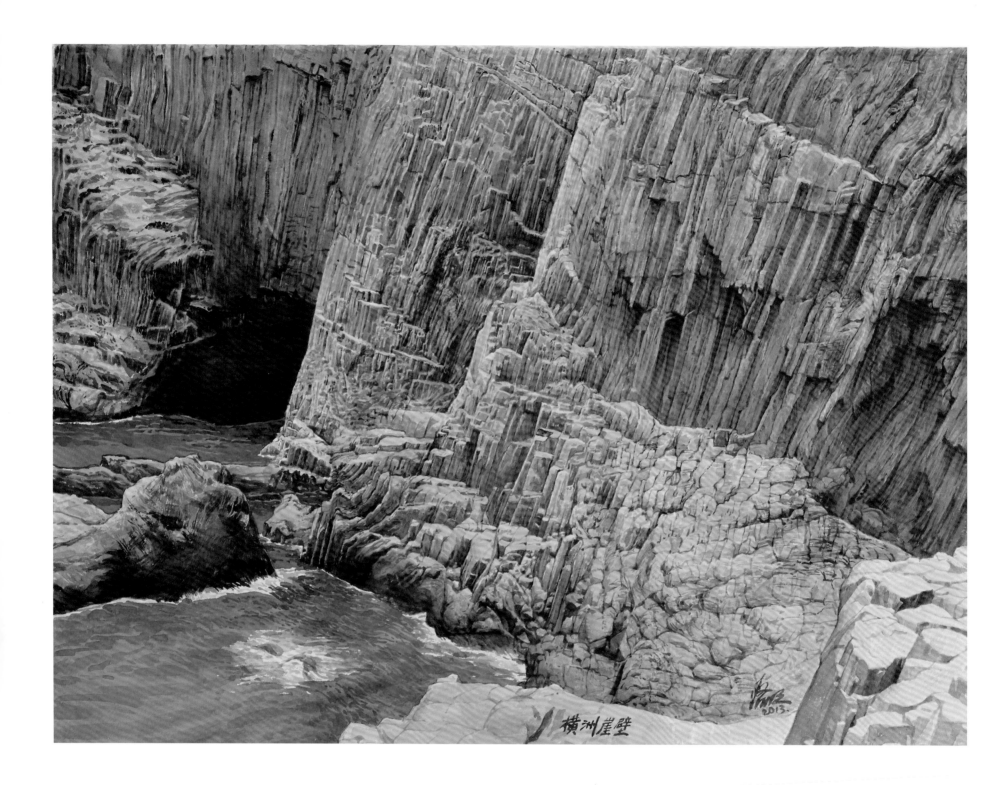

横洲崖壁

55. 橫洲崖壁 Seaward Cliff of Wang Chau

57 x 76cm

56. 橫洲角海蝕拱 Sea Arch in Wang Chau Kok

57 x 76cm

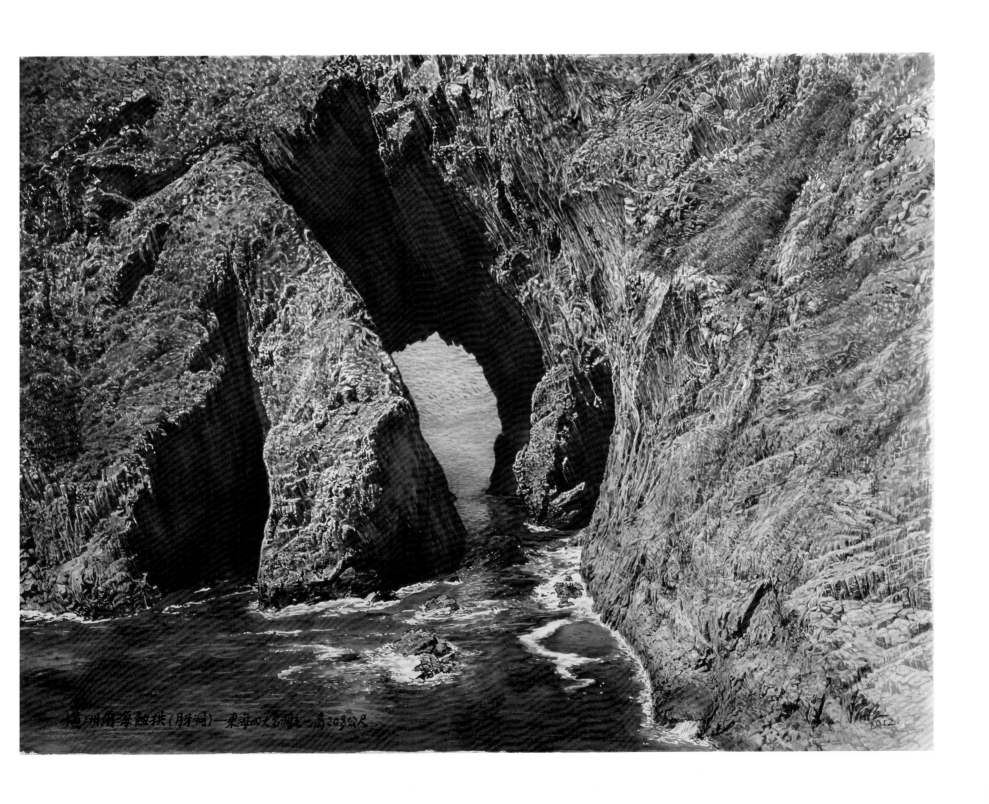

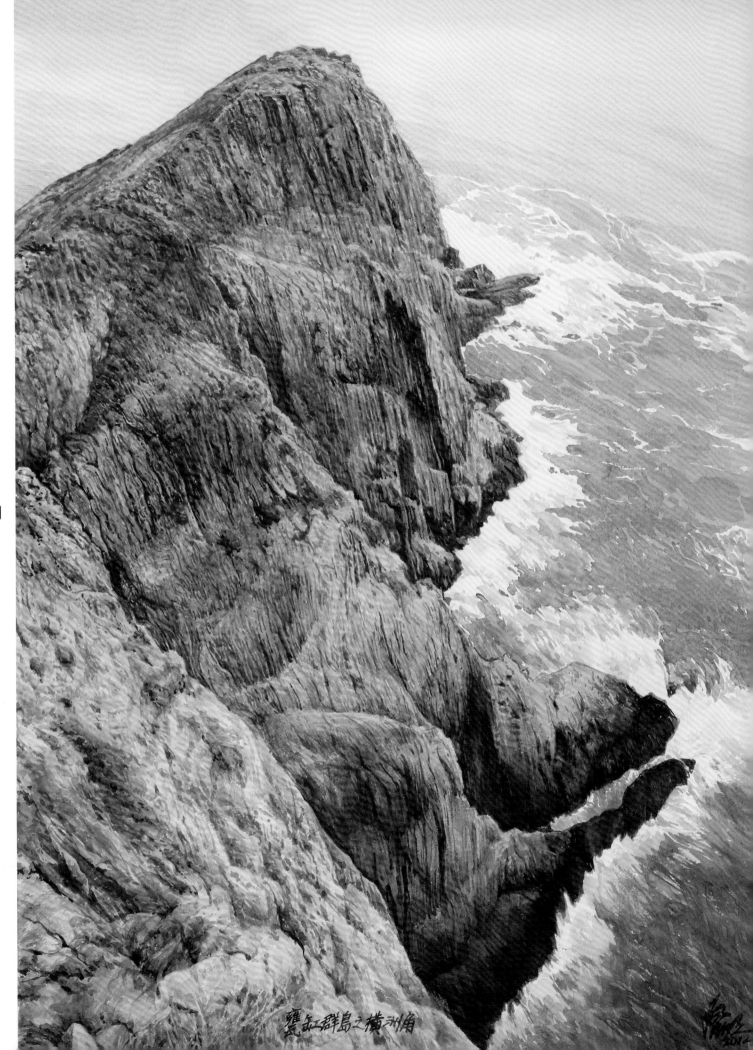

2012

57. 甕缸群島之橫洲角
Wang Chau Kok,
Ung Kong Islands

76 x 57cm

58. 火石洲 Basalt Island

57 x 76cm

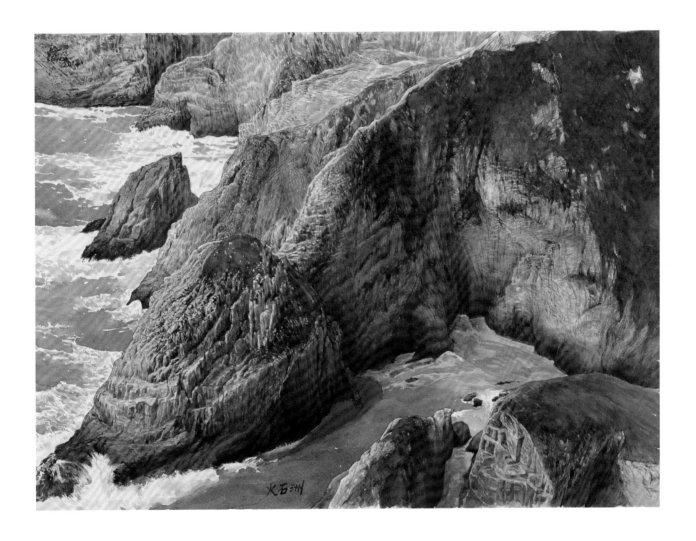

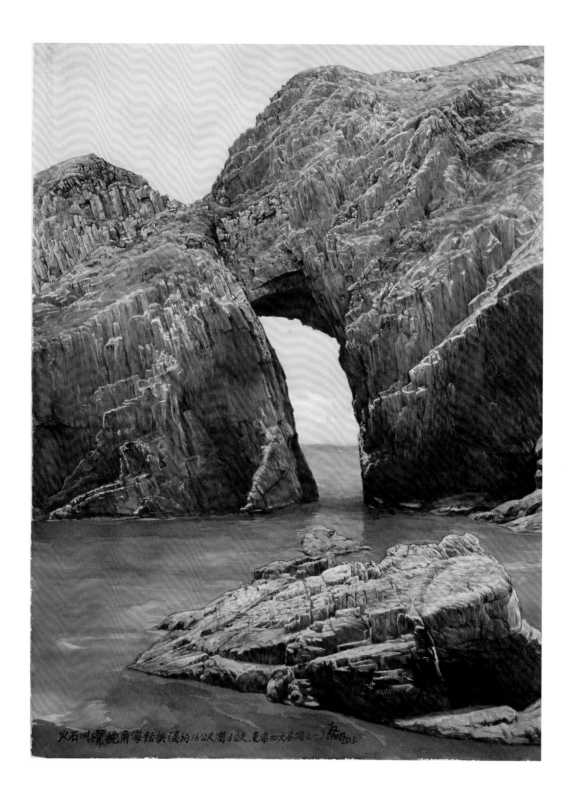

火石洲欖挽角海蝕拱（高約16公尺,闊3公尺,東海四大名洞之一）㟁2013.

2013

59. 火石洲欖挽角海蝕拱 Lam Wan Kok Arch in Basalt Island

76 x 57cm

60. 伙頭墳洲 Town Island (Fo Tau Fan Chau)

57 x 76cm

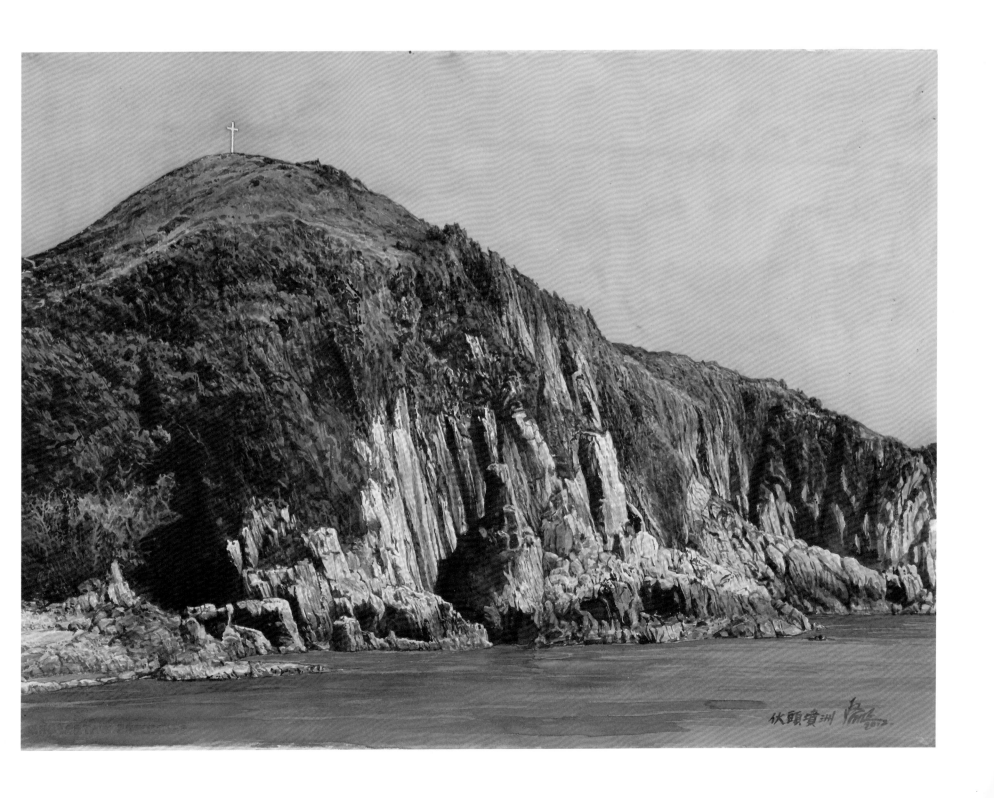

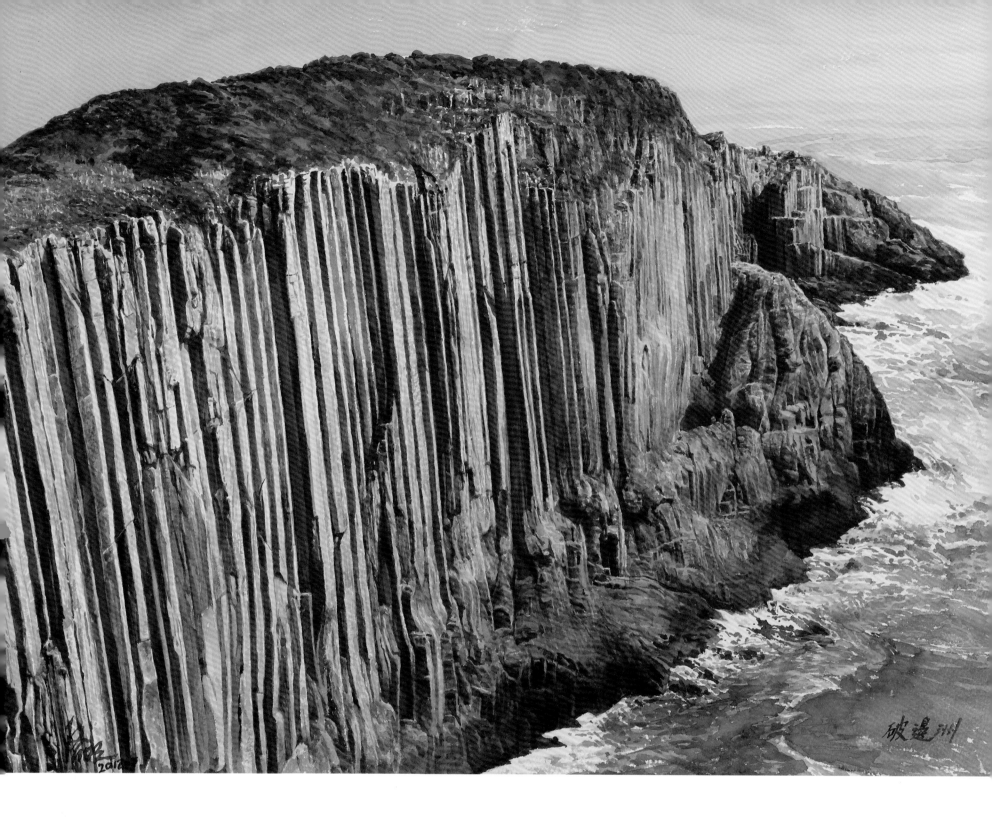

61. 破邊洲 Po Pin Chau

57 x 76cm

2015

62. 萬宜水庫 High Island Reservoir

57 x 76cm

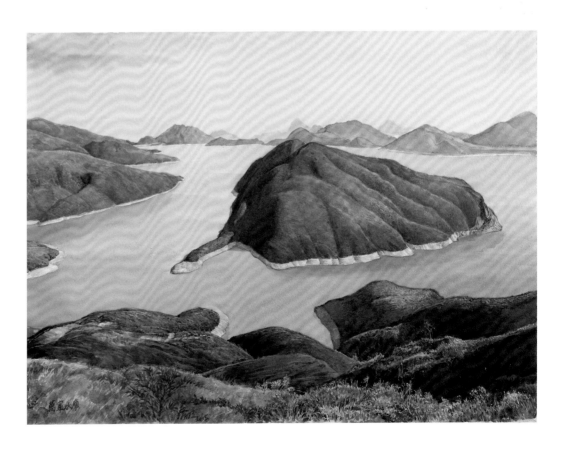

63. 萬宜水庫火山複褶的流紋岩 Acidic Rhyolite in High Island

57 x 76cm

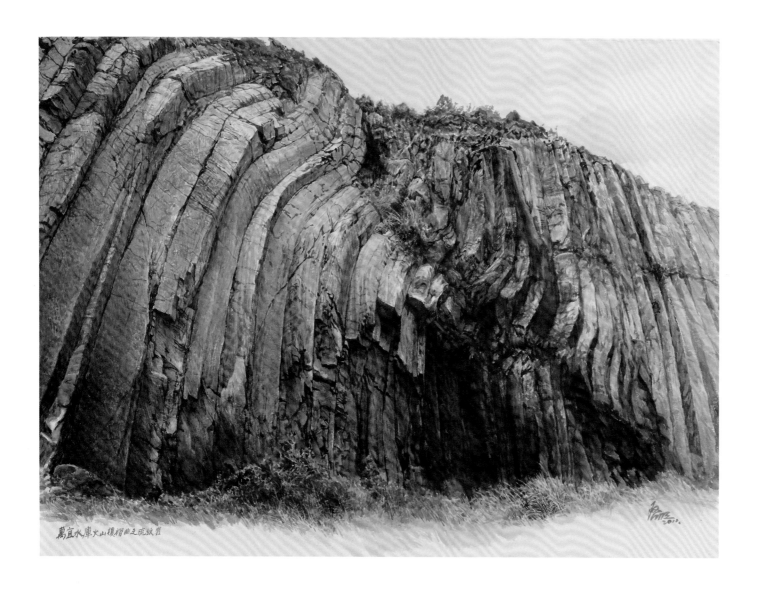

萬宜水庫火山複褶曲之流紋岩

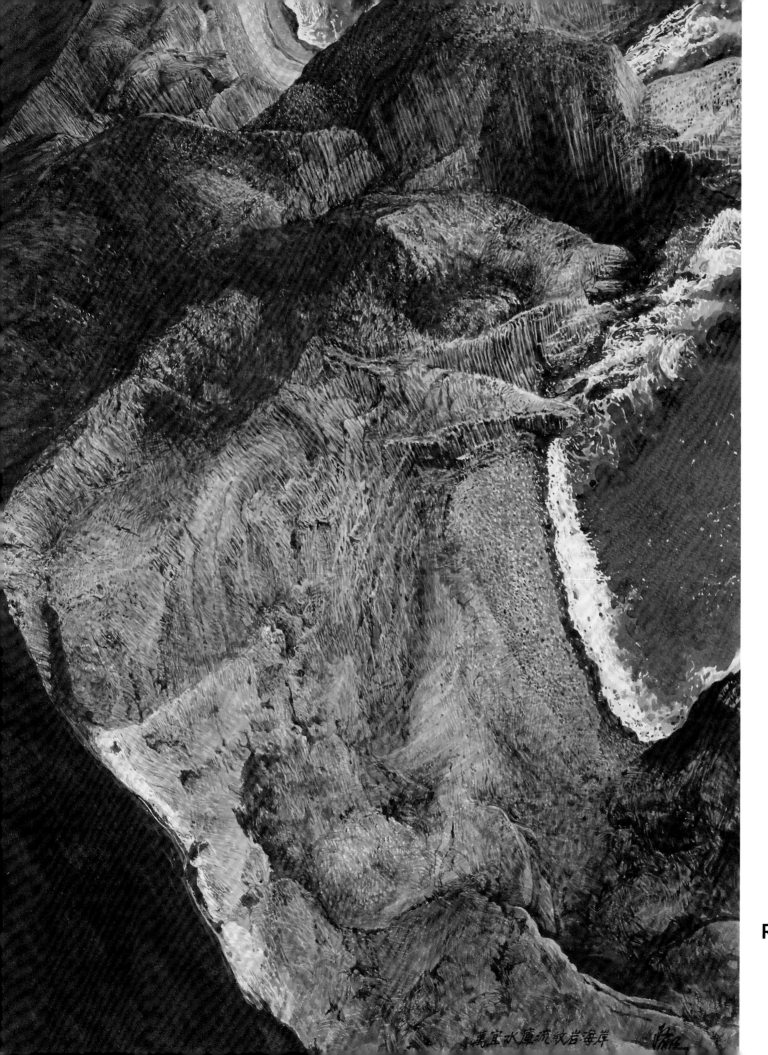

萬宜水庫流紋岩海岸

2013

64. 萬宜水庫
流紋岩海岸
Coastal View of
Rhyolitic Ash Tuff
in High Island

76 x 57cm

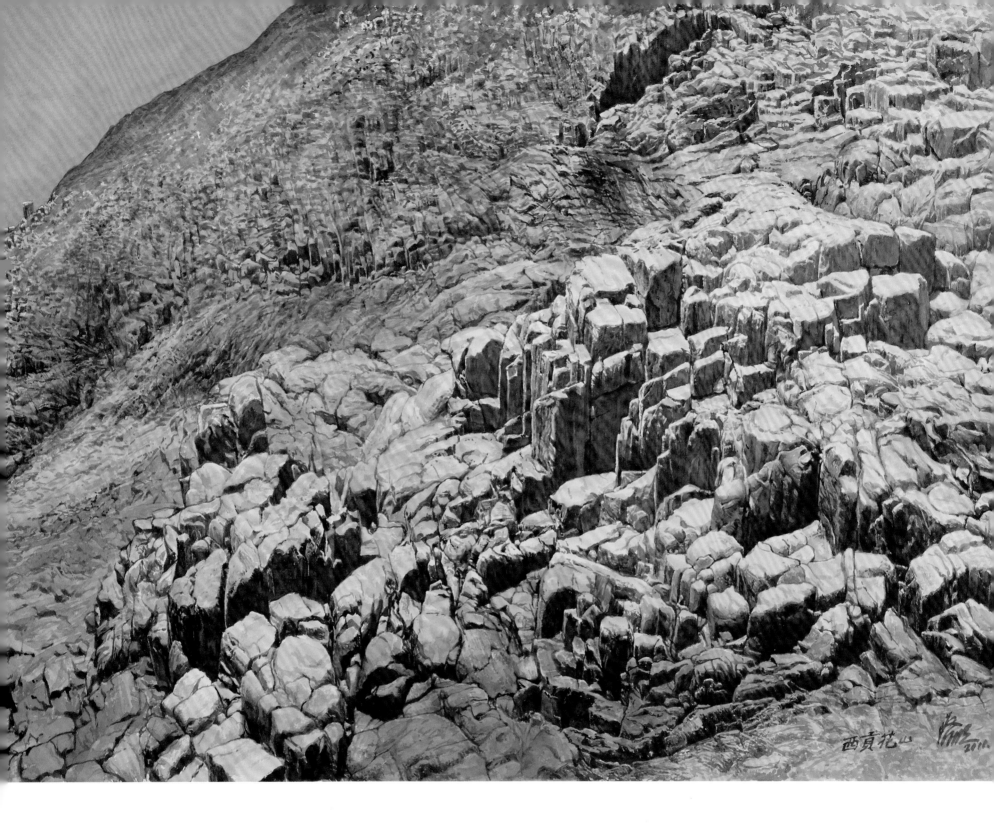

65. 西貢花山 Fa Shan, Sai Kung

56 x 76cm

66. 白腊 Pak Lap

57 x 76cm

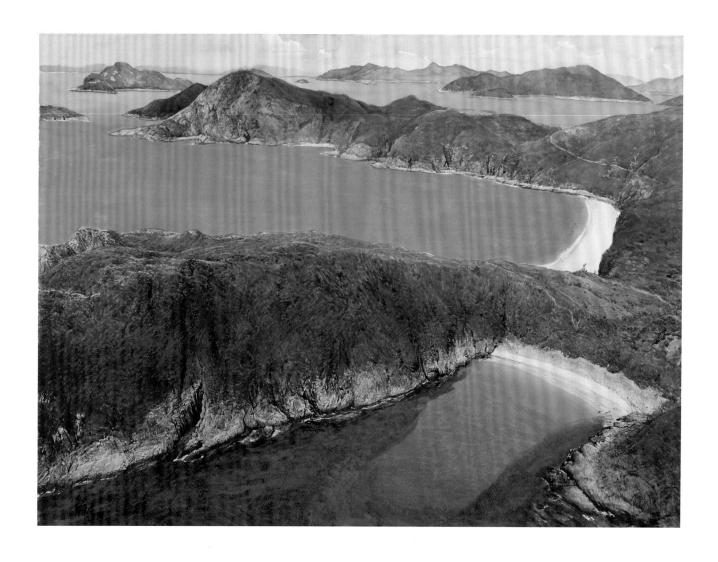

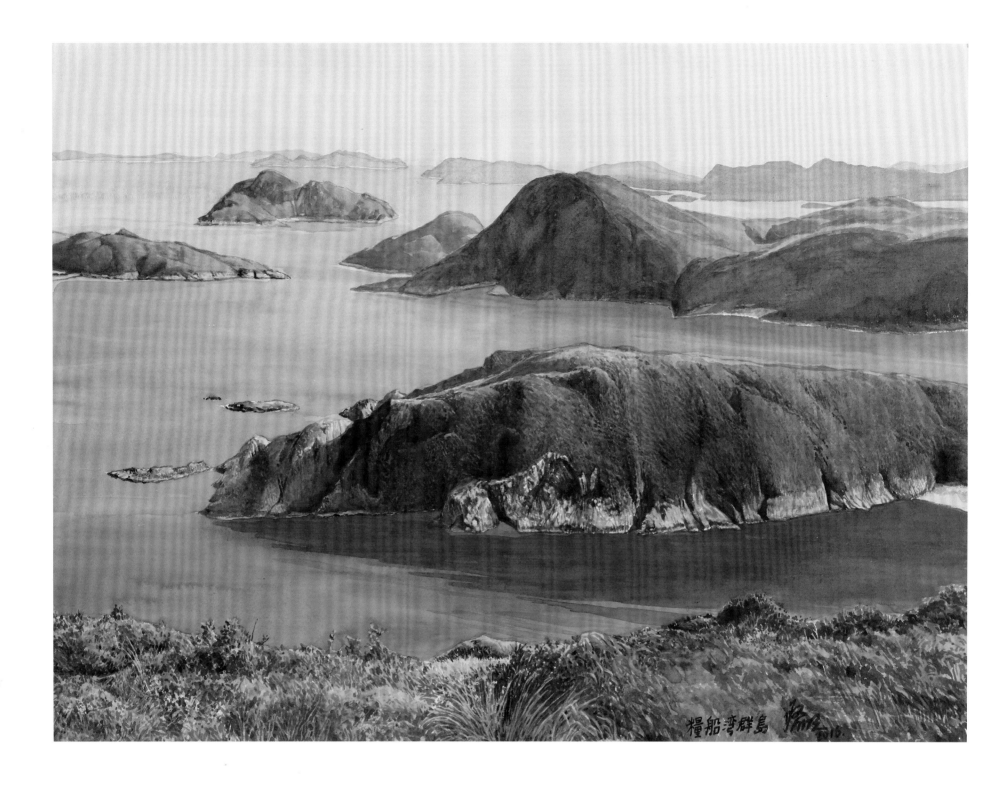

2016

67. 糧船灣群島 High Islands (Leung Shuen Wan)

57 x 76cm

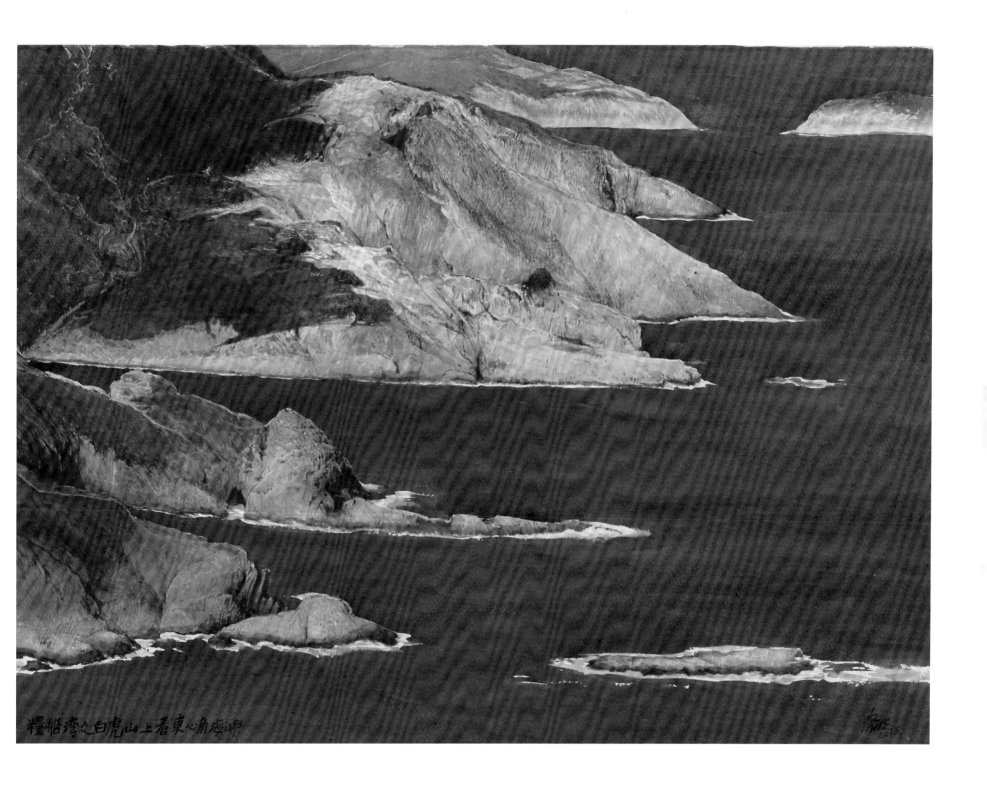

糧船灣之白虎山上看東心角海岬

2016

68. **糧船灣之白虎山上看東心角海岬**
East Angular Headland, Pak Fu Shan, High Island

57 x 76cm

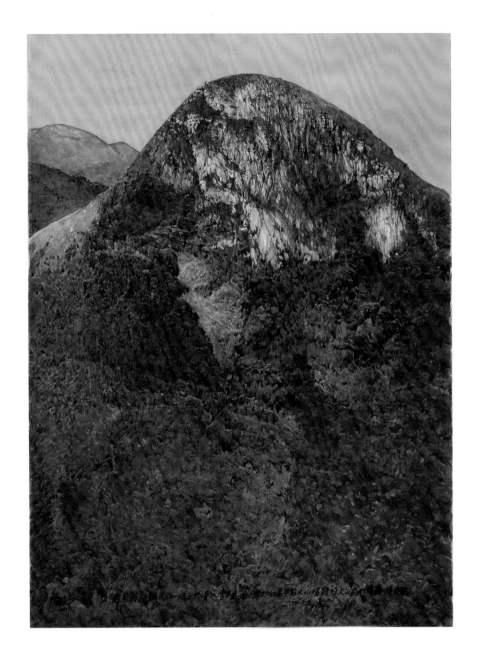

2013

69. 清水灣釣魚翁山（344 米）
High Junk Peak, Clear Water Bay(344m)

76 x 57cm

70. 西貢鹹田 Ham Tin, Sai Kung

57 x 76cm

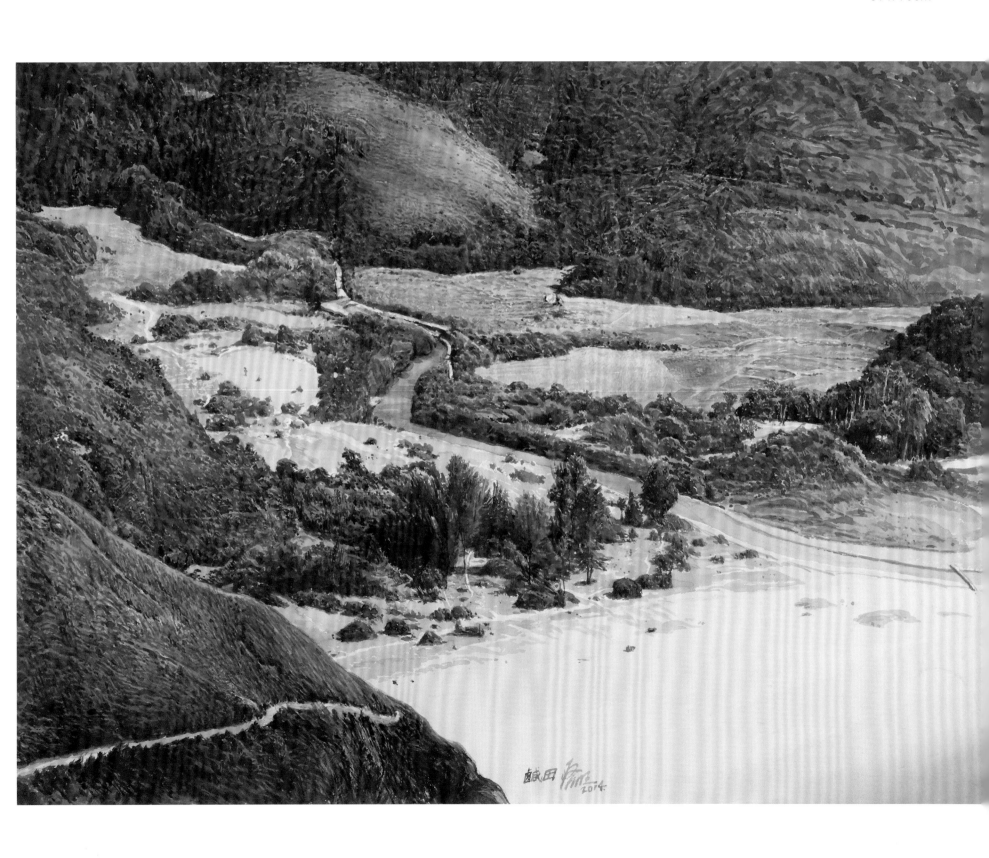

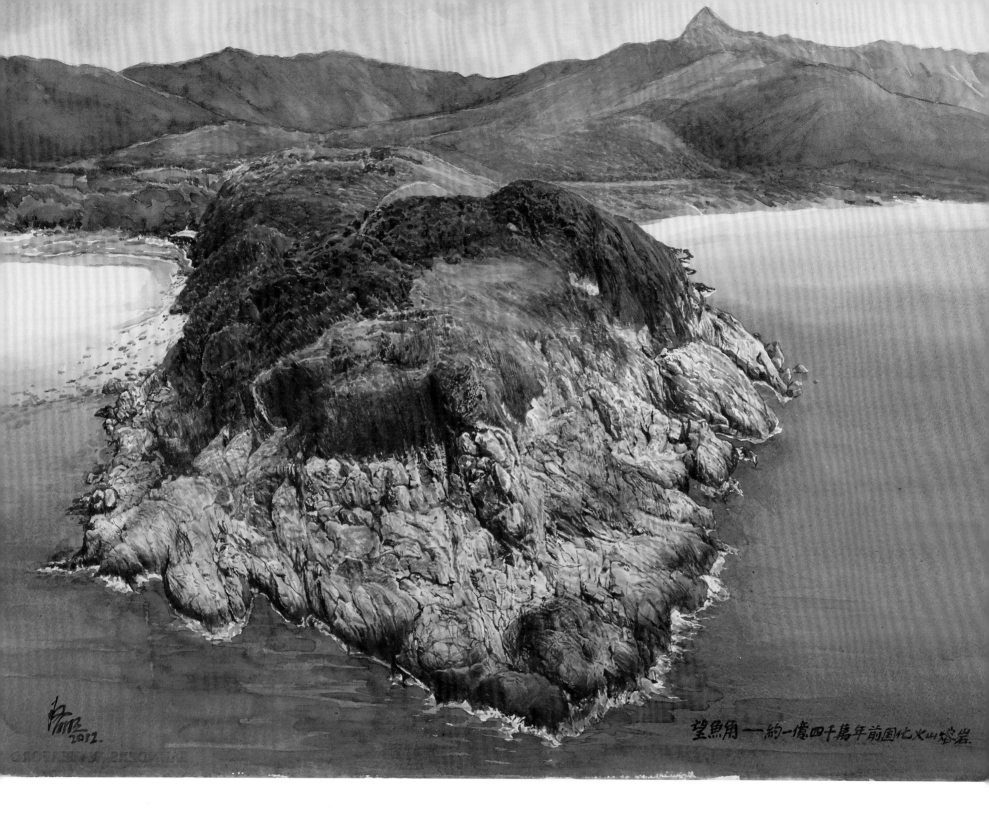

望魚角 — 約一億四千萬年前固化火山熔岩.

2012

71. 西貢望魚角 Mong Yue Kok, Sai Kung

57 x 76cm

72. 西貢罾棚角千柱海岸 Pillar Coast, Tsang Pang Kok, Sai Kung

57 x 76cm

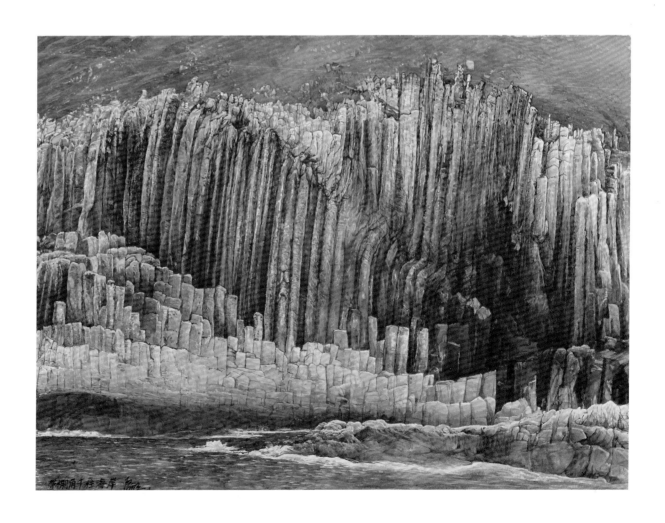

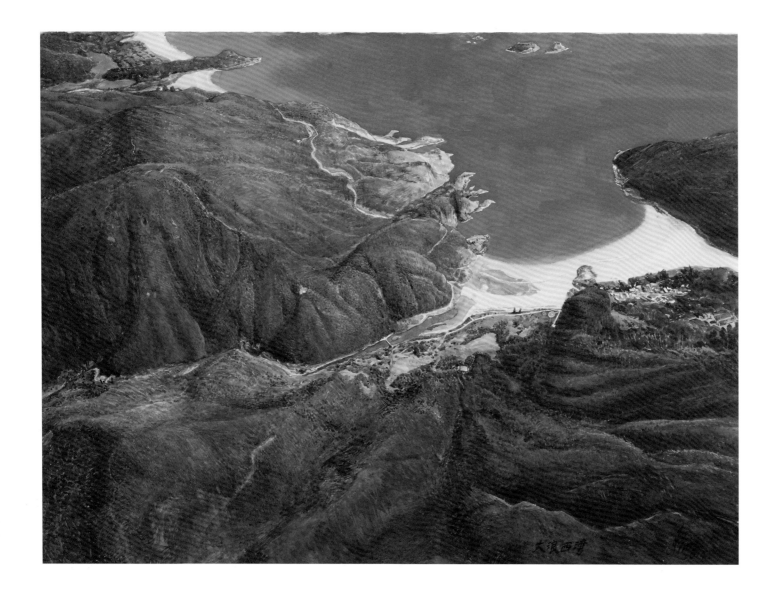

2014

73. 西貢大浪西灣 Tai Long Wan West,Sai Kung

57 x 76cm

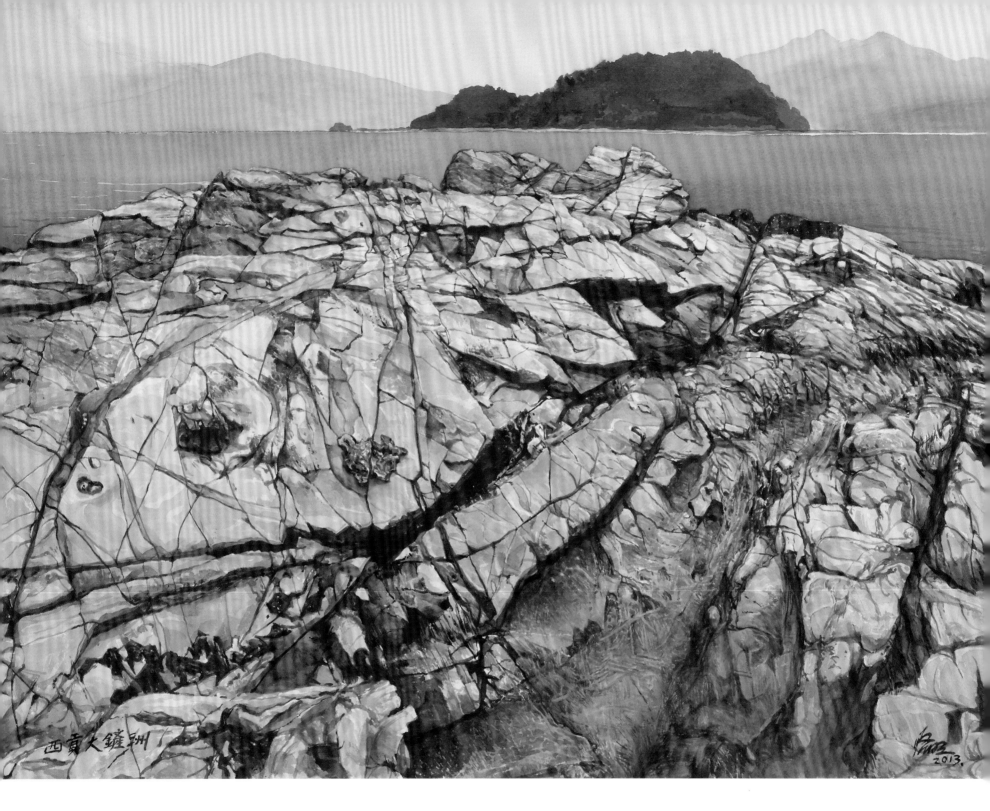

西貢大鑱洲

74. 西貢大鑱洲 Tai Tsan Chau, Sai Kung

57 x 76cm

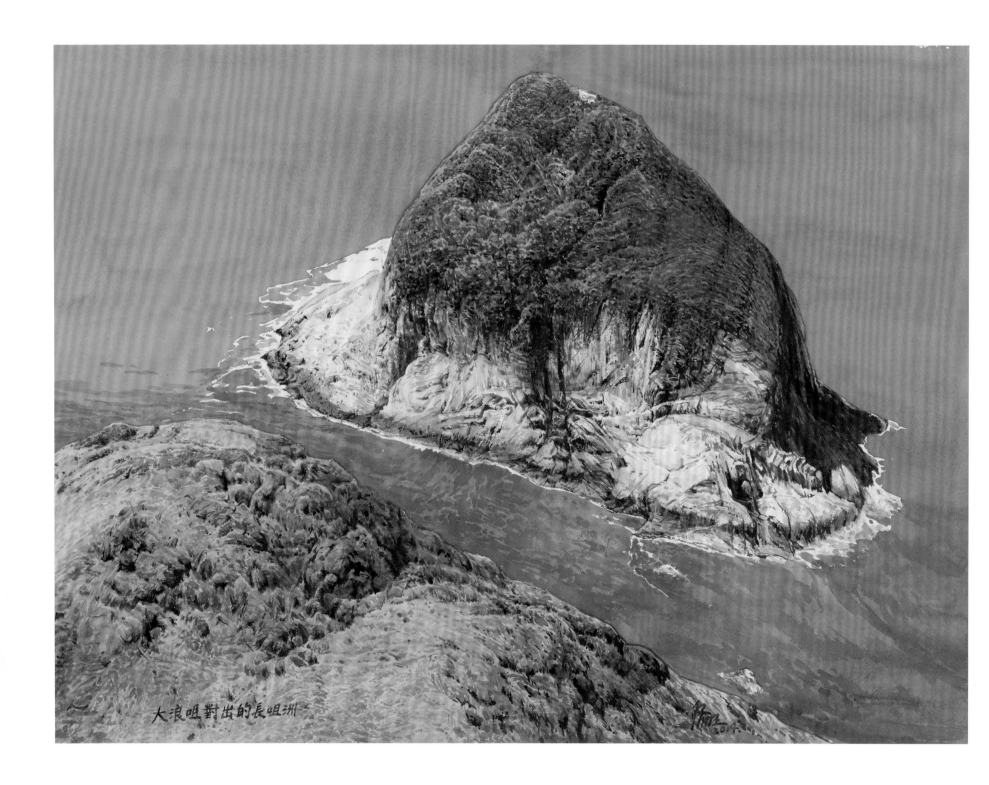

大浪咀對出的長咀洲

2014

75. **大浪灣對出的長咀洲 Cheung Tsui Chau, Tai Long Wan**

57 x 76cm

76. 大洲（大浪三洲之一）Tai Chau, Tai Long Wan

57 x 76cm

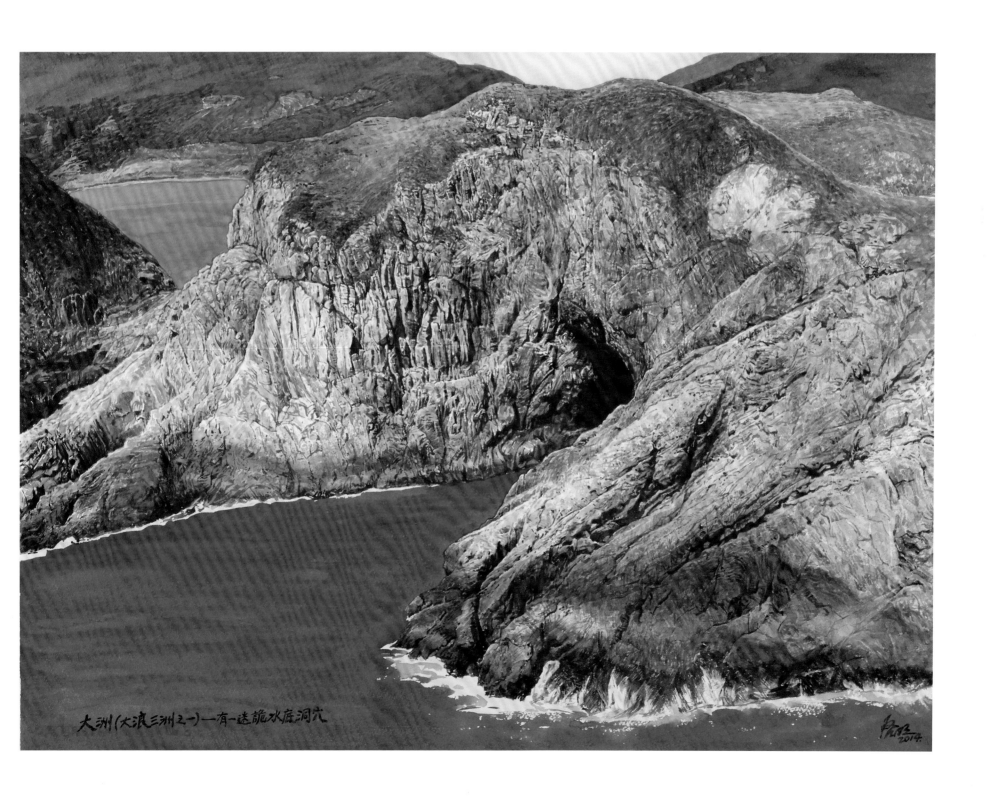

大洲（大浪三洲之一）一有一迷詭水庭洞穴

77. 企嶺下海的榕樹澳 Yung Shue O, Three Fathoms Cove

57 x 76cm

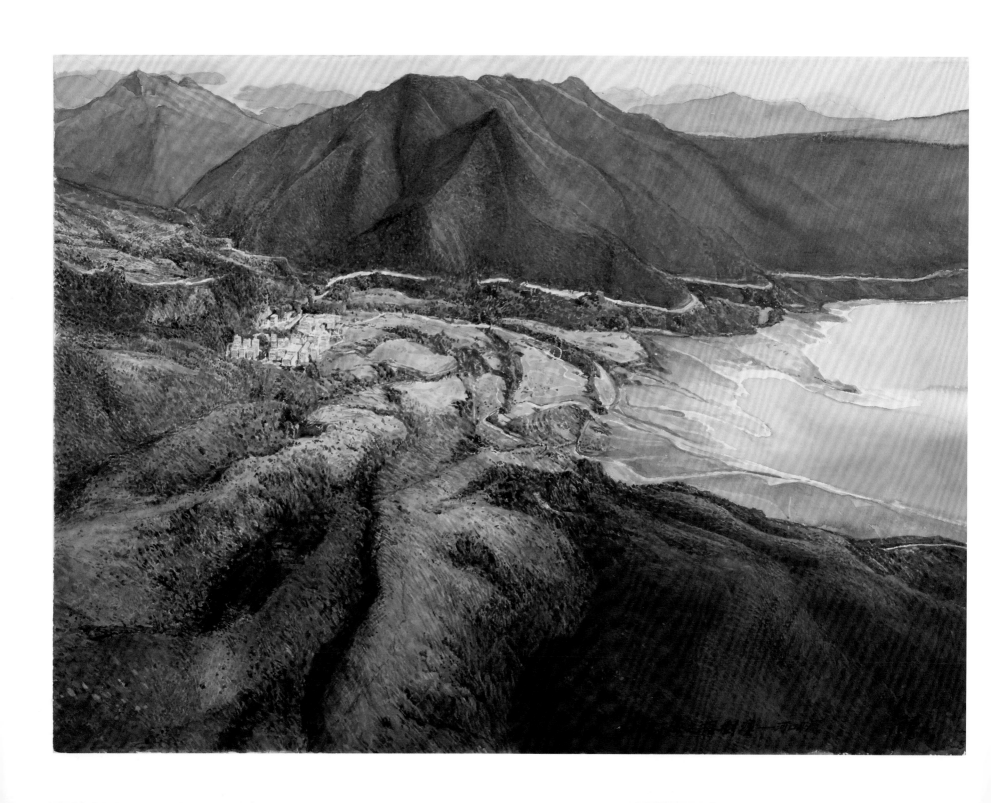

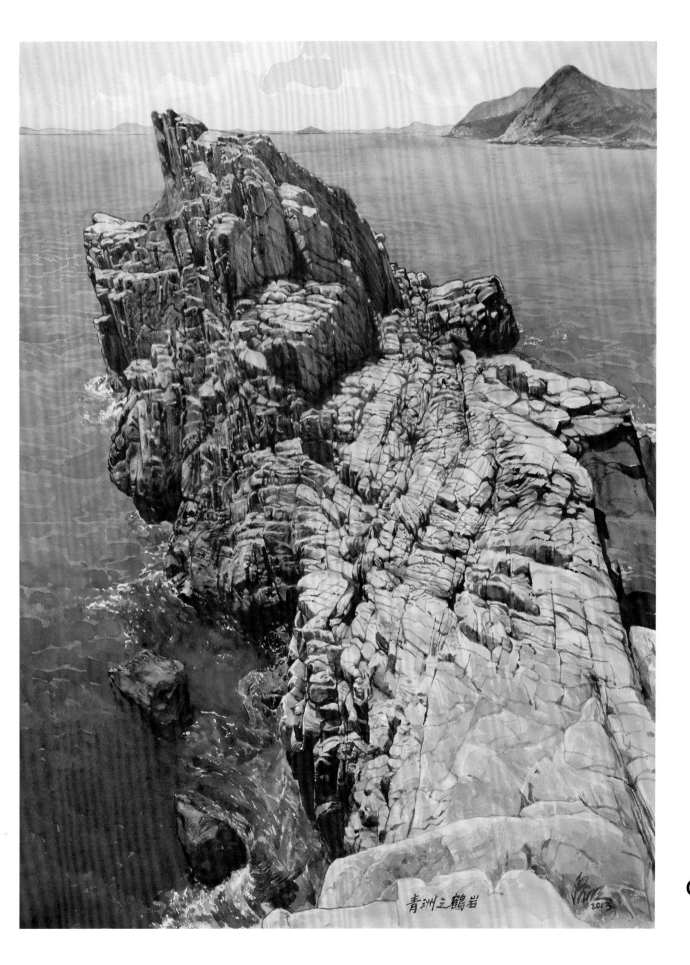

青洲之鶴岩

2013

78. 青洲之鶴岩
Crane Rock, Green Island

76 x 57cm

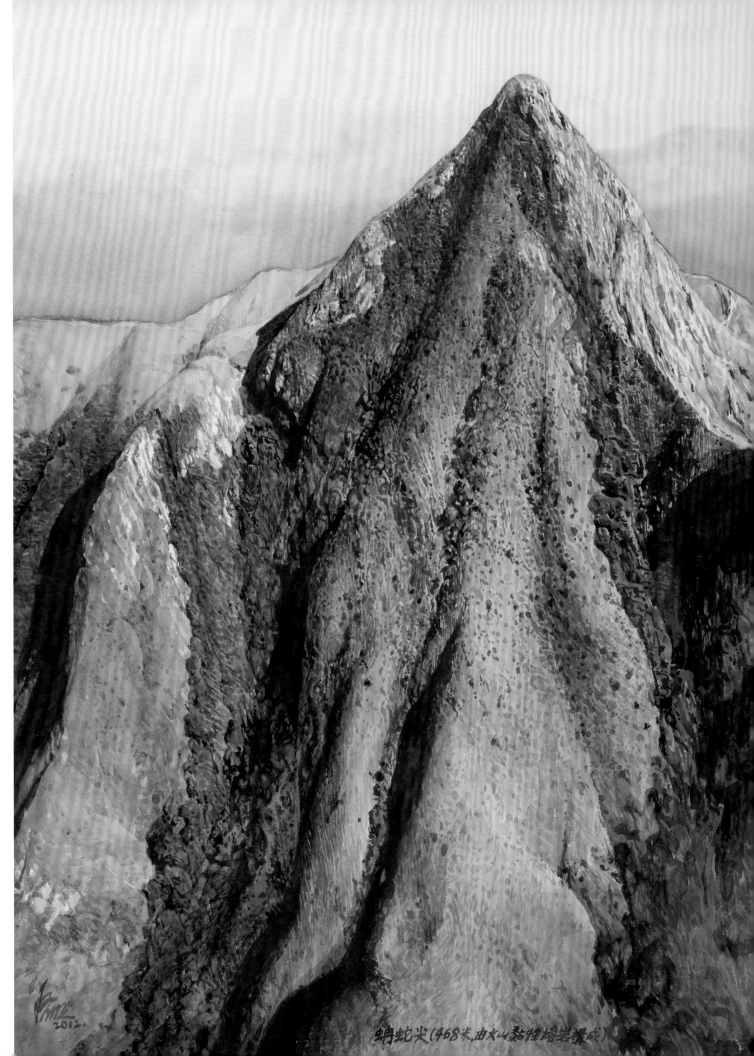

2012

79. 蚺蛇尖（468 米）
Sharp Peak(468m)

76 x 57cm

蚺蛇尖（468米,由火山黏性熔岩構成）

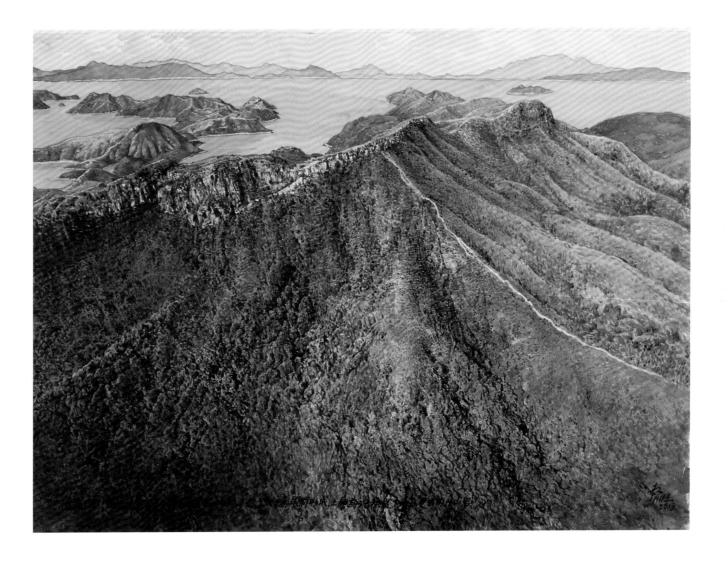

80. 橫嶺 Wang Leng

57 x 76cm

2014

81. 短咀 Tuen Tsui

57 x 76cm

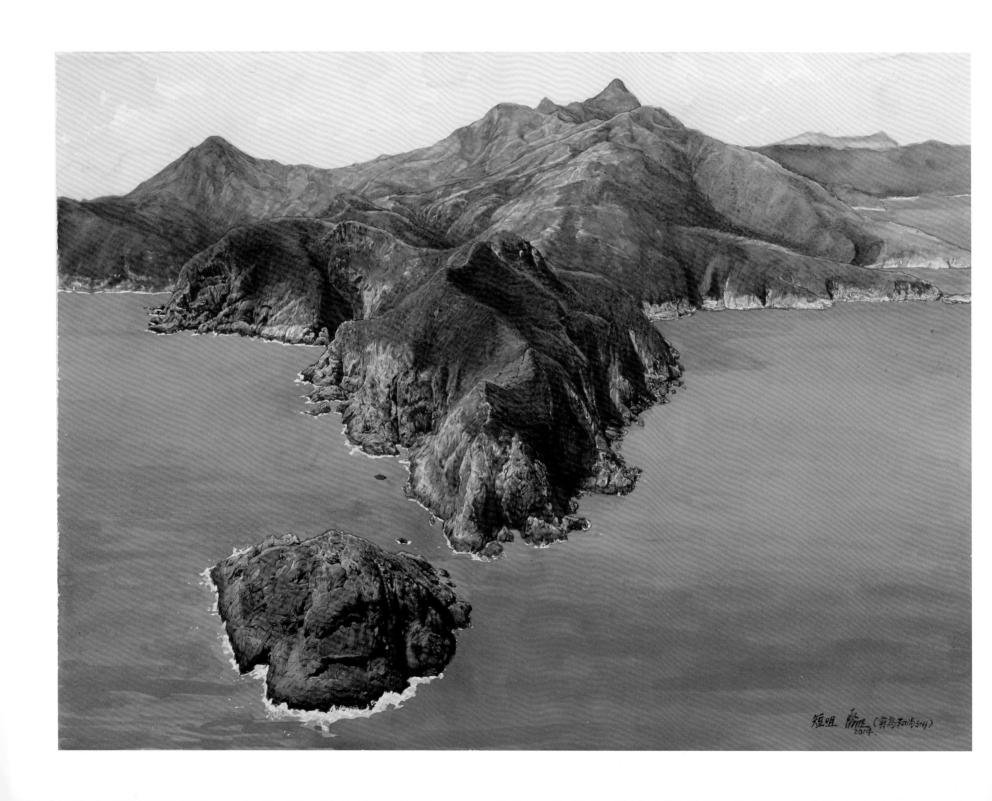

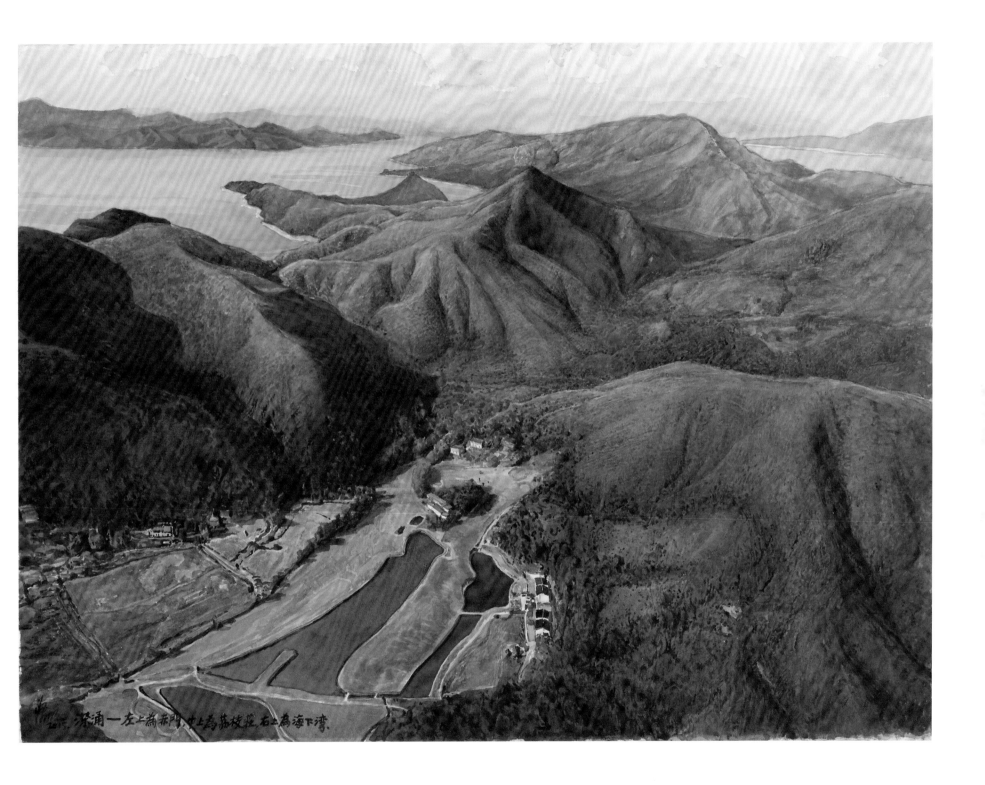

深涌一左上為荔門 中上為荔枝莊 右上為海下灣

2015

82. 深涌 Sham Chung

57 x 76cm

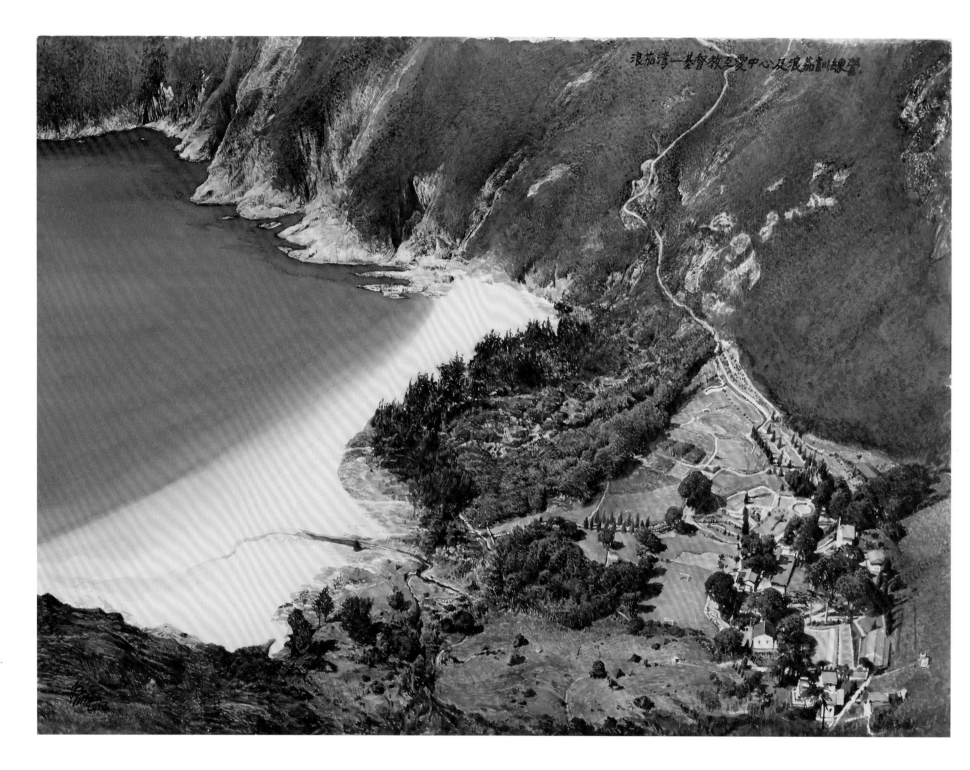

浪茄灣—基督教至愛中心及浪茄訓練營

2013

83. 浪茄灣 **Long Ke Wan**

57 x 76cm

84. 赤徑之大蚊山下 Foot of Tai Mun Shan, Chek Kang

57 x 76cm

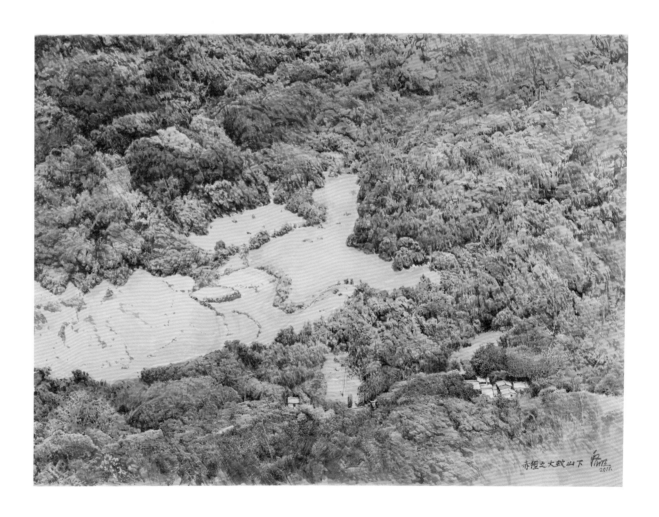

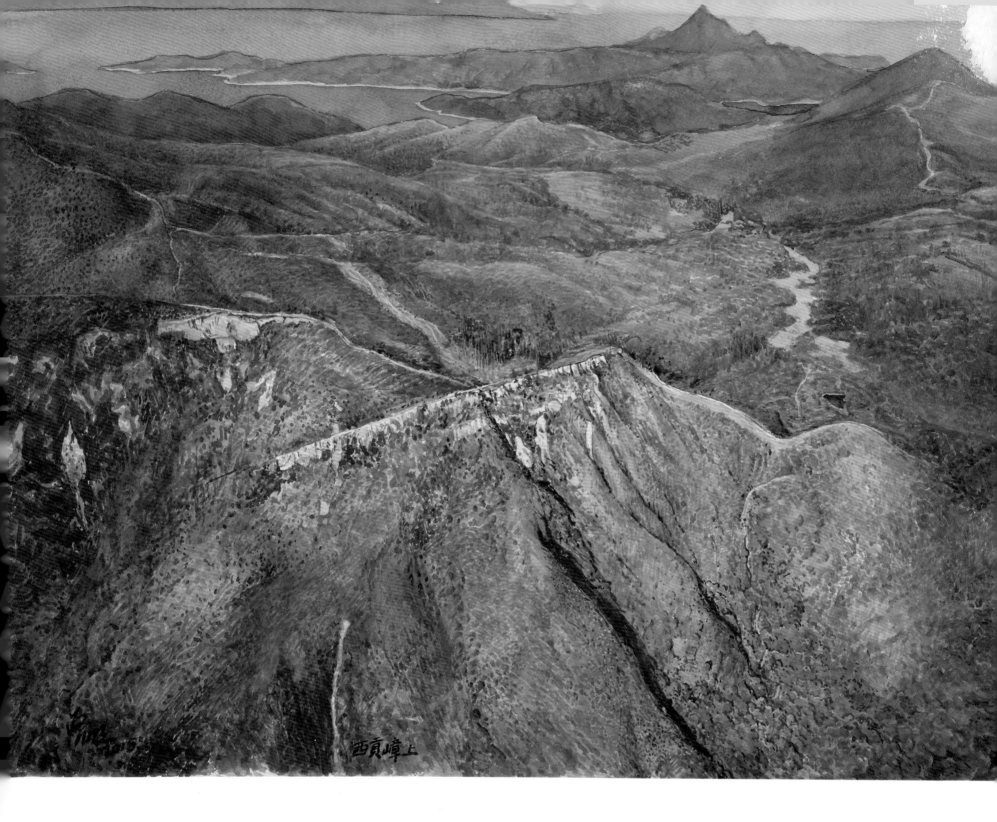

西貢嶂上

2015

85. 西貢嶂上 Cheung Sheung, Sai Kung

57 x 76cm

86. 西貢西灣路 Sai Wan Road, Sai Kung

57 x 76cm

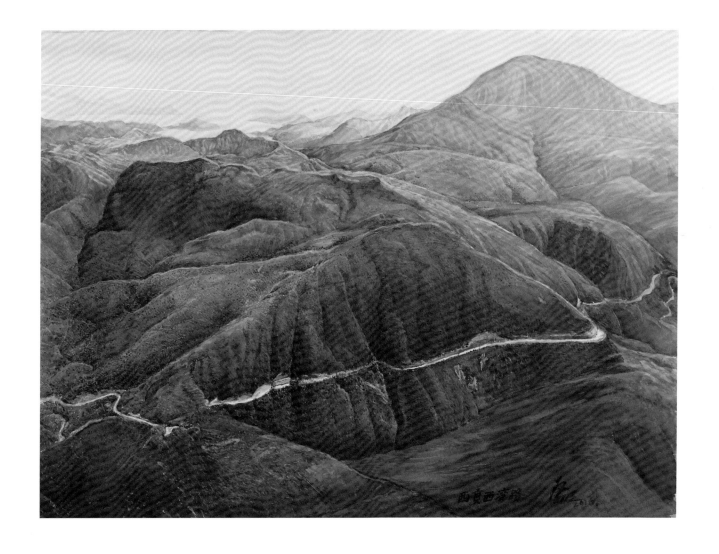

2012

87. 八仙嶺 Pat Sin Leng

57 x 76cm

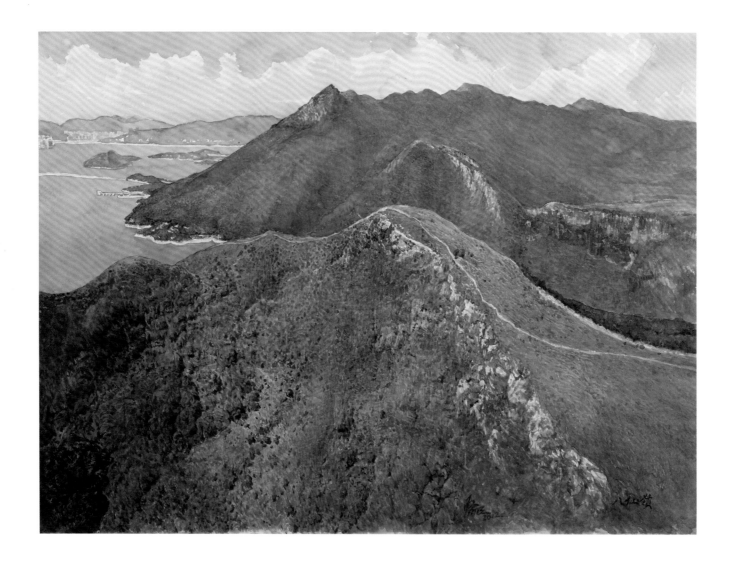

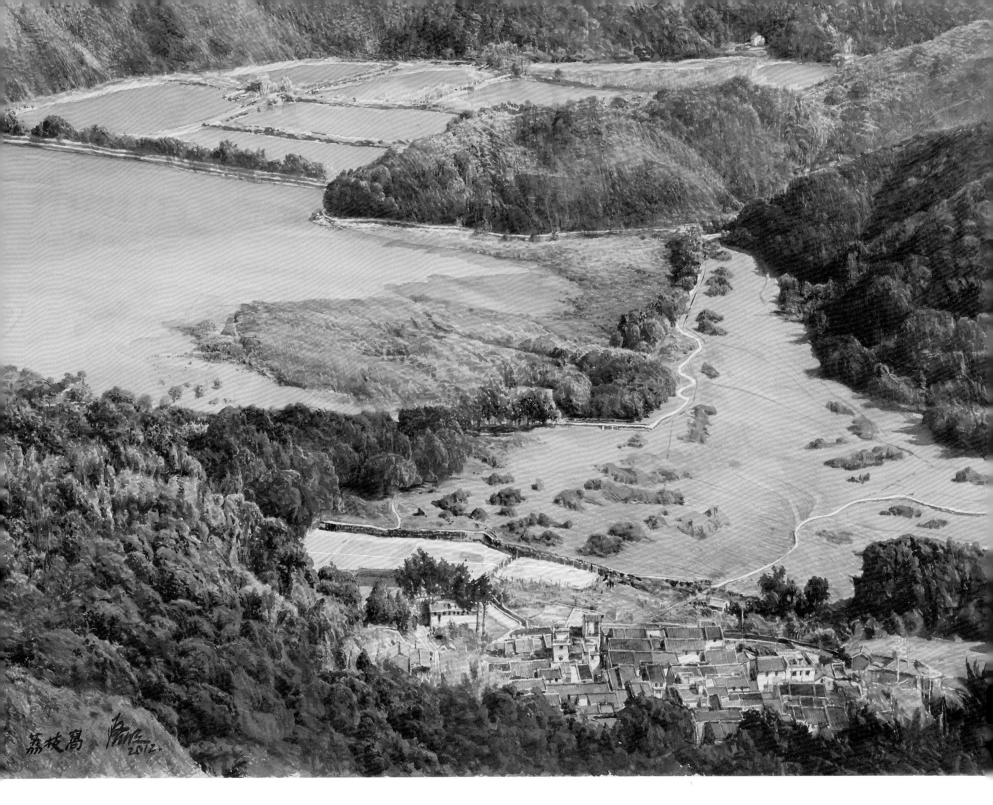

荔枝窗

2012

88. 荔枝窩 Lai Chi Wo

57 x 76cm

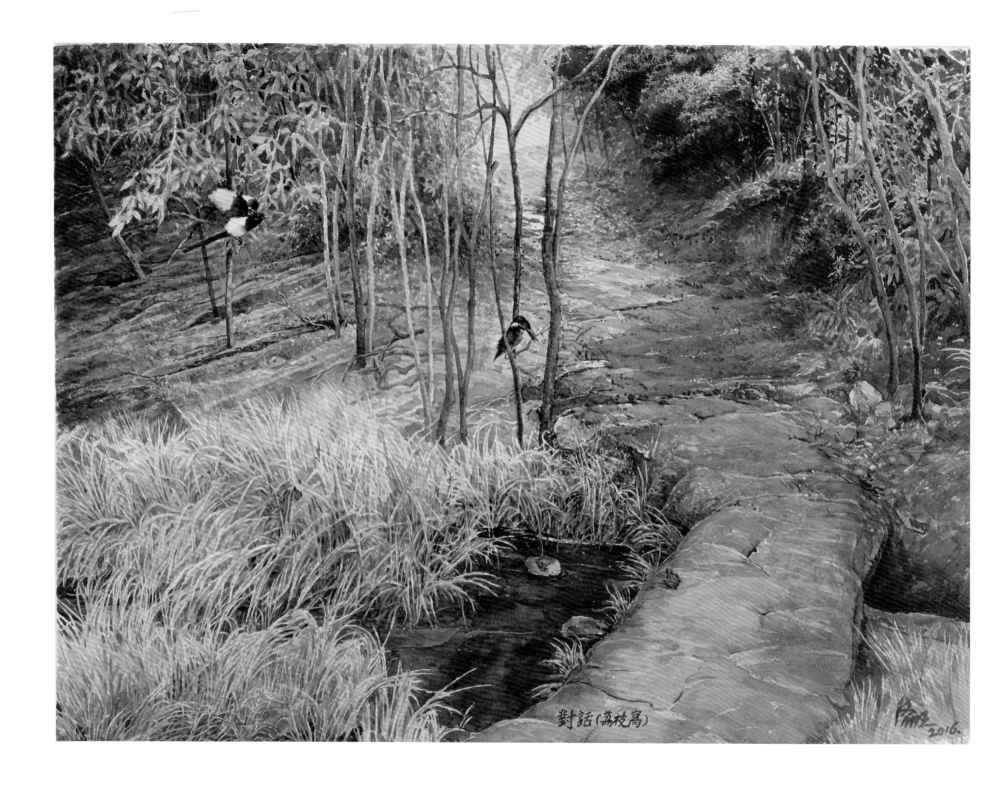

對話（荔枝窩）

2016

89. 對話（荔枝窩）Dialogue (Lai Chi Wo)

57 x 76cm

90. 三椏灣 Sam A Wan

57 x 76cm

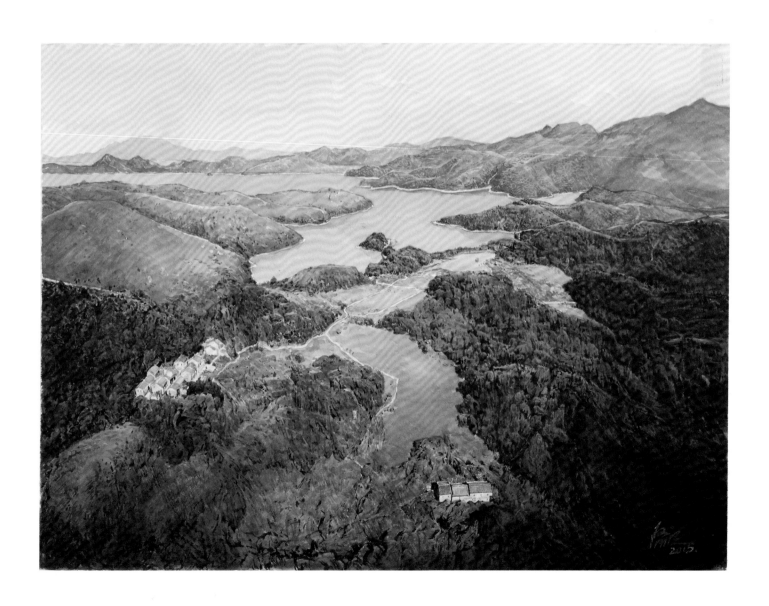

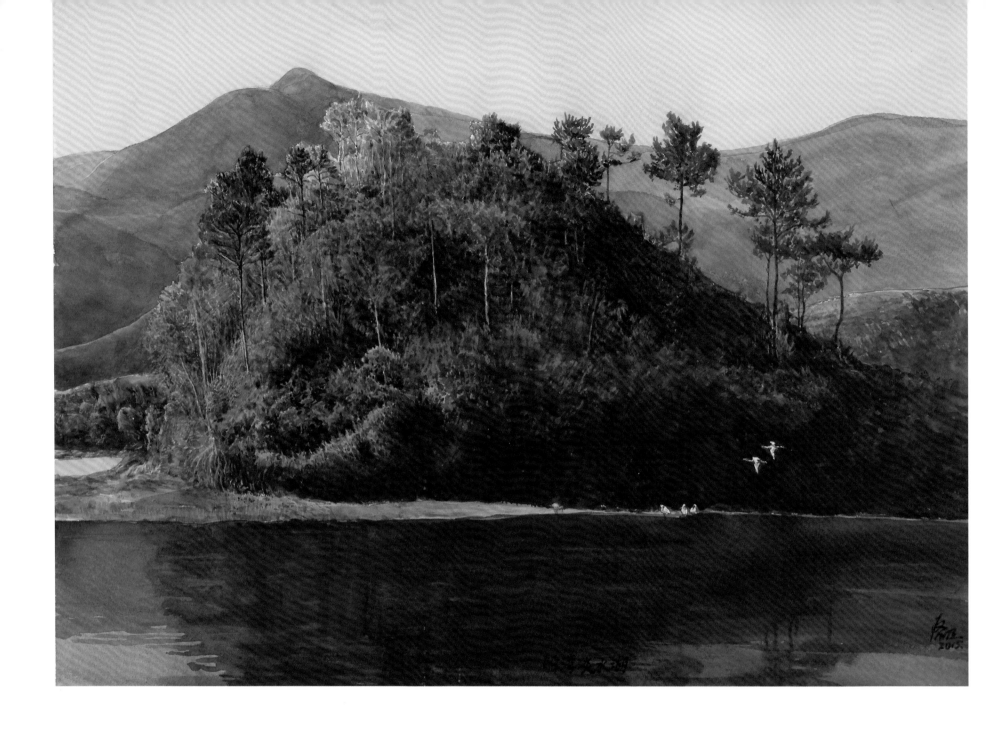

91. 船灣淡水湖 Plover Cove Reservoir

57 x 76cm

92. 船灣九担租村 Kau Tam Tso, Plover Cove

57 x 76cm

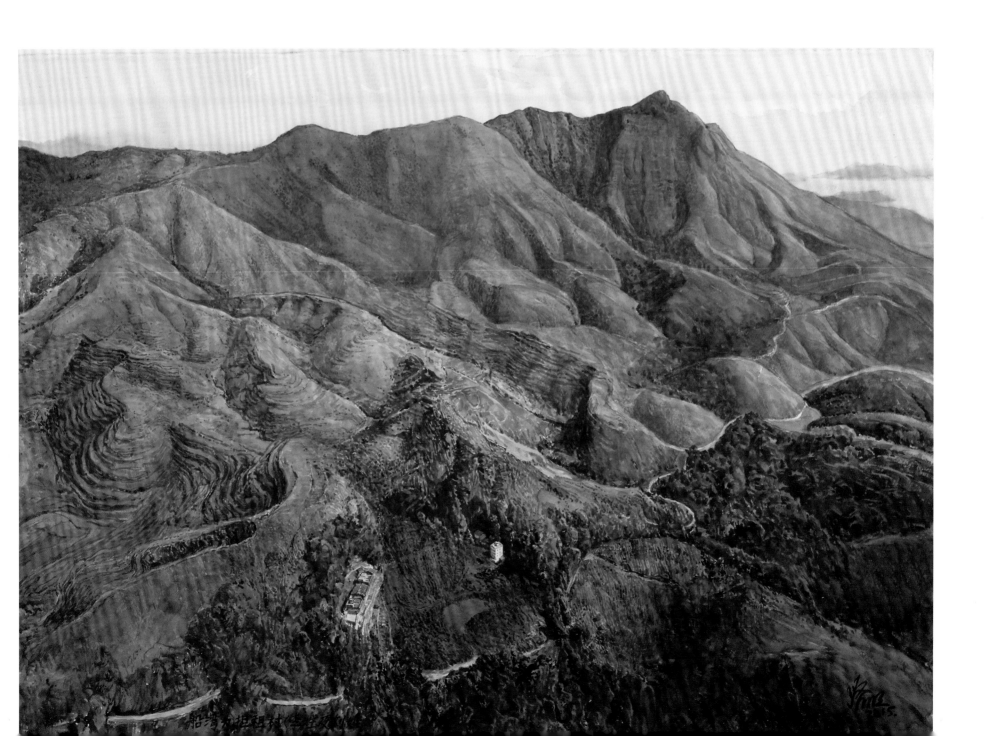

2013

93. 馬屎洲之「石龍」 The "Dragon Rock" of Ma Shi Chau

57 x 76cm

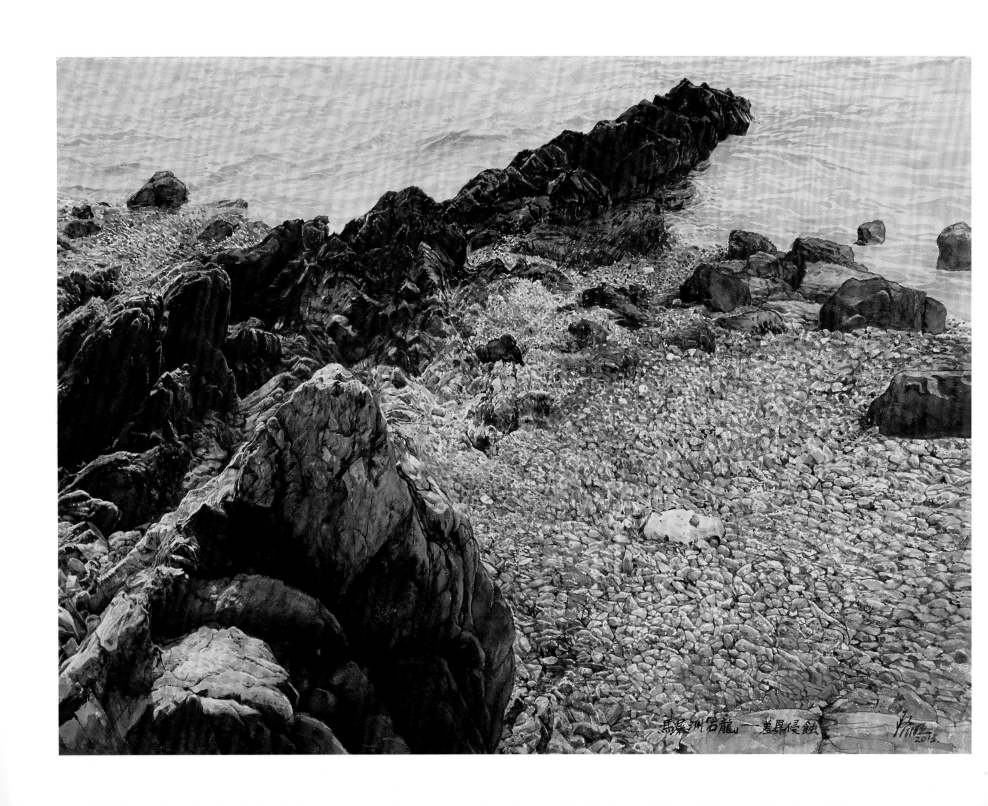

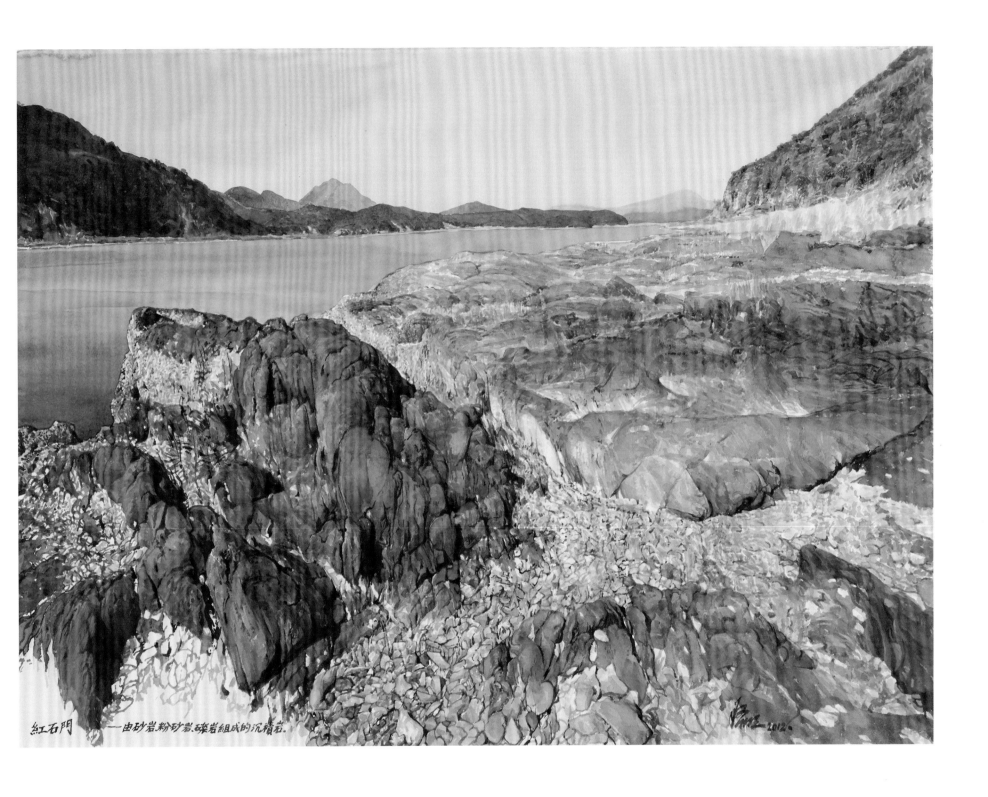

紅石門 ——由砂岩粉砂岩,碎岩組成的沉積岩.

2012

94. **紅石門 Hung Shek Mun**

57 x 76cm

2014

95. 娥眉洲之長岩 Infinite Rock, Crescent Island

57 x 76cm

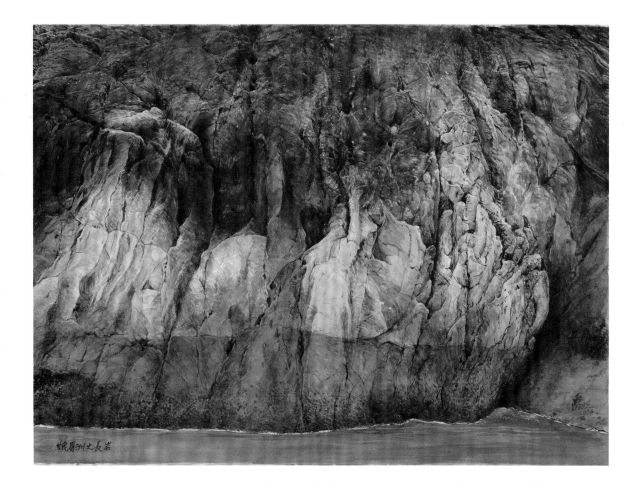

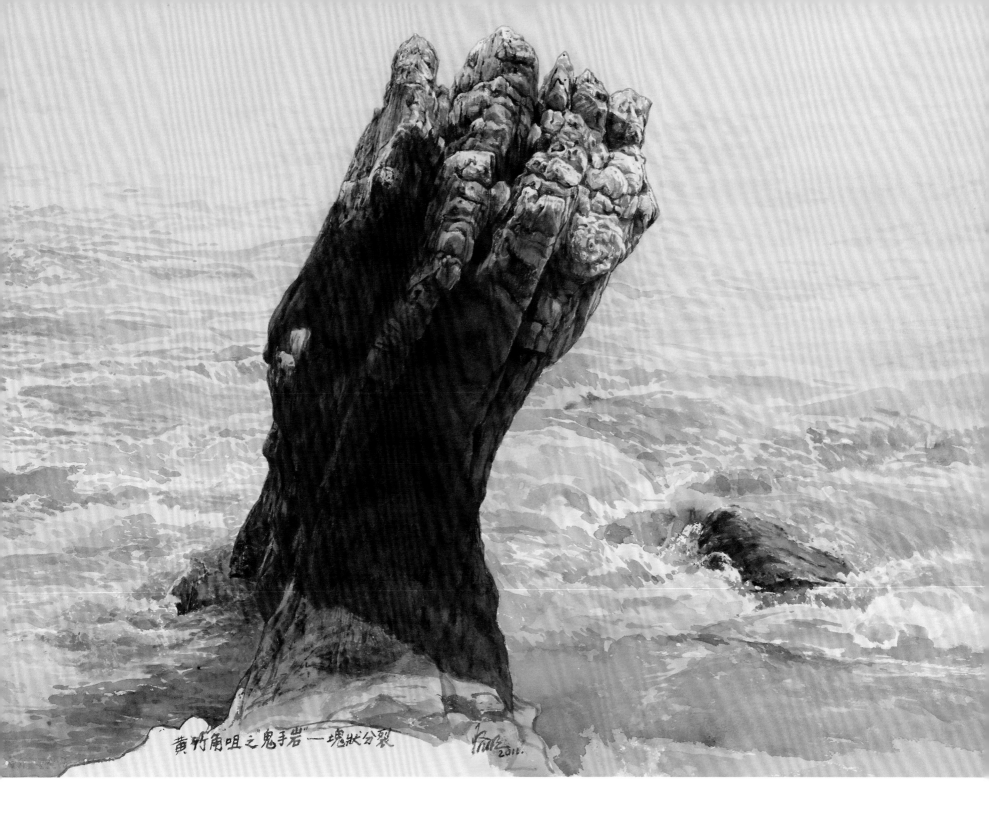

黃竹角咀之"鬼手岩"—塊狀分裂

96. 黃竹角咀之鬼手岩 Eerie Hand Rock , Wong Chuk Kok Tsui

57 x 76cm

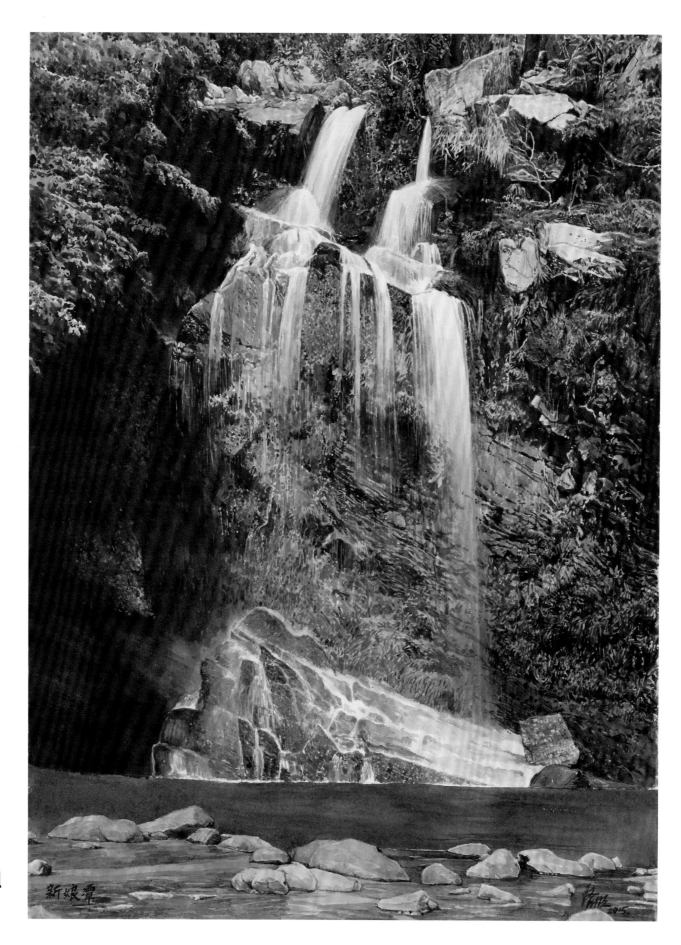

2015

97. 新娘潭
Bride's Pool

76 x 57cm

98. 烏蛟騰 Wu Kau Tang

57 x 76cm

2012

99. 大埔三椏涌 Sam A Chung, Tai Po

57 x 76cm

100. 大埔鳳園蝴蝶保育區 Fung Yuen Butterfly Reserve, Tai Po

57 x 76cm

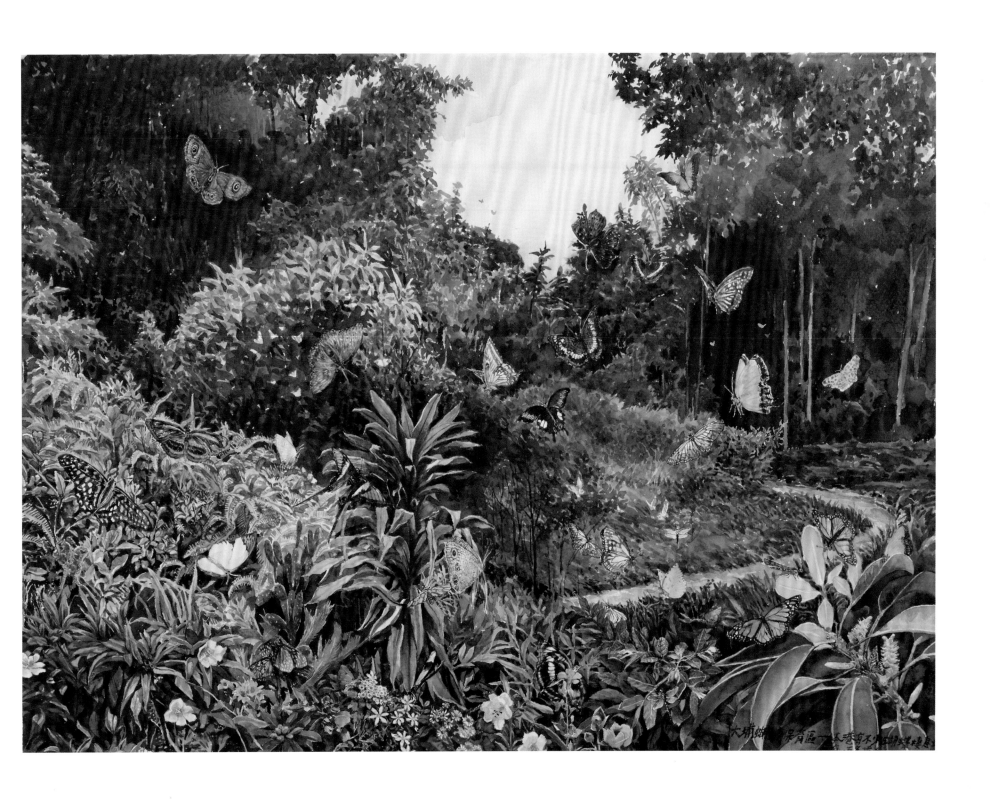

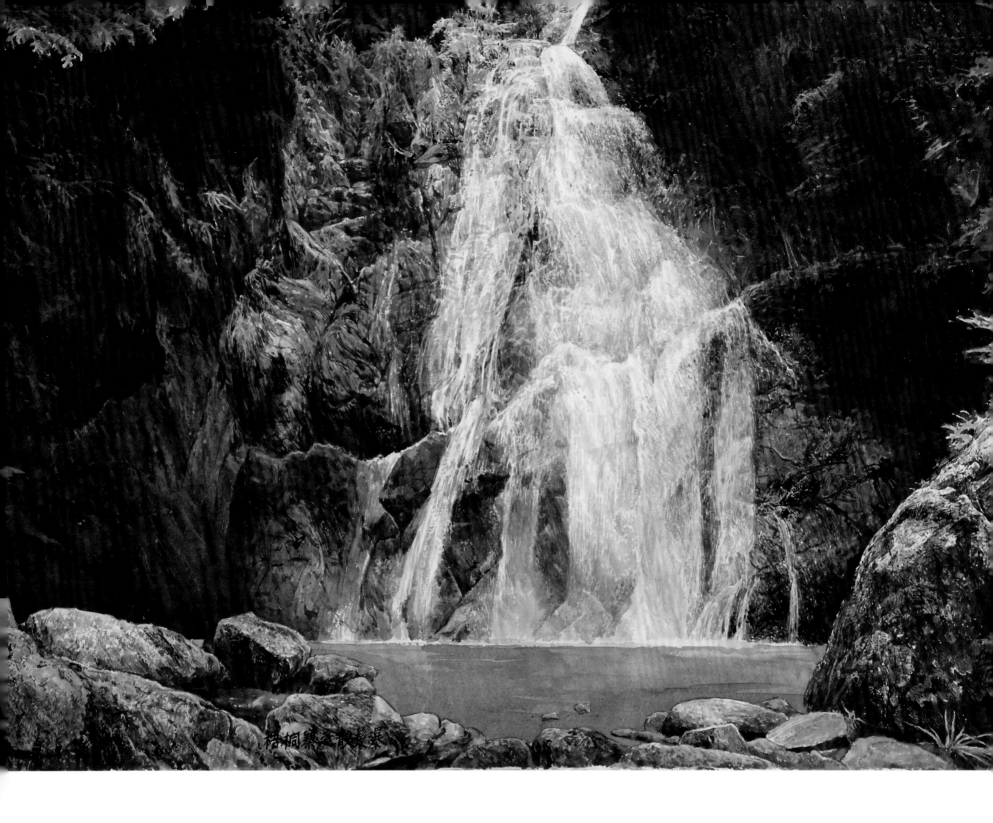

101. 梧桐寨之散髮瀑 Disheveled Waterfall, Ng Tung Chai

57 x 76cm

102. 榕樹凹 Yung Shue Au

57 x 76cm

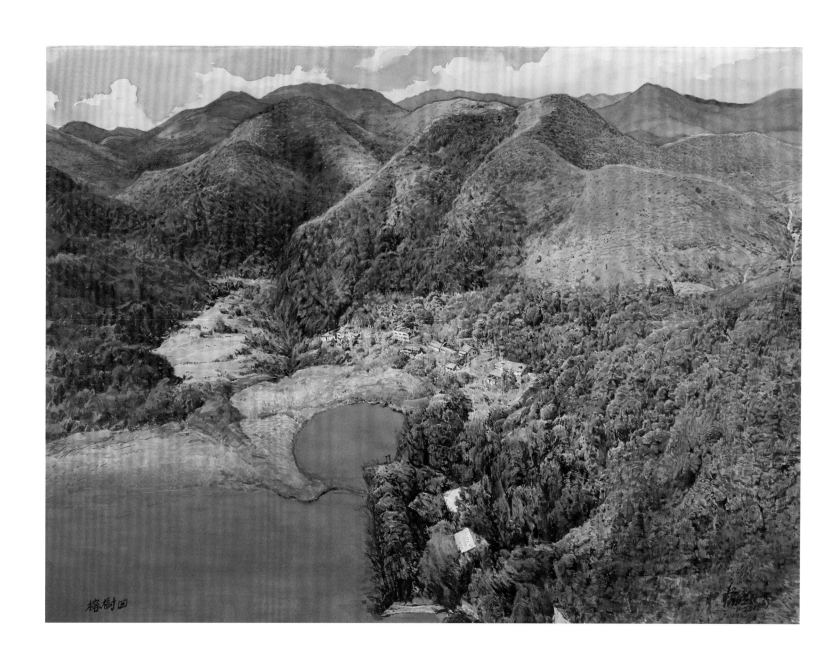

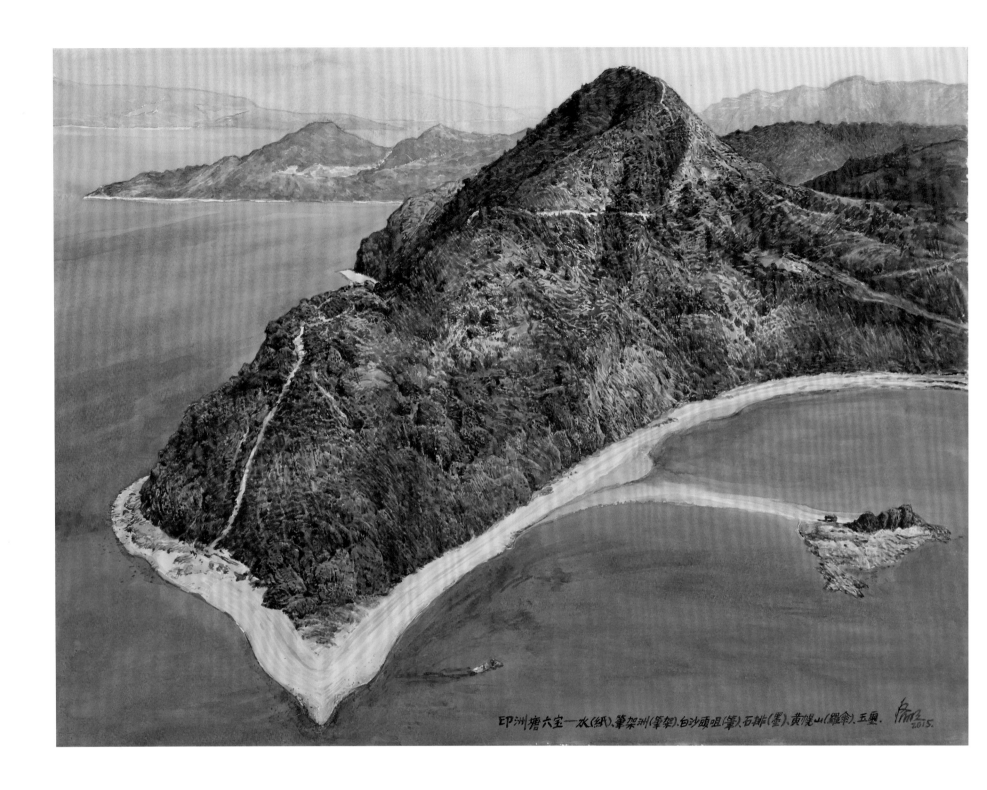

印洲塘六宝一水(紙)、筆架洲(筆架)、白沙頭咀(筆)、石排(墨)、黄幌山(羅傘)、玉璽.

2015

103. 印洲塘六寶 Treasures of Double Haven (Yan Chau Tong)

57 x 76cm

104. 南涌與鹿頸 Nam Chung and Luk Keng

57 x 76cm

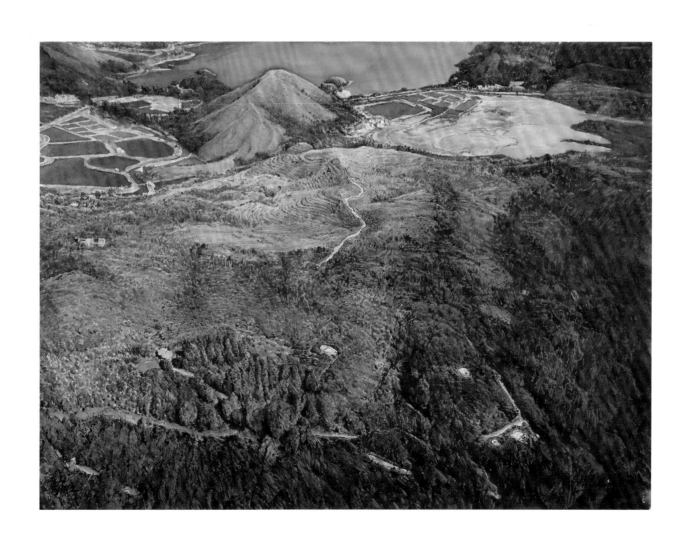

2013

105. 鴨洲 Ap Chau

76 x 57cm

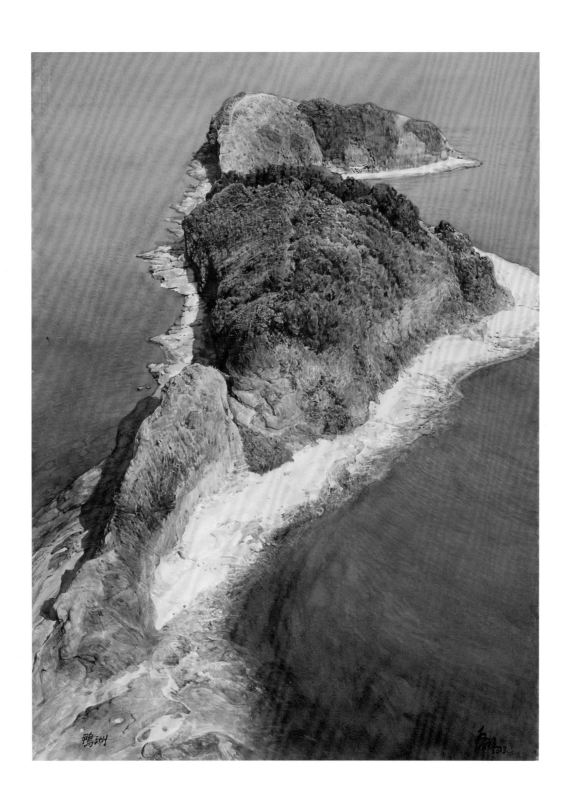

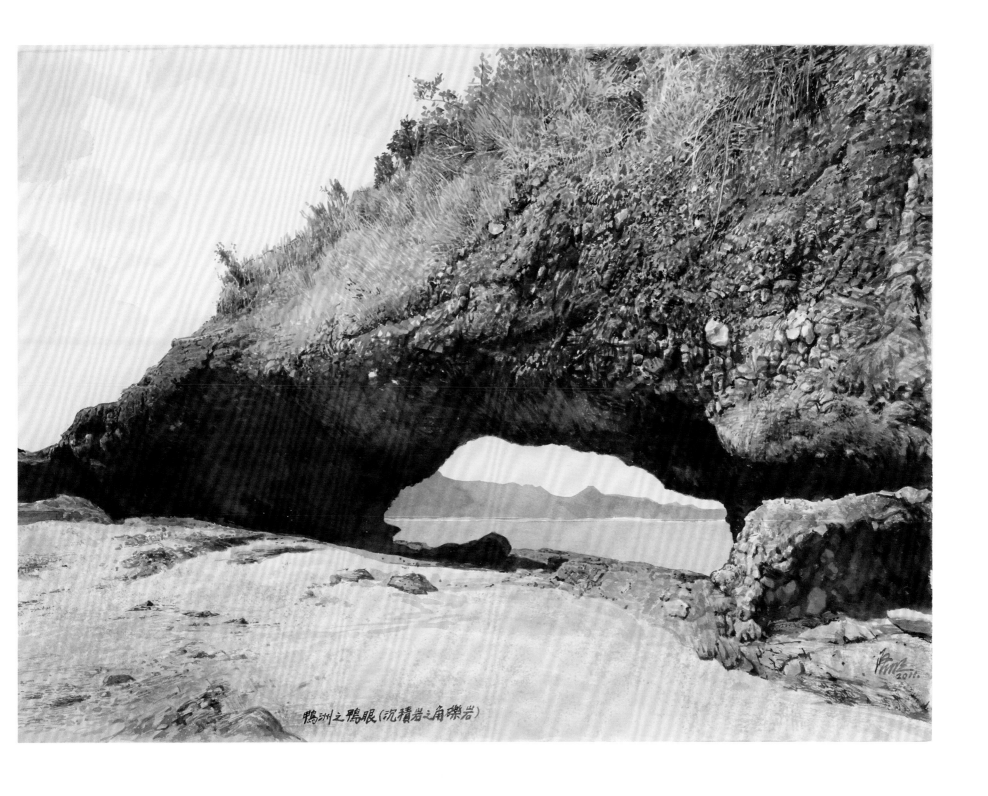

鴨洲之鴨眼 (沉積岩之角礫岩)

106. **鴨洲之鴨眼 "Duck's Eye" at Ap Chau**

57 x 76cm

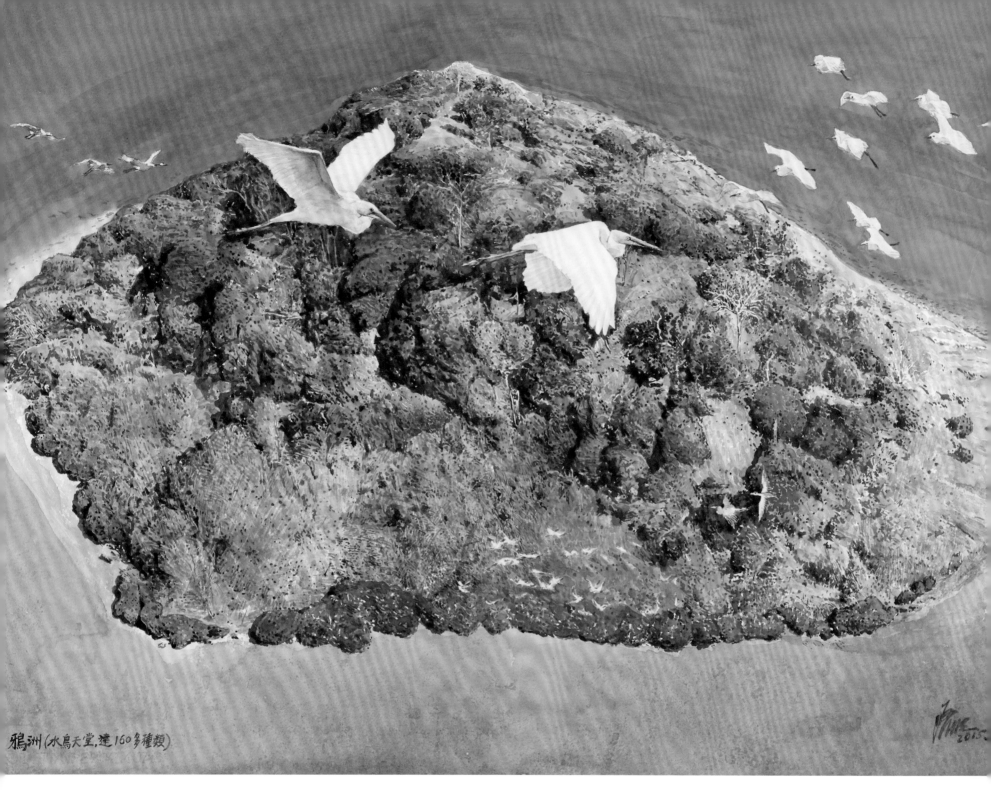

鴉洲(水鳥天堂,達160多種類)

2015

107. 鴉洲 A Chau

57 x 76cm

2013

108. 吉澳之飛鼠岩與觀音洞
Flying Squirrel Rock and Bodhisattva Cave, Kat O (Crooked Island)

57 x 76cm

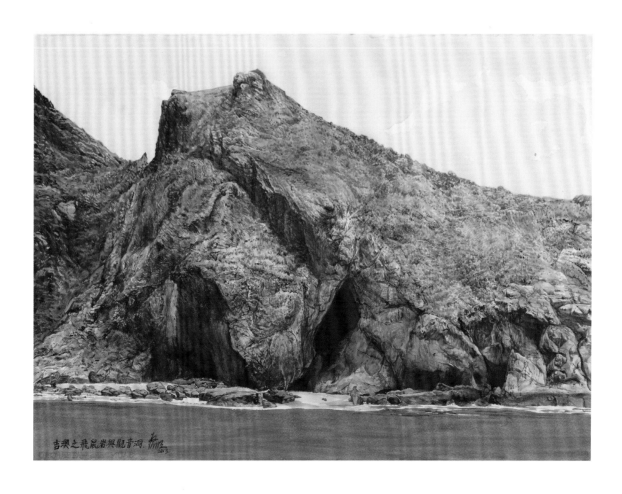

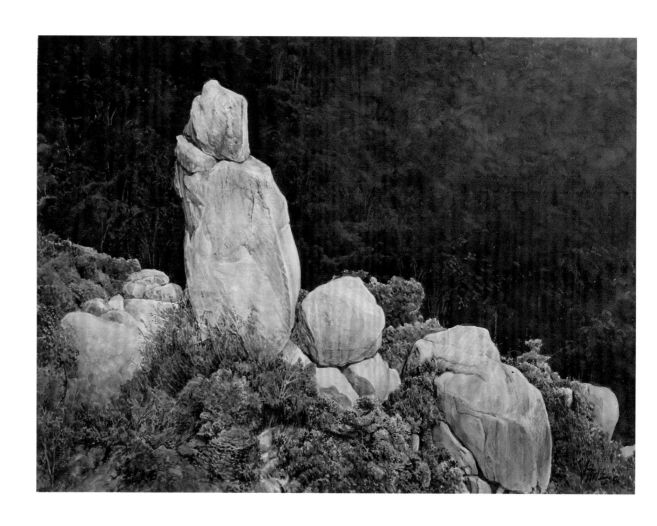

2015

109. 望夫石 Amah Rock

57 x 76cm

110. 大金鐘 Pyramid Haill

57 x 76cm

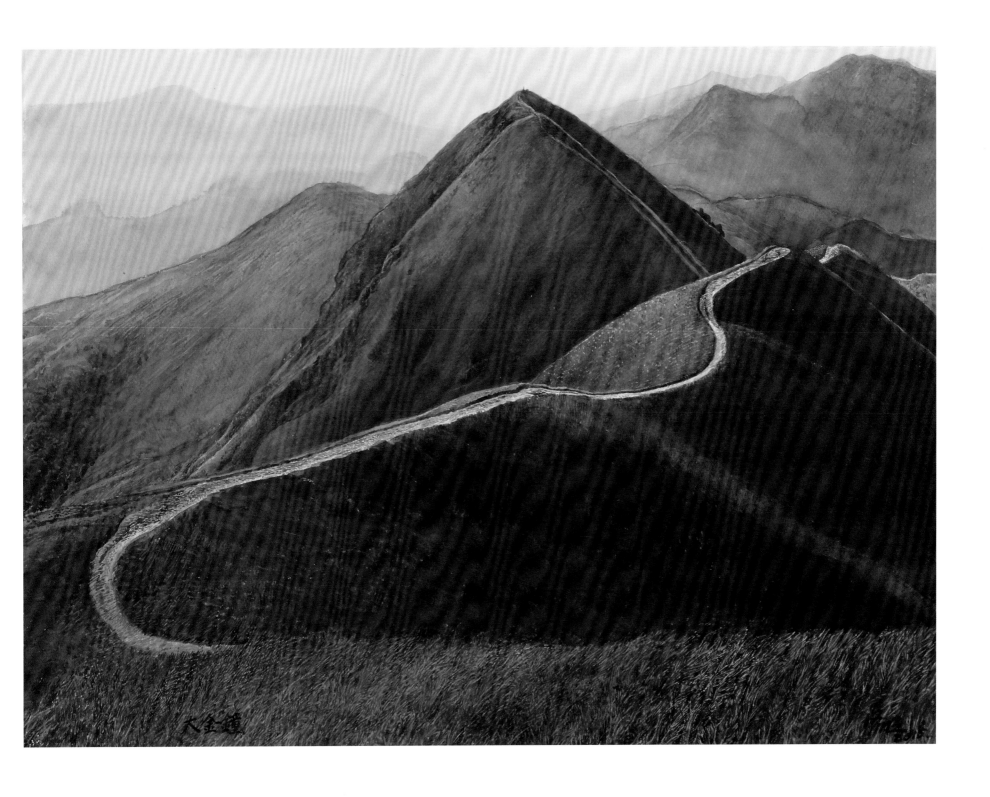

2012

111. 馬鞍山 Ma On Shan

57 x 76cm

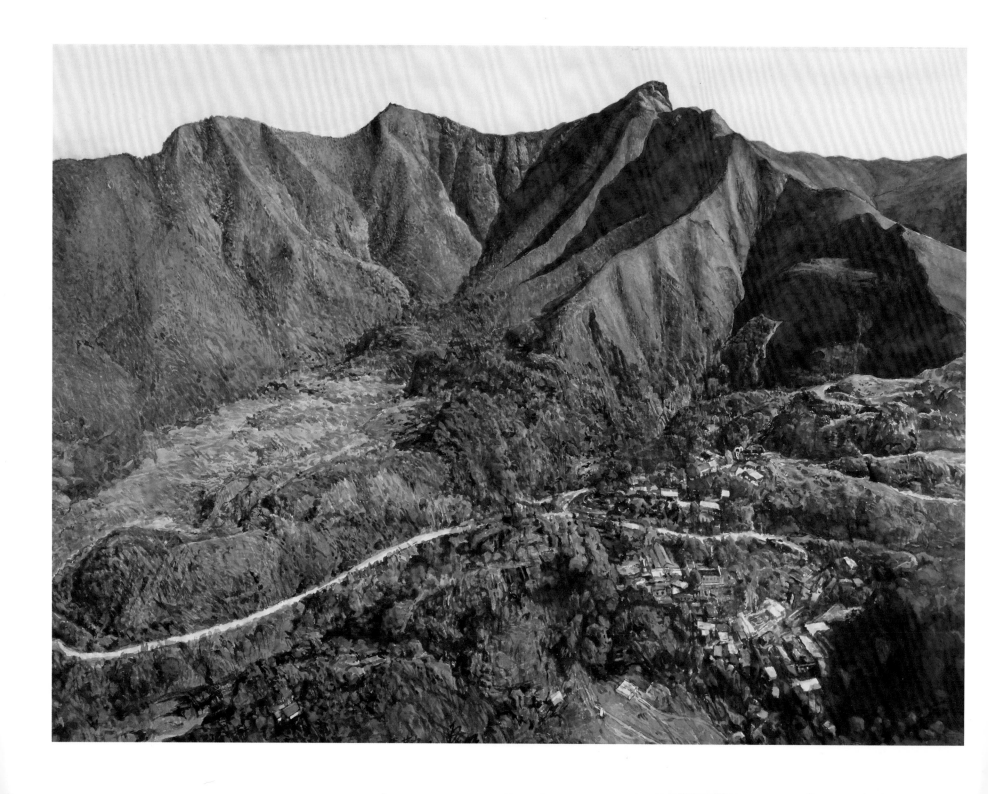

112. 鹿巢山之蜥蜴石 Lizard Rock, Luk Chau Shan

57 x 76cm

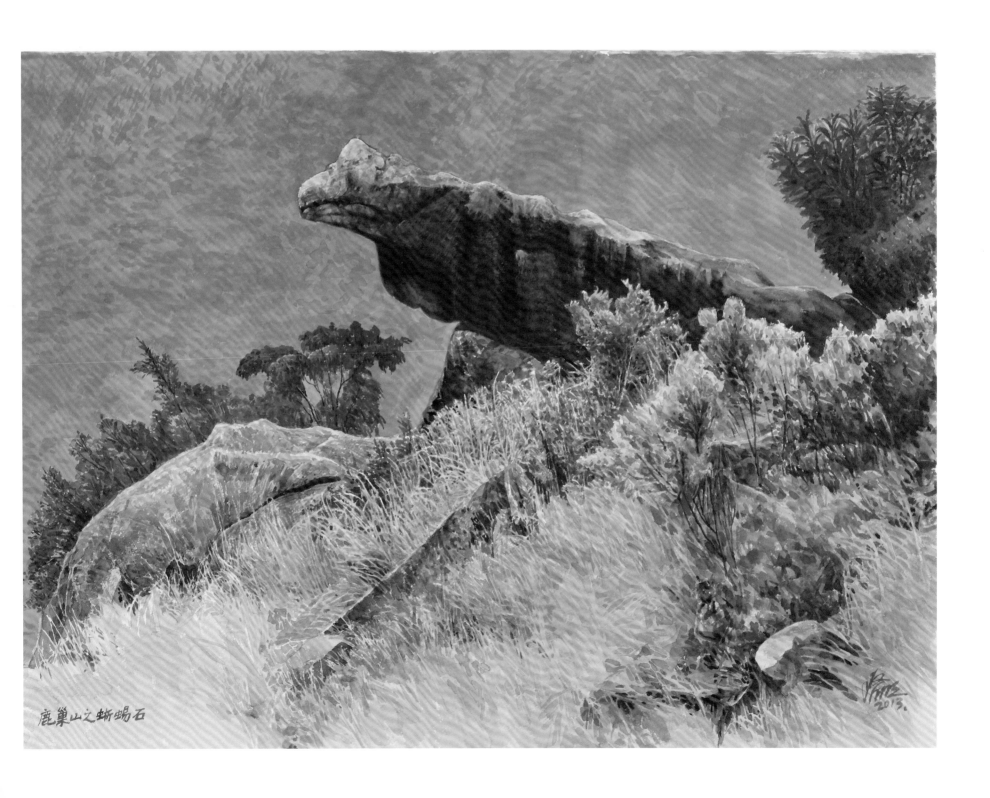

鹿巢山之蜥蜴石

2012

113. 大帽山（957 米，全港最高）
Tai Mo Shan (957m, the highest peak in Hong Kong)

57 x 76cm

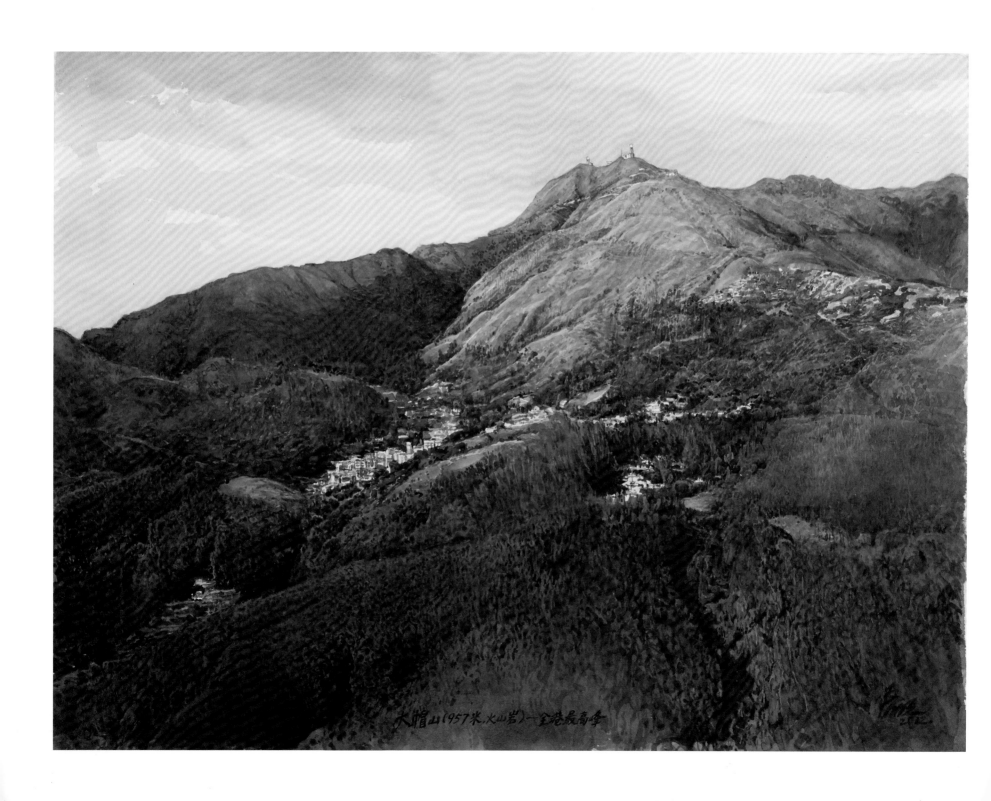

大帽山（957米，火山岩）—全港最高峰

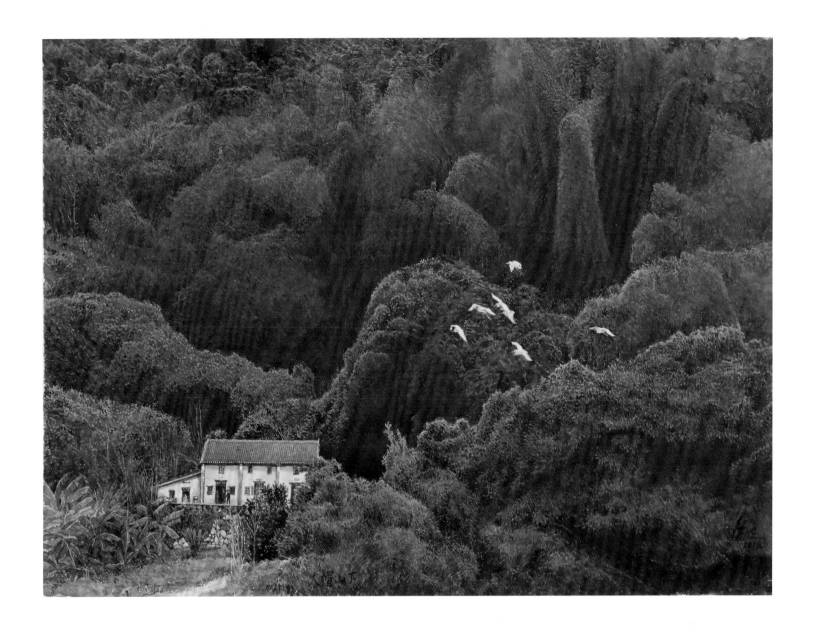

114. 大帽山下 Foot of Tai Mo Shan

57 x 76cm

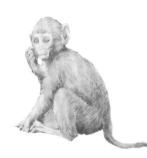

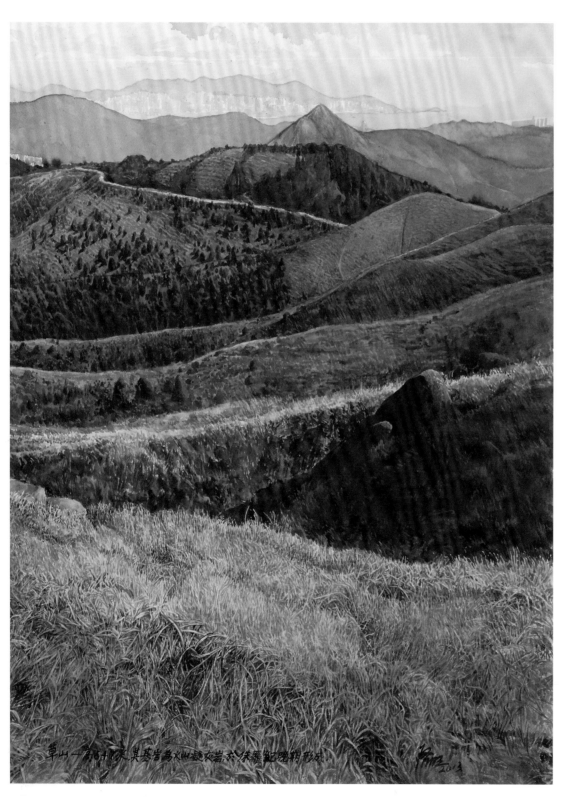

115. 草山 Grassy Hill

76 x 57cm

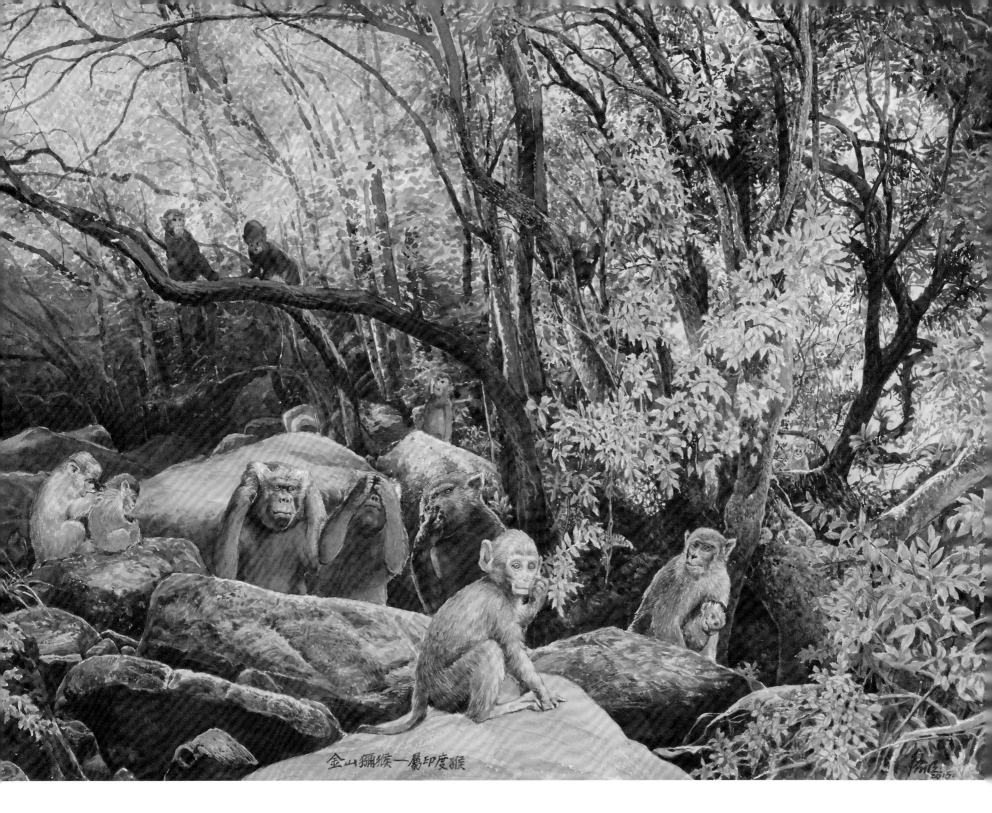

金山獼猴一屬印度猴

2015

116. 金山獼猴 Macaque of Kam Shan

57 x 76cm

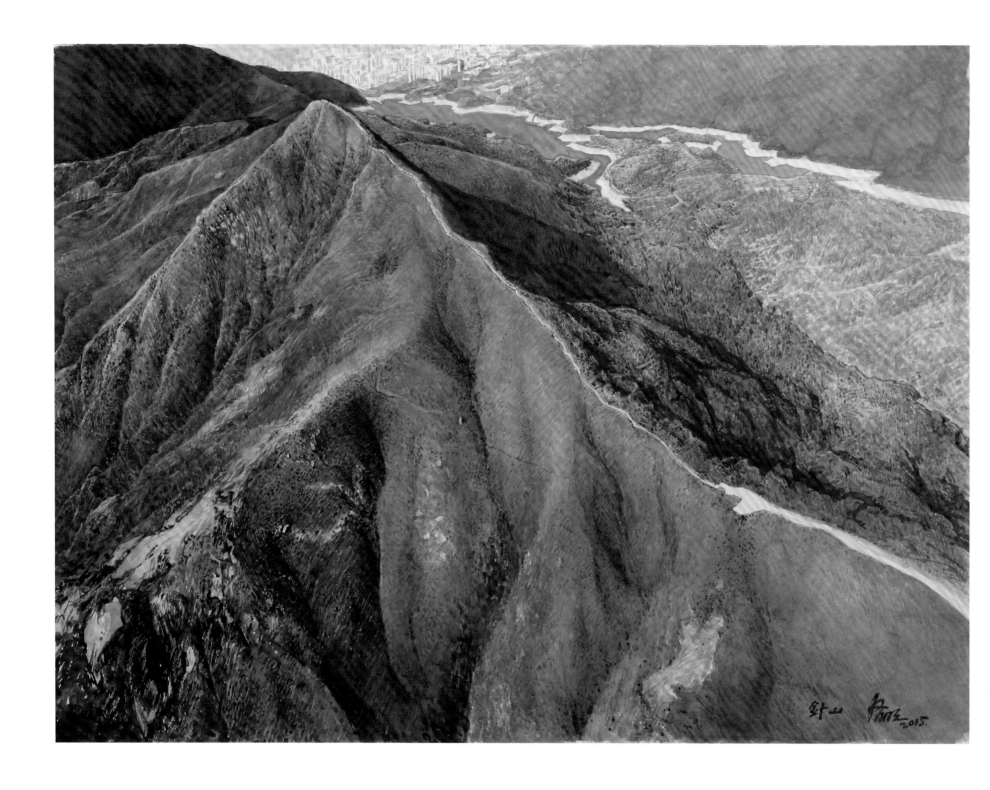

2015

117. 針山 Needle Hill

57 x 76cm

118. 城門水塘 Shing Mun Reservoir

57 x 76cm

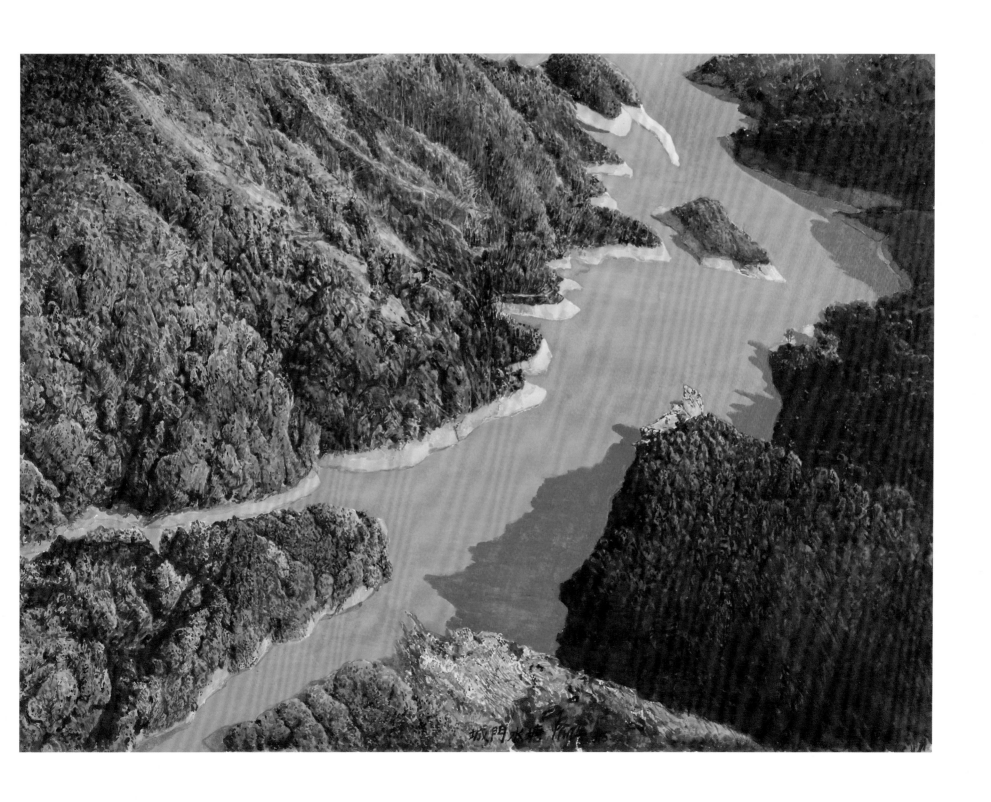

2013

119. 青山 Castle Peak

57 x 76cm

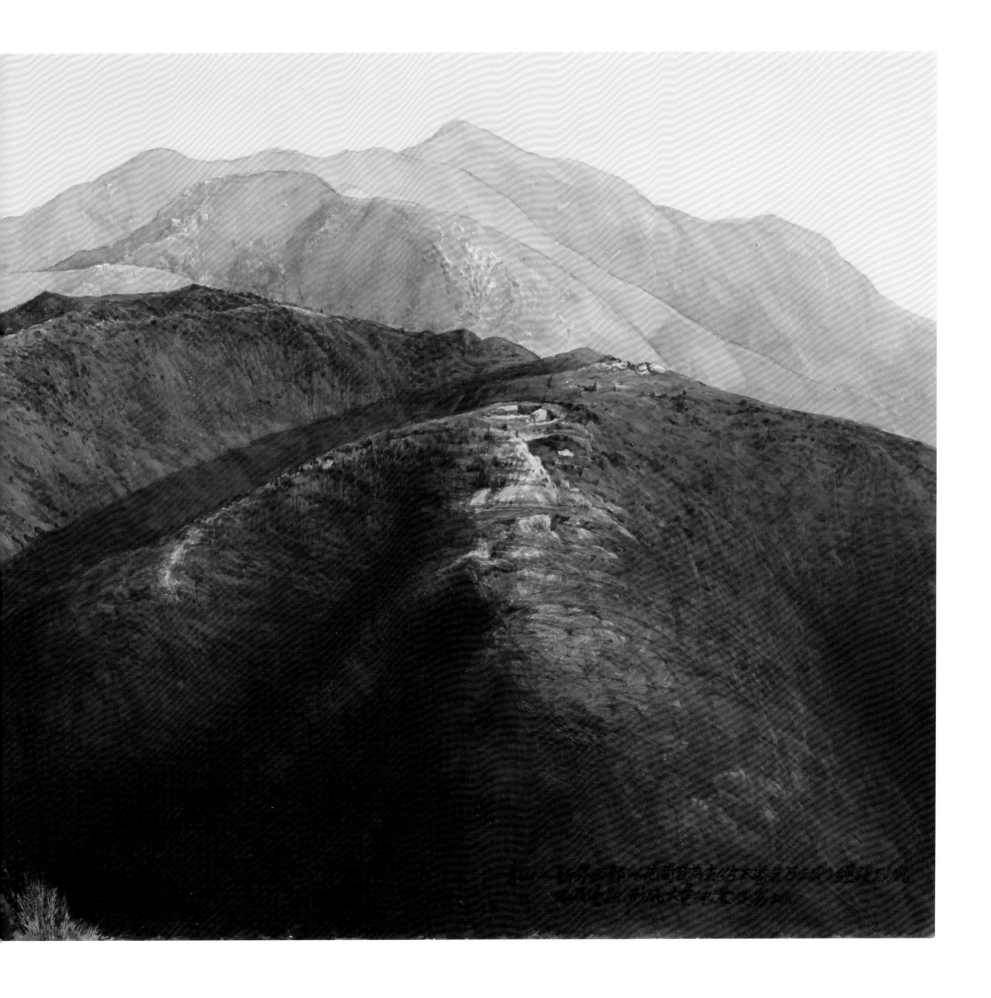

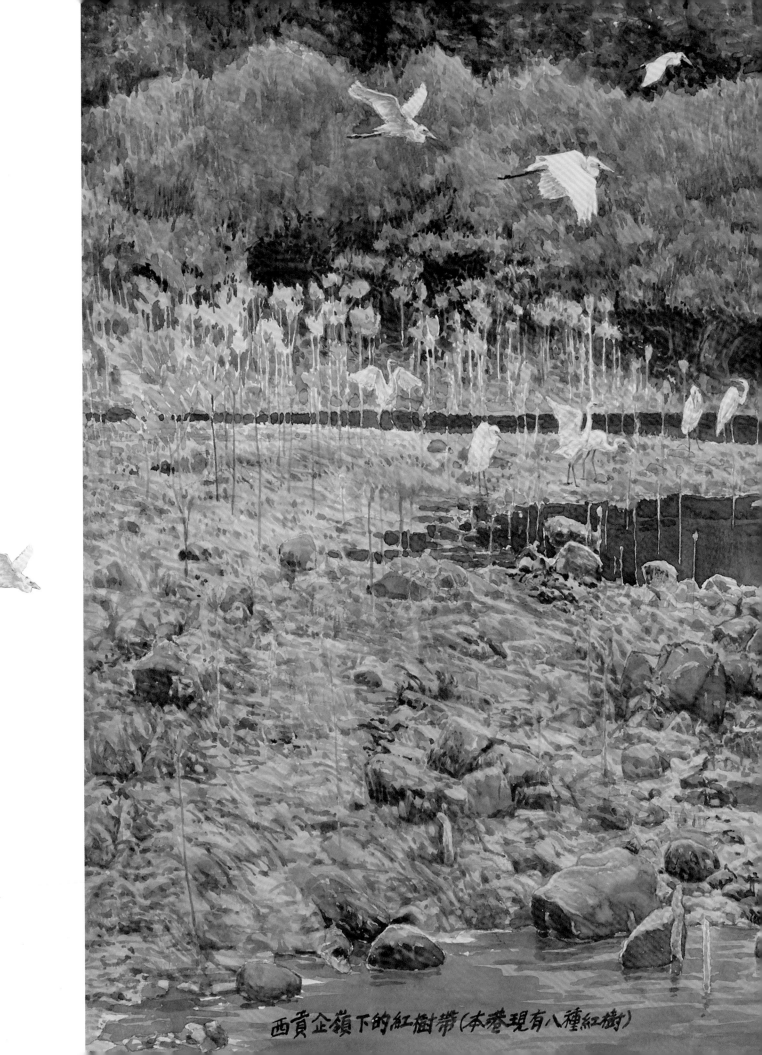

西貢企嶺下的紅樹帶（本港現有八種紅樹）

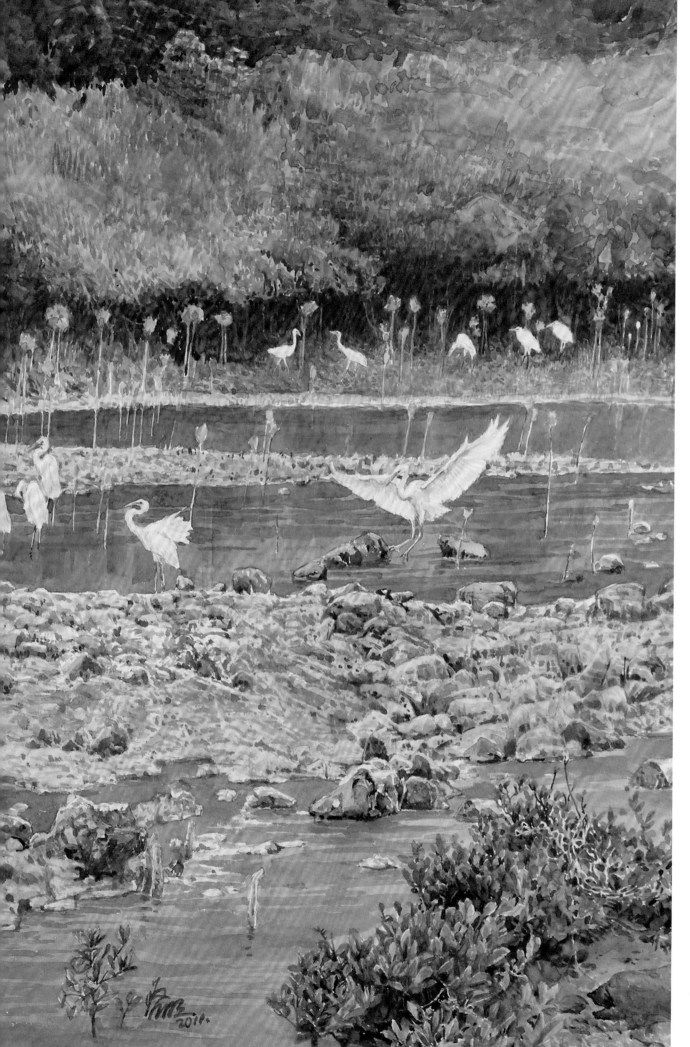

2011

120. **西貢企嶺下的紅樹林**
**Mangrove at Kei Ling Ha,
Sai Kung**

57 x 76cm

地圖 Map

新界
New Territories

101

113-114

119

118 117

116

21

22 大嶼山
Lantau Island

19

14 銀礦灣

14 梅窩

15 17 芝麻灣

17 芝麻灣懲教所

20

18

1

2

香
Hong Kor

3

13 16

23

9

24

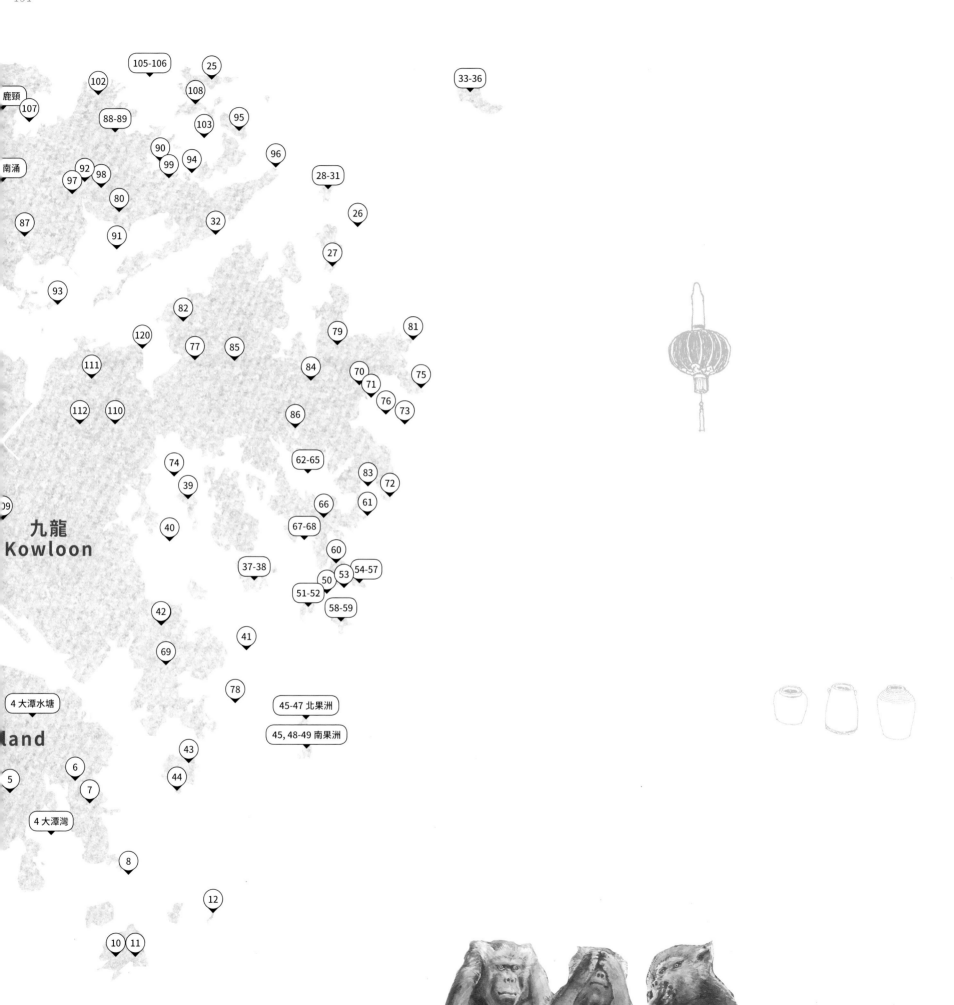

151

The Vitality of Hong Kong

江 啟 明 香 港 大 自 然 組 畫

A Collection of "Hong Kong's nature" by **Kong Kai Ming**

著者　　　江啟明
Author　　Kong Kai Ming

題字　金嘉倫　　Inscription by King Chia Lun
香港中文大學前校外進修學院藝術課程主任　　Former Senior Staff Tutor in Art Courses School of Continuing Education, The Chinese University of Hong Kong

翻譯　王璐瑤　　Translation by Louisa Lo-yiu Wong
翻譯本科畢業，現從事法律行業。　　Wong studied translation at the undergraduate level due to her passion for words and her belief in effective communication of ideas across language barriers. She is now pursuing a career in the legal industry.

責任編輯　謝慧莉　　Editor　Sia Wai Li
裝幀設計　明　志　　Design　MingChi
印務　劉漢舉　　Print Production　Lau Hon Kui

出版　中華書局（香港）有限公司　　Published by Chung Hwa Book Co. (H.K.) Ltd.
香港北角英皇道 499 號北角工業大廈 1 樓 B　　Flat B, 1/F, North Point Industrial Building, 499 King's Road, North Point, H.K.
電話：(852) 2137 2338　傳真：(852) 2713 8202　　Tel：(852) 2137 2338　Fax：(852) 2713 8202
電子郵件：info@chunghwabook.com.hk　　Email：info@chunghwabook.com.hk
網址：www.chunghwabook.com.hk　　Website：www.chunghwabook.com.hk

發行　香港聯合書刊物流有限公司　　Distributed by SUP Publishing Logistics (H.K.) Ltd
新界大埔汀麗路 36 號中華商務印刷大廈 3 字樓　　3/F, C & C Buliding, 36 Ting Lai Road, Tai Po, N.T., Hong Kong
電話：(852) 2150 2100　傳真：(852) 2407 3062　　Tel：(852) 2150 2100　Fax：(852) 2407 3062
電子郵件：info@suplogistics.com.hk　　E-mail：info@suplogistics.com.hk

印刷　中華商務聯合印刷（香港）有限公司　　Printed by C & C Joint Printing Co., (H.K.) Ltd.
新界大埔汀麗路 36 號中華商務印刷大廈 14 樓　　14/F, C & C Building, 36 Ting Lai Road, Tai Po, N. T., Hong Kong

版次　2016 年 6 月初版　　Edition　First Published in June 2016
©2016 中華書局（香港）有限公司　　©Chung Hwa Book Co. (H.K.) Ltd.

規格　280mm x 280mm　　Format　280mm x 280mm

國際書號　978-988-8394-78-4　　ISBN　978-988-8394-78-4